770.92

World Photographers Reference Series Volume 3

Henry Fox Talbot
Selected Texts and Bibliography

Anne Hammond & Amy Rule *Series Editors*
Robert G. Neville *Executive Editor*

Volumes in the Series

1 *Frederick H. Evans* edited by Anne Hammond
2 *Imogen Cunningham* edited by Amy Rule
3 *Henry Fox Talbot* edited by Mike Weaver
4 *Carleton Watkins* edited by Amy Rule

In Preparation

Bill Brandt edited by Nigel Warburton
James Craig Annan edited by William Buchanan

Each volume in **The World Photographers Reference Series** is a
bibliographical and documentary study of the work of a photographer
who has made an important contribution to the history of the medium. It
provides the scholar and the collector with a chronology, a biographical
and critical essay, reproductions of the photographer's work, and
comprehensive bibliographies, together with a selection of important and
often inaccessible texts by and about the photographer.

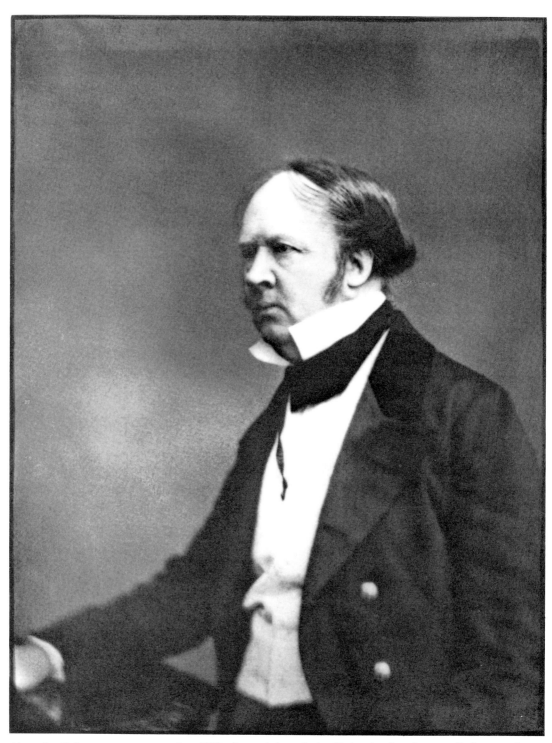

Henry Fox Talbot, anonymous portrait, c.1858; silver-gelatine print by Herbert Lambert from a collodion negative, 1934. Courtesy of Hans Kraus of New York.

Henry Fox Talbot

Selected Texts and Bibliography

Edited by
Mike Weaver

CLIO PRESS OXFORD, ENGLAND

British Library Cataloguing in Publication Data

Weaver, Mike
Henry Fox Talbot: Selected Texts and
Bibliography. — (World Photographers
Reference Series)
I. Title II. Series
779.092

ISBN 1–85109–192–0

Clio Press Ltd.
55 St. Thomas' Street
Oxford OX1 1JG, England

Typeset by Columns Design and Production Services Ltd.,
Reading, England.
Printed and bound in Great Britain by
Butler and Tanner, Ltd., Frome and London.

Contents

List of Illustrations

Henry Fox Talbot, anonymous portrait, *c*.1858; silver-gelatine print by Herbert Lambert from a collodion negative, 1934.

frontispiece

Diogenes with a Camera

The Pencil of Nature

Views in Scotland

Preface and Acknowledgements

This volume of the World Photographers Reference Series presents a documentary and bibliographical study of Henry Fox Talbot, who not only invented the negative-positive process which we still use today but also created a small body of beautiful photographic work. It includes a chronology of his career in the context of his intellectual interests, a critical essay emphasizing meaning in his photographs, a selection of texts by and about him, and an extensive, sometimes annotated, bibliography.

The documentary texts by him reveal his multifarious interests. They include a memoir on his early work in photography; the complete text of his book illustrated with photographs, *The Pencil of Nature*; an early poem; and a piece of writing on mythology. The writings about Talbot include evidence of his interest in painting; commentaries on his photographic and photomechanical inventions; notes to the plates of *The Pencil of Nature*; and an account of *Sun Pictures in Scotland*. The introductory essay by the editor treats Talbot as a scholar-photographer rather than as an inventor.

The preferred form of Talbot's name today seems to be just Talbot, rather than the nineteenth-century usage Fox Talbot. In his earliest writings, Talbot himself used the initials W.H.F., but in his later writings simply H.F.

Each bibliographical entry is identified by a bold numeral. It is designated in marginal notes to the text as, for example, 'Bibl. **243**, p. 96', where p. 96 would represent the page number referred to in the listed article or book. Articles reprinted or abridged in this book as documentary texts are marked in the bibliography with an asterisk (*).

The marginal notes which appear in the texts are authorial; the use of daggers (†) is editorial.

Corrections or omissions in the bibliography may be sent to Clio Press, 55 St Thomas' Street, Oxford OX1 1JG, which publishes twice-yearly entries on photographers in the index *ARTbibliographies Modern*. Essays and further studies on Talbot may be submitted for publication to the journal *History of Photography*, Taylor & Francis, 4 John Street, London WC1N 2ET.

The largest collection of Talbot's photographs is held at the National Museum of Photography, Film and Television, Bradford, but there is also a major collection of material at the Fox Talbot Museum, Lacock. In the United States, there is a notable collection of Talbot's photographs at the Department of Photographs, J. Paul Getty Museum, Santa Monica, California; other American public collections can be located by using the *Index to American Photographic Collections*, edited by Andrew Eskind and Greg Drake (Boston: G.K. Hall & Co., 1990).

The editor acknowledges with gratitude H.J.P. Arnold for his excellent biography (Bibl. **498**); Gail Buckland, whose selection of illustrations and text is still the best visual introduction to Talbot's work as a photographer (Bibl. **512**); and William S. Johnson, for the Talbot section of *Nineteenth Century Photography: An Annotated Bibliography 1839–1879* (Boston: G.K. Hall & Co.; London: Mansell, 1990). In addition, he wishes to thank the other fine scholars who permitted abridgements of their writings to be included in this book: Christopher Lloyd, Eugene Ostroff, Larry J. Schaaf, Graham Smith, and R. Derek Wood; and also, for their kind assistance, Peter Agius, Hubertus von Amelunxen, Gordon Baldwin, Paolo Costantini, Andreas Haus, Alasdair Hawkyard, Hans Kraus, Robert Lassam, Tony Simcock, Roger Taylor, and Mike Ware. Finally, the editor wishes to express a special debt to Michael Gray, Curator of the Fox Talbot Museum, Lacock, not only for his indispensable help with the illustrations but for sharing so freely his great knowledge of our mutual hero.

Contextual Chronology

1763 Horace Walpole, *Catalogue of Engravers born and resident in England*.

1764 Winckelmann, *History of Ancient Art*. Dilettanti Society of London sends members to Greece and Asia Minor to study antiquities.

1765 Walpole, *The Castle of Otranto*.

1768 Thomas Gray, *Poems*.

1769 Josiah Wedgwood opens his pottery works at 'Etruria'.

1772 J.G. Herder's *On the Origins of Speech* begins the study of comparative philology.

1774 Thomas Warton, *History of English Poetry*.

1777 *The Botanical Magazine* founded.

1784 Kant, *Notion of a Universal History in a Cosmopolitan Sense*.

1789 Lavoisier, *Traité élémentaire de chimie*. Gilbert White, *Natural History of Selborne*. Revolution in France.

1790 Goethe, *Versuch, die Metamorphose der Pflanzen zu erklären*.

1791 Constantin Volney's *Les Ruines, ou méditations sur les révolutions des empires*.

1793 Richard Porson heads a revival of Classics at Cambridge University.

1794 Ann Radcliffe, *The Mysteries of Udolpho*. Fichte, *On the Notion of the Theory of Science* and *Vocation of a Scholar*.

1797 Thomas Girtin's first watercolour exhibition.

1798 Alois Senefelder invents lithography.

1799 Count Rumford obtains a charter for the Royal

Institution of Great Britain.

1800 William Henry Fox Talbot is born, 11 February. His father dies, 31 July.

1802 Thomas Wedgwood and Humphry Davy publish an account of their photographic experiments in the *Journals of the Royal Institution*.

1803 J.S. Cotman and John Crome found the Norwich School of painters.

1804 Talbot's mother, Lady Elisabeth, marries Charles Feilding. Bonaparte crowned Napoleon I in Paris.

1805 H.T. Colebrooke compiles his Sanskrit grammar.

1806 Davy isolates sodium and potassium by electrolysis.

1807 Thomas Moore, *Irish Melodies*. Treaty of Tilsit leaves Britain alone against Napoleon.

1808 Talbot attends Rottingdean School. John Dalton, *New System of Chemical Philosophy*. Goethe, *Faust, part one*.

1809 Etienne Malus discovers polarization of light by reflection.

1810 Walter Scott, *The Lady of the Lake*.

1811 Talbot enters Harrow School.

1812 Davy, *Elements of Chemical Philosophy*. H.F. Gesenius, *Hebrew and Chaldaic Dictionary*. Brothers Grimm, *Fairy Tales*. Prime Minister Spencer Percival assassinated in the House of Commons, 11 May.

1813 David Cox, *Treatise on Landscape Painting and Effect in Water Colours*.

1814–15 Talbot compiles *Flora Harroviensis* with Walter Trevelyan.

1815 Talbot receives private tuition. Antonio Canova sculpts *Three Graces*. Augustin Fresnel's experiments on the diffraction of light. Battle of Waterloo, 18 June.

1816 David Brewster invents the kaleidoscope. Scott, *The Antiquary*.

1818 Talbot matriculates at Trinity College, Cambridge.

1819 Alois Senefelder, *A Complete Course of Lithography*. John Herschel publishes 'On the hyposulphurous acid and its compounds' in the *Edinburgh Philosophical Journal*.

1820 Talbot wins Porson Prize for translating part of *Macbeth* into Greek.

1821 Talbot, member of the Cambridge Philosophical Society, graduates as twelfth Wrangler.

1821–28 Jean-François Champollion publishes his decipherment of Egyptian hieroglyphics.

1822 Talbot is elected a member of the Royal Astronomical Society. Colebrooke founds the Royal Asiatic Society for study of Eastern languages.

1824 Talbot is invited to join the Athenaeum Club.

1826 Talbot, on the way back from a botanical trip to Corfu, plans a picture gallery at Lacock Abbey.

1827 Talbot moves into Lacock. Niépce produces an image on an asphalt-coated plate.

1829 Talbot is elected Fellow of the Linnean Society.

1830 Talbot, *Legendary Tales, in Verse and Prose*. Auguste Comte, *Course of Positive Philosophy*. Agricultural riots sweep the West of England.

1831 J.A. Paris's *Life of Humphry Davy* reprints account of Wedgwood–Davy experiments in photography. British Association for the Advancement of Science is established. First and Second Reform Bills fail in Parliament.

1832 Talbot is admitted as Fellow of the Royal Society of London, 2 February. He is elected a Liberal M.P. to the House of Commons, 10 December. He marries Constance Mundy, 20 December. The Reform Bill becomes law.

1834 Talbot takes Constance on a honeymoon trip to the continent, June–December. John Keble initiates Oxford Movement for the reform of the Church of England.

1834 Talbot conducts photographic experiments, January–May, continuing in Geneva on his continental tour, August–November. He resigns as an M.P.

1835 Talbot makes what remains the earliest extant negative at Lacock.

1836 British Association of Advancement of Science Meeting at Bristol brings eminent figures in science to Lacock.

1837 Talbot receives the Bakerian Prize from the Royal Society for his work on the optical phenomcna of crystals. Georg Grotefend deciphers cuneiform inscriptions in Persia.

1838 Talbot, *Hermes, or Classical and Antiquarian Researches*. He receives Royal Medal for work in

integral calculus.

1839 Daguerre's process announced, 7 January. Talbot shows photogenic drawings at the Royal Institution, 25 January, and presents a paper to the Royal Society, 31 January. He reveals details of his photogenic drawing process, 21 February, which Daguerre does not do until 19 August. Talbot, *The Antiquity of the Book of Genesis*.

1840 Talbot is appointed Sheriff of the County of Wiltshire. He uses gallic acid to develop the latent image of the Calotype negative. William Whewell, *Philosophy of Inductive Sciences*. Penny post introduced in Britain.

1841 Talbot announces the Calotype process.

1842 Talbot receives the Rumford Medal from the Royal Society for photographic work.

1843 Scottish religious Disruption provokes D.O. Hill to consider photography as a means of making portraits. Talbot sets up his printing establishment in Reading under Nicolaas Henneman.

1844 Talbot tours the Scottish Borders, Edinburgh, and the Perthshire Highlands, in autumn. Samuel Morse transmits first telegraphic message in U.S.

1844–46 Talbot publishes *The Pencil of Nature* in six fascicles.

1845 Talbot publishes *Sun Pictures of Scotland*. Syro-Egyptian Society founded by Dr John Lee, the astronomer, of Hartwell House.

1846 Henry Rawlinson deciphers cuneiform inscriptions in Persia.

1847 Talbot, *English Etymologies*.

1848 Marx and Engels issue *Communist Manifesto*. Chartist meeting in London.

1850 Natural sciences established as a subject of study at Oxford University.

1851 Talbot first demonstrates electric flash photography at the Royal Institution, 14 June. Great Exhibition, London.

1852 Talbot obtains injunction against Richard Colls for using the Calotype process. London *Times* prints letter from Talbot, 13 August, giving up his patent rights except for portraiture.

1854 Talbot loses his patent case against Martin Laroche. Crimean War begins.

1855 Calotype patent expires, February.

1855–59 Talbot spends winters in Edinburgh.

1856 Talbot considers action against Paul Pretsch's Photogalvanographic engraving process, December.

1858 Talbot elected honorary member of the Royal Society of Edinburgh.

1859 Talbot elected Vice-President of the Royal Society of Literature. He adds nine photoglyphic engravings to the Third Annual Exhibition of the Photographic Society of Scotland, Edinburgh, 10 January. Charles Darwin, *The Origin of Species by Natural Selection*.

1862 Charles Lyell, *The Antiquity of Man*.

1863 Talbot receives honorary degree from University of Edinburgh.

1864 Talbot and Sir David Brewster photographed together by Moffat by magnesium light. Joseph Bertrand, *Treatise on Differential and Integral Calculus*.

1867 Karl Marx, *Das Kapital*, volume one.

1868 Ernst Haeckel, *The History of Creation*.

1869 Edouard von Hartmann, *The Philosophy of the Unconscious*.

1870 Talbot is a founder-member of the Society of Biblical Archaeology with Joseph Bonomi, Samuel Birch, Sir Henry Rawlinson, J.W. Bosanquet, 9 December. Heinrich Schliemann excavates Troy.

1873 Walter Pater, *Studies in the History of the Renaissance*.

1874 Talbot, *Contributions towards a Glossary of the Assyrian Language*.

1875 Max Müller, *The Sacred Books of the East*.

1876 Bell patents the telephone. Edison invents the phonograph.

1877 Talbot dies, 17 September.

Diogenes with a Camera

Mike Weaver

As a gentleman of science, Talbot was a typical, if distinguished, example of his time. He had been to Trinity College, Cambridge, was a liberal Anglican in religion, and a Whig in politics. He had been a member of the Cambridge Philosophical Society, of the Philological Society, of the Royal Astronomical Society, and a Fellow of the Royal Society of London. He was, therefore, a fully paid-up member of the scientific clerisy, but in two respects he seems to have been less than typical: firstly, although he originally undertook natural philosophy as a pure avocation, he took a keen interest in a financial return on his inventions; and secondly, he made photographs, some of which (the ones we admire most today) produced a metaphorical rather than purely descriptive account of reality. Scientific knowledge and antiquarian scholarship were complemented by something of a more metaphysical nature, the imagery of art. He was probably one of the most visually literate members of the British Association for the Advancement of Science.

Talbot's most important connection with the fine arts came through his uncle, William Fox-Strangways, who guided him on a collecting tour of the Low Countries and Italy in the 1820s, and made donations of early Italian paintings to the Ashmolean Museum and Christ Church Picture Gallery in Oxford. Remodelling the south gallery at Lacock Abbey in 1827, Talbot would have made it into a picture gallery if he could have afforded it.

The invention of photography came at the end of a long search for a method for printing directly from nature. Talbot's book *The Pencil of Nature*, illustrated with salted-

paper prints, took its place in the history of the illustrated book with Charles Joseph Hullmandel's *The Art of Drawing on Stone* (1824). The word photography was coined by analogy with lithography, and Talbot's motivation towards a chemical kind of nature printing was much less radical than has been supposed. He did not expect to revolutionize ways of seeing so much as to satisfy contemporary taste in antiquarian and picturesque subjects by a more efficient process. The Scotsman David Octavius Hill, in his *Sketches of Scenery in Perthshire* (1821), had been one of the first artists in Britain to use lithography; with Talbot's process and help from the young Robert Adamson, he then turned to photography.

In the Georgian Gothic hall at Lacock Abbey there is a terracotta statuette in a niche of Diogenes with his lantern. Of all the little statues there Talbot chose to photograph this one as one of four images made in his new Calotype process on 29 September 1840 (fig. 1). The Stoic philosopher was emblematic to him of the mystical rather than sceptical chemist who delighted in revealing what lay hidden in darkness. Talbot admitted it was not easy, either for the chemist or the philologist: 'Like one who follows Ariadne's clue through a tortuous labyrinth, he may himself be convinced of its safe guidance, but unable to convince others – who have taken a different path'.[1] The figure of Diogenes was a cultural hero in the period of the European Enlightenment. Rousseau, who described himself as a 'second Diogenes', was characterized wickedly by Voltaire as 'Diogenes without a Lamp'. By the late eighteenth century Diogenes had become the hero of the French Revolution, with light as a metaphor for all kinds of truth – political, religious, and scientific – symbolized by his magic lantern.[2] His *dark lantern* was more than a mere tool; it was also the emblem of a spiritual search. Similarly, the *camera obscura*, the darkened room from which the camera as instrument is derived, also referred to the *Dunkelkammer* or *chambre à reflexion* of the hermetic tradition: the dark room was a place for reflection on the need for spiritual enlightenment. Just as Sir Humphry Davy as inventor of the miner's safety lamp expressed this idea at the operative level, so Talbot's lantern in *The Open Door* (fig. 2) evoked it speculatively. If the lantern illuminates (even at midday) all that lies in darkness, the bridle of Stoicism checks the passions that threaten pure reason, and the broom sweeps the threshold of the dark chamber clean.[3] It is an emblematic picture in which these

1. Bibl. **114**, p. vii.
2. Klaus Herding, 'Diogenes als Bürgerheld', *Boreas* (Münster), vol. 5 (1982), p. 232–54.
3. See Talbot's etymology of *sweep*: 'To *sweep* is related to the Latin *scopa*, a broom'. Bibl. **114**, p. 328.

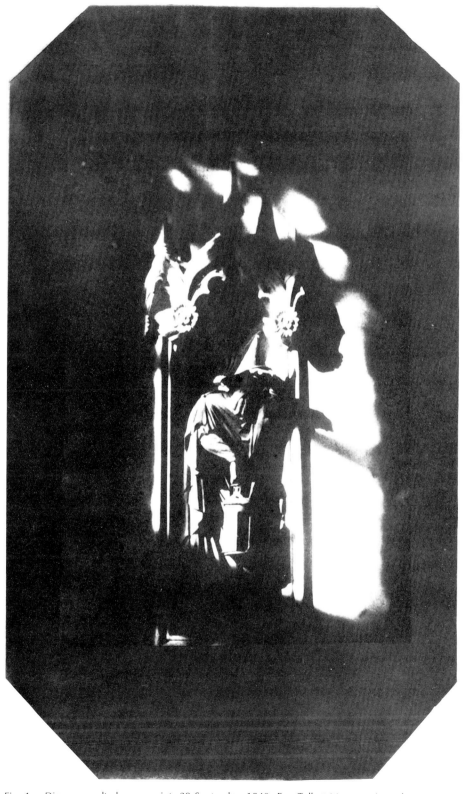

Fig. 1. *Diogenes*, salted-paper print, 29 September 1840. Fox Talbot Museum, Lacock.

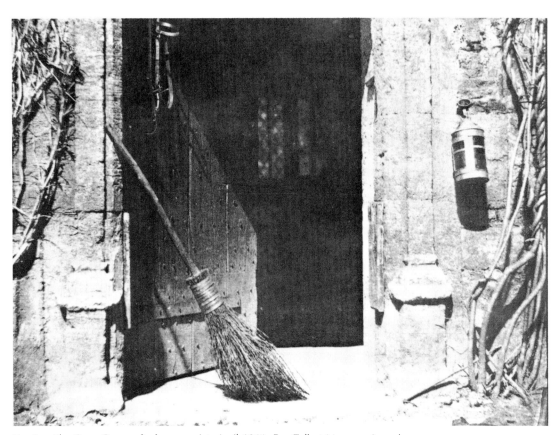

Fig. 2. *The Open Door*, salted-paper print, April 1844. Fox Talbot Museum, Lacock.

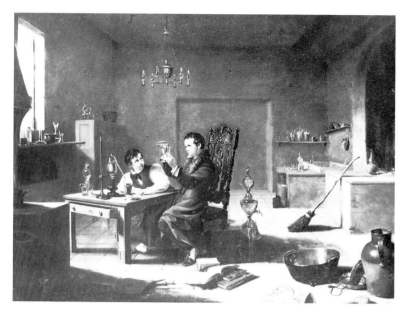

Fig. 3. 'L. R.', *The Chemist*, oil on board, 1827. Museum of the History of Science, Oxford.

instruments of spiritual and scientific labour provide means for passage from one world into another. The same spirit may be present in a little painted portrait of a chemist (said to be Davy) and his youthful assistant (fig. 3), which features a similar broom in a contemporary version of a Dutch alchemist's workshop.

In the Augsburg edition of Cesare Ripa's *Iconologia* (1758–60), a handbook for painters, the image of Diogenes forms the frontispiece (fig. 4), and in Michael Maier's *Atalanta Fugiens* (1618) the Diogenic figure is appropriated by the alchemical tradition, co-opted for spiritual chemistry.[4] The figure of Diogenes provides a clue to Talbot's interest in the pagan foreshadowing of Christianity, and his desire to harmonize the Bible with other sacred texts. At the beginning of a period of technological advance now regarded as largely positivist, in which science and culture had ceased to have any value which was not experimental, the tradition represented by Diogenes as patron of mythographers, poets and artists had been reawakened by the poets Shelley and Byron. The decay of orthodox Christian beliefs under the pressure of deism and what became Darwinism turned the attention towards the idea of a universal man. The philosopher with the lantern, trimming the flame of knowledge and passing the torch of truth to others, became a secular saint. For one short-lived moment, Talbot took part in a Reform parliament but, like Diogenes, soon realized that his intervention in public affairs was less useful to society than his pursuit of

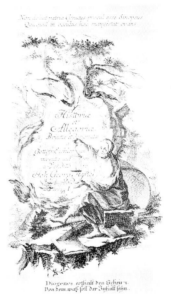

Fig. 4. C. Ripa, *Iconologia*, Augsburg, 1758–60.

4. See J. Fabricius, *Alchemy*, rev. edn., Wellingborough: Aquarian Press, 1989, p. 55.

knowledge. It is true that he had no intention of becoming a wandering beggar-scholar without home or possessions. On the contrary, his drive towards success in applied science suggests that he was very much concerned to stabilize the shaky family fortunes which had kept him out of Lacock Abbey until 1827. But this did not prevent him from aspiring, at least, to the sublime ideal of opening doors on all kinds of knowledge.

An early reviewer of Talbot's announcement of the art of photogenic drawing reminded his readers of the story *Schlemihl* by Adelbert von Chamisso, whom Talbot had met on a visit to Berlin in 1827. He compared 'the spells of our scientific enchanter, Mr Talbot' with Peter Schlemihl's power to sell his own shadow, 'the purchaser of which kneels down in the broad sunshine, detaches the shadow from its owner's heels, folds it up, and puts it in his pocket.'[5] Sir David Brewster, in an early review of photography, cited Lucretius in Creech's translation:

> my muse declares and sings
> What those are we call images of things,
> Which like thin films from bodies rise in streams,
> Play in the air and dance upon the beams.
> A stream of forms from every surface flows,
> Which may be called the film or shell of those,
> Because they bear the shape, they show the frame
> And figure of the bodies whence they came.[6]

These figures of things are shadows or hieroglyphs detachable from the bodies from which they originate. They are conceptual rather than literal representations of the things to which they refer; that is to say, they have a certain symbolic value. Talbot's life-long interest in philology was similarly determined by the widely held conviction that words represented latent things as well as expressible ideas, and his study of mythology assumed that meaning lay dormant in hieroglyphics and cuneiform script.

The combination of chemical studies with Egyptology and Assyriology was unexceptional in Talbot's circle. Thomas Young (1773–1829), whose Bakerian lecture 'On the Theory of Light and Colours' (1801) was a prime source of photographic experiment for Talbot's succeeding generation, was equally famous as a decipherer of Egyptian hieroglyphics. As Talbot was to Daguerre in rivalry for priority of the discovery of photography, Young was to Jean-François Champollion in priority arguments over the

5. Bibl. **248**, p. 139.
6. Bibl. **290**, p. 467.

decipherment of the Rosetta Stone. While editor of the *Journals of the Royal Institution* in which Sir Humphrey Davy presented Thomas Wedgwood's account of his photographic experiments, Young also studied Hebrew, Chaldean, and Syriac.

Enthusiasm for things Egyptian was widespread in Talbot's milieu (fig. 5). John Lee of Hartwell House, whose circle included the Reverend J.B. Reade, vicar of Stone and Talbot's challenger on the first use of gallic acid, was a gentleman of science and a collector of Egyptian antiquities, and William Whewell, the mathematician who coined the word scientist, was one of the referees for the translation from the Assyrian of the cuneiform inscription of King Tiglath-Pileser in 1857. According to Sir Wallis Budge, 'passages in Fox Talbot's translation were paraphrastic in character, and though there were many parts in which he agreed with the rendering of Edward Hicks and Rawlinson, there were others that showed he had missed the scribe's meaning.'[7] This Rawlinson was Sir Henry Rawlinson, who deciphered in 1837 the trilingual inscription of Darius on the Rock of Bihistûn, the Assyrian equivalent of the Rosetta Stone.

In his book, *The Antiquity of the Book of Genesis* (1839) Talbot remarked that the more he studied allusions to the

7. E.A. Wallis Budge, *The Rise and Progress of Assyriology*, London: Hopkinson, 1925, p. 93.

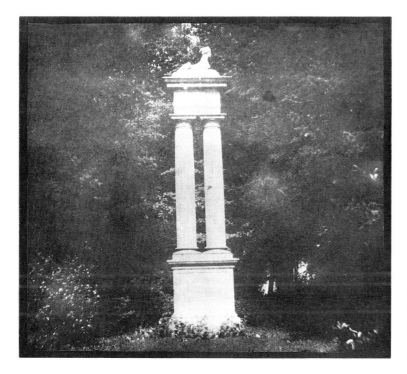

Fig. 5. *Sphinx Garden Ornament*, salted-paper print, 29 August 1840. National Museum of Photography, Film & Television, Bradford. By courtesy of the Board of Trustees of the Science Museum.

stories of Moses in classical authors the more certain he became that 'Heathens' must have known the Bible:

> and when by a sufficient number of instances the judgment of the reader is satisfied that the Heathens must have possessed copies of the Scriptures in very ancient times – or at any rate extracts from them – then it becomes probable that those allusions to the sacred narratives, which are too faint in themselves to be capable of independent proof, are nevertheless real allusions, and ought not to be rejected.[8]

By this Talbot showed he belonged to the speculative school of eighteenth-century antiquarian authors like Jacob Bryant who were comparative mythologists. To sample his mythological studies in relation to his *English Etymologies*, through to his multitudinous writings on Assyrian cylinders and inscriptions, is to glimpse Talbot's mind at its full creative stretch, and shows him to have been capable of the most imaginative metaphorical thought. Whether the Hermes of Talbot's book by that name, published in 1838–39, was Hermes Logios, the Greek messenger of the gods, or Hermes Trismegistus, the Egyptian patron of science and the arts, matters less than that both were identified with the Egyptian god Thoth, originator of alchemy and inventor of hieroglyphics. A well-established connection between Hermes and Moses in Christian Hermeticism was consistent with the desire to produce a unified history of mankind in which pagan and biblical traditions were reconciled.

Consider, for example, Talbot's discussion of the representation of the mythical King Arcesilas of Etruria (fig. 6):

> A king is seated on a throne of dignity. Before him is placed an enormous balance. On the beam of the balance *a Cynocephalus* is seated, and over it hovers *an Ibis*. Attendant ministers are busily occupied in weighing in the balance certain objects, which I believe to be emblematic of *good works*.
>
> Over each of these attendants is written his name: but these names, through of Grecian sound, are one and all of them unknown to fame.
>
> Not so, the king himself. Over his head is most distinctly written the name Αρχεσιλας.
>
> We have then here, without any doubt, the monarch – or hero – Arcesilas. And in what character? In what employment? so unlike that of a Hellenic warrior!

8. Bibl. **74**, p. 71.

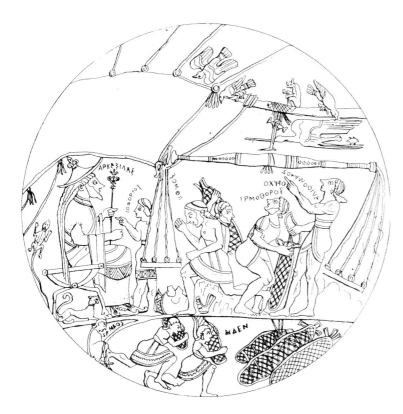

Fig. 6. G. Micali, *Storia degli Antichi Popoli Italiani*, 2nd edn., Milan, 1836, vol. 2, pl. 97. [illus. not in Talbot's text]

In a chapter in which no one, perhaps, could have expected to meet with him . . . As the Judge of the lower world . . . as the Osiris of Egypt . . . taking account of the good and evil deeds of men.

For, let us only compare this representation with the scene of Judgment, depicted in so many Egyptian MSS. There we have Osiris sitting in state, with an immense balance before him, in which Mercury with the *Ibis head* (Thoth), is weighing the good deeds of men against their evil ones; and *a Cynocephalus*, to complete the resemblance, is usually sitting on the beam. . . .

According to Micali, the objects weighed in the presence of Arcesilas are *sacks of grain*, which are being carried into a *subterranean granary*. I consider that in this *mythos* they are emblematic of good works. Such emblems are found in the corresponding Egyptian scene. For, since it was difficult to represent *good and evil works* by any material image, the Egyptians symbolised them by a *vase* and an *ostrich feather*, placed in the opposite scales: objects which, according to their ideas, bore some mysterious analogy to *good* and *evil*.

The nations of the East, while they employed the metaphor of the balance in the hand of the Deity, in which he weighed

the merits of mankind (*Thou art weighed in the balance, and art found wanting* – Daniel, v. 27), yet adopted, as was natural, quite other objects as symbolical of vice and virtue. Among these types and images, one will immediately occur to the reader as being extremely apposite to the present question; I mean the parable in which good men and good works are represented by *wheat*: evil men and their works by *tares:* and at the time of harvest the final judgment passes (*Gather together the tares, and bind them in bundles to burn them: but gather the wheat into my barn* – Matthew, xiii. 30).[9]

The Society of Biblical Archaeology, to whose journal Talbot contributed so heavily in his later years, appealed not only to philologists but to scientists and theologians of every persuasion. In 1842, Talbot was named as an original member of the Philological Society of London. The close connection between the development of empirical science and the practical construction of an etymological English dictionary in this period shows that Talbot's interests were characteristic of a man of his education, and explains why his publication of *The Pencil of Nature* (1844–46) was immediately followed by his *English Etymologies* (1847). He had been working on it for at least fifteen years under the influence of William Whewell's short-lived journal, *The Philological Museum* (1832–33), the precedent for his own philological researches. *The Philological Museum* presented an important little essay on the great Italian scholar Giambattista Vico (1668–1744), and his influence in England through William Warburton, author of *The Divine Legation of Moses Demonstrated* (1737–41), with whose researches on hieroglyphics Talbot would have been familiar. Vico's *Scienza Nuova* (new science of mythology) showed that languages were the most reliable sources of the beliefs of a people, and that their comparative study would demonstrate that human history was determined by laws as regular in their operation as those of the rest of nature.

For Talbot, as for Whewell, there was no conflict involved in the simultaneous pursuit of mythological syncretism and of the inductive sciences. Linguistic ethnology was on the agenda of the British Association for the Advancement of Science from its beginnings in 1831, and the year of publication of Talbot's etymologies saw a rash of publications in its annual report, of which the most notable was one on language classification. Its author wrote that this work gave support 'to the hypothesis of the original unity of mankind and of a common original of all

languages of the globe',[10] although he was equally sure that individual peoples underwent changes throughout their history which their languages were bound to reflect. Such scholars were concerned to weigh the perennial or original aspects of language against its developing usage. Talbot's conjectural turn of mind also accompanied an otherwise empirical approach to science. One part of his mind functioned in terms of ideal categories and sought metaphysical relief in the metaphorical properties of language, whereas another part worked on the basis of historical evidence and valued hard facts. As a transitional figure between the eighteenth and nineteenth centuries, Talbot came to intellectual maturity before Victoria took the throne, and lived through the period which saw the change of the name of his avocation from *natural philosopher* to *scientist*.

A photographer, like a poet, does not deal in separable abstractions but engages in a process by which knowledge is constantly transformed by interests sustained simultaneously over long periods of time, forming eventually a single organism – the creative identity of the artist. Photographic thinking, like any kind of artistic thinking, is analogical, creating links between things and thoughts. By directing our attention to words we learn to look past present usage to the things in the minds of people who used the words previously. Dormant in words lie latent thoughts brought to light by the etymologist. This is Talbot's definition of *thing*:

> So very abstract a term as a *thing* must have caused some difficulty to our early ancestors to determine what they should call it. They made choice of a term derived from the verb 'to *think*'. Any*thing* is any*think* – whatever it is possible to think of. So in German, ein *ding*, comes from *denken*. This etymology is farther confirmed by the Latin *Res*, a thing – derived from *Reor*, I think.[11]

Rejected by linguists as unscientific but loved by poets and philosophers, etymology is a field notorious for imaginative combination of conjecture and evidence. In his pursuit of etymological truth Talbot was an average contemporary practitioner. He was perfectly happy to substitute consonants and to disregard vowels in his desire to discover a word's latent meaning, believing that words were related to things as indissolubly as shadows were to the objects that cast them, as long as the sun continued to shine. A word or

10. C.C.J. Bunsen, 'Recent Egyptian Reseaches' *BAAS Report for 1847*, p. 299.
11. Bibl. **114**, p. 13.

a thing encoded a perennial meaning at the core of its being as well as served a practical use.

Consider, for instance, Talbot's etymology of *sublime*. He found it amusing that some scholars thought it was derived from *supra limum*, above the mud ('Verily, that is more than can be safely said of the intellect of some persons!'); others suggested *sublimen*, a threshold ('To which it may be replied that no such word appears to exist'):

> Let us proceed more philosophically, even if it should not be successfully, by inquiring first, what is the leading idea contained in the adjective *sublimis*? The leading idea seems to be, *anything which we look up to*, which implies the notion of its being *very high Su-blemmis, he that looks upward; or, that which we look up to.*[12]

The concept of a step towards enlightenment embodied in *The Open Door* is also present in *The Ladder* (fig. 7). Emblematically, the ladder represents the leading idea of a countenance looking upwards. It appears in the Bible as Jacob's ladder; in alchemy as a ladder of experimental ascent from which it is all too easy to fall; and in freemasonry as symbolic of the progress of the soul. As an emblem it signifies ascent towards the light. In the work of Ramon Lull (1232–*c*.1316), the ladder of ascent refers to the the philosophical rungs by which man climbs eventually to God,[13] as in Baccio Baldini's version (fig. 8), in which the hierophant aspires to join Christ on the Holy Mountain.

In both Talbot's and Baldini's pictures, the figure at the left, occupying the donor's position in the tradition of Christian art, is witness to a scene in which a humbler man at the foot of a ladder is connected with a younger man at the top by both of them grasping it. The youth will never descend this ladder because the pictorial tradition of this mystical motif predetermines movement in terms of ascent. This not an illustration just of farm work; or if it is, the carrying of grain to a granary is, as Talbot said of the picture of King Arcesilas, 'emblematic of good works'. The scene depicts what Talbot called a *mythos*.

Thus far in the history of photography such images have been stripped of their cultural frame of reference, and praised merely for their formal properties. *The Haystack* (fig. 9) is the most notable example to have suffered from this attitude: it is considered usually as simply a piece of abstract art ahead of its time. But, again, it is not an

12. Bibl. **47**, p. 33–5.
13. F.A. Yates, 'The Art of Ramon Lull', *Journal of the Warburg & Courtauld Institutes*, vol. 17 (1954), pl. 14b.

illustration of agricultural ladder use: no farm worker would use a ladder at that angle. Perhaps it has been deliberately placed to echo Robert Fludd's image of a ladder without any means of support, which has inscribed on its ascending rungs words referring to the senses, imagination, reason, intellect, intelligence and the Word, and which is topped by what is called in hermetic circles a Glory (fig. 10). In Talbot's picture, the ladder leans, as it were, on its own shadow and makes a triangle signifying the penetration of darkness by divine light.[14] However, there is no Glory, only a shaped mass of hay. His etymology of *hay* derives the word from the German *hauen*, to hew: 'Hay means *cut grass*.'[15] The mower is the grim reaper identified by alchemists as Saturn and associated in Albrecht Dürer's famous woodcut with the figure of Melancholy (fig. 11). Talbot's knowledge of Dürer certainly seems latent in *Man with a crutch* (fig. 12), a picturesque version of the celebrated *Melencolia*, in which Dürer's winged figure surrounded by the tools of the alchemist's art is replaced with a lame man in a tool-shed corner of the farmyard. Grindstones and ladders are found in both images, and the stone at the foot of the ladder in Talbot's image, while hardly Dürer's polyhedron in all its cut precision, may represent the lapis or philosopher's stone, just as the crossed branches in the foreground in Talbot's image echo the crossed saw-blade and piece of wood in Dürer's.

The carved beauty of the rick in *The Haystack* becomes an analogue for the utility and futility of man's aspirations compared with the promise of the ladder: no matter how well the rickman cuts the hay with his hay-knife, however well he shapes it into steps, all life, like hay itself, is ultimately of this world and perishable. This great tumulus is a pyramid of hay and a charnel-house of grass. But Talbot so naturalized the motif, rendering it with a particularity only possible to photography, that it was almost impossible for contemporary reviewers to see the image as other than as a descriptive study of a haystack. Yet the ladder is as important as the haystack itself: for Lull, it was an attribute of Philosophy; for Dürer, it was one of Melancholy.

If Talbot as scholar-photographer was tugged in one direction by his philological interest in the hermetic tradition, as a photographer-poet he was highly responsive to the melancholic strain in the mid-eighteenth century sensiblility epitomized by Thomas Gray's *Elegy Written in a Country Churchyard* (1753). Gray's friend, Thomas Warton

14. See J. Godwin, *Robert Fludd*, London: Thames & Hudson, 1979, p. 42–3.
15. Bibl. **114**, p. 445.

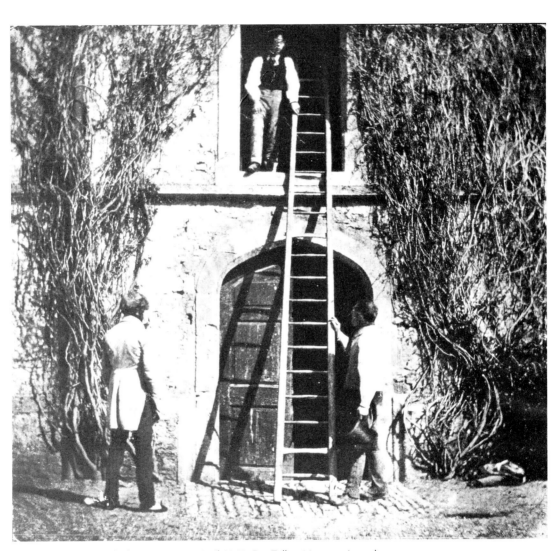

Fig. 7. *The Ladder*, salted-paper print, c. April 1845. Fox Talbot Museum, Lacock.

Fig. 8. B. Baldini, from *Il Monte Sancto di Dio*, Florence, 1477.

the Younger (1728–90), provided Talbot's epigraph for both *Hermes* and *English Etymologies* with the last two lines of his poem 'Written in a Blank Leaf of Dugdale's *Monasticon*' (1777):

Deem not devoid of elegance the sage
By Fancy's genuine feelings unbeguiled,
Of painful pendantry the poring child
Who turns of these proud domes th' historic page
Now sunk by Time and Henry's fiercer rage.
Think'st thou the warbling Muses never smiled
On his lone hours? Ingenious views engage
His thoughts, on themes unclassic falsely styled,
Intent. While cloister'd Piety displays
Her mouldering roll, the piercing eye explores
New manners and the pomp of elder days,
Whence culls the pensive bard his pictured stores.
Nor rough nor barren are the winding ways
Of hoar Antiquity but strewn with flowers.

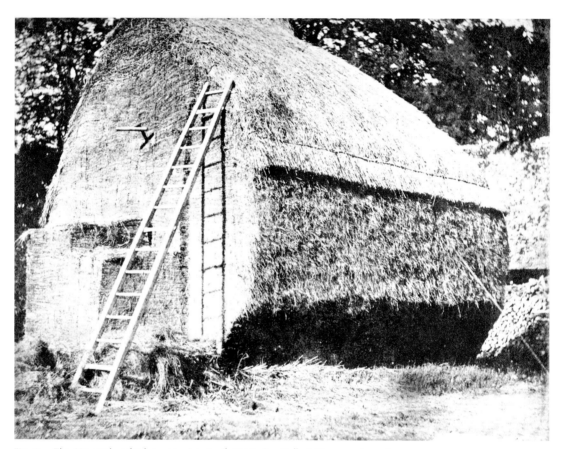

Fig. 9. *The Haystack*, salted-paper print, April 1844. Fox Talbot Museum, Lacock.

What a portrait this conjures up of the younger Talbot dreaming over engravings of Lacock and other abbeys with their fretted pinnacles and ivied towers, and the older Talbot preoccupied with Romantic ideas! Warton's use of the word elegance raises the scholar to the elect also in his 'Pleasures of Melancholy' (1747):

> Few know that elegance of soul refined,
> Whose soft sensation feels a quicker joy
> From Melancholy's scenes than the dull pride
> Of tasteless splendour and magnificence
> Can e'er afford.

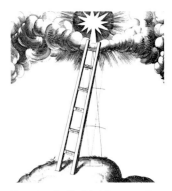

Fig. 10. R. Fludd, *Microcosmi Historia* (1619), vol. 2, tractate 1, p. 272.

Eighteenth-century taste thus assumed that the poet's attitude would be marked with the melancholy of pensive contemplation. Born in 1800, Talbot came out of that century, and was the contemporary of the great Romantic poets and the Gothic novelists, whose work provided the context of his *Legendary Tales in Verse and Prose* (1830).

To look at his photographic portrait (frontispiece) is to recognize at once that melancholy marked Talbot for her own. Scientific ambition drove him to achieve the prodigious promise of his infancy but left him doubting, perhaps, whether memory would ever raise a trophy over *his* tomb. As Gray wrote in his *Elegy*:

> Can storied urn or animated bust
> Back to its mansion call the fleeting breath?
> Can Honour's voice provoke the silent dust,
> Or Flatt'ry soothe the dull cold ear of Death?

With Talbot's photograph of the Hellenistic bust in the British Museum before us,[16] can we doubt that his motivation was not to breathe life back into this image of the most melancholic of Greek heroes?

> The boast of heraldry, the pomp of power,
> And all that beauty, all that wealth e'er gave,
> Awaits alike th' inevitable hour.
> The paths of glory lead but to the grave.

The eighteenth-century practice of viewing such statuary by candlelight lies behind the glimmering, moonlight effects of chiaroscuro which Talbot used in his *Patroclus* (fig. 13).

Like Talbot's photographs, Gray's poem is notable for its shifts across social class – from nobleman to farm worker,

16. On the Patroclus series, see Bibl. **626**.

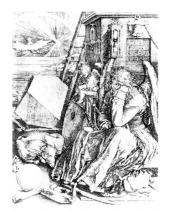

Fig. 11. A. Dürer, *Melencolia I*, woodcut, 1514.

from Roman senate to village England. The eighteenth-century ideal embodied in Queen's College, Oxford, appealed to Talbot's neo-classical impulse towards the Enlightenment, even as Lacock filled him with neo-Gothic fantasies and offered him the picturesque charms of its thatched ricks and stone-built sheds. Warton and Gray were responsible with their antiquarian tastes for the Gothic Revival, of which Lacock Abbey's eighteenth-century additions and alterations are a good example. But they were also an influence on the cult of the Picturesque. Richard Bentley (1708–82) was an artist who combined their tastes (as well as his own for the Rococo) in *Designs by Mr. R. Bentley for Six Poems by Mr. T. Gray*, published in 1753. The most famous of his drawings was the frontispiece for Gray's *Elegy* (fig. 14), and was described in the text as follows:

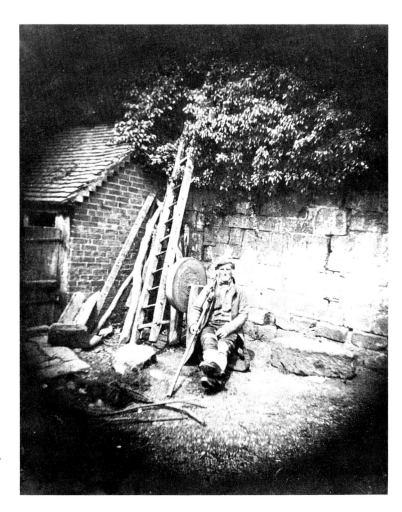

Fig. 12. *Man with a Crutch*, salted-paper print, c.1844. National Museum of Photography, Film & Television, Bradford. By courtesy of the Board of Trustees of the Science Museum.

Fig. 13. *Patroclus*, salted-paper print, c.1839–40. Fox Talbot Museum, Lacock.

A Gothic gateway in ruins with the emblems of nobility on one
side; on the other, the implements and employments of the
Poor. Thro' the arch appears a church-yard and village-church
built out of the remains of an abbey. A countryman [is]
showing an epitaph to a passenger.

The bundle of rake, pitchfork, spade, and axe is a
picturesque but accurate emblem of implements of
husbandry. Talbot takes up this side of the picture in
several treatments of the subject, presenting the tools in a
garden version of Bentley's lych-way arch (fig. 15). The
connection between the garden door and Bentley's arch is
subtly felt in the group portrait of Talbot's own husbanded
harvest (fig. 16). If in Bentley's image the shadow of the
young person falls upon the grave, here the shadow of the
eldest daughter falls upon the door as headstone, with
rusticated trellis as the crude decoration of a family vault:

Yet ev'n these bones from insult to protect
Some frail memorial still erected nigh,
With uncouth rhymes and shapeless sculpture decked,
Implores the passing tribute of a sigh.

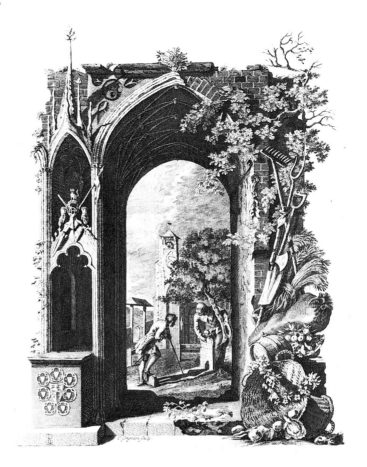

Fig. 14. R. Bentley, *Gothic Gateway*, engraving by Grignion, 1753.

The theme is that of *Et in Arcadia Ego*, which Nicholas Poussin had made famous in his *Shepherds in Arcady* in the Louvre Museum. But here, instead of three shepherds and one maternal shepherdess, are three daughters and their mother; and Poussin's tomb, upon which the shadow of one of the shepherds is projected, is replaced by Talbot's closed door. But whereas the tone of Poussin's picture and Bentley's drawing is classical and universal, that of Talbot's photograph is, perhaps, romantic and personal. If it is one thing to philosophize about shepherds and an anonymous passer-by, it is quite another to present one's own family in a *memento mori*. Here melancholy verges on morbidity: 'I, too, once lived in the bliss of ignorance but, beset by melancholy, I contemplate from my position as father the passing of my children and their mother, even as I think of my own':

Full many a gem of purest ray serene
The dark unfathomed caves of ocean bear:
Full many a flower is born to blush unseen,
And waste its sweetness on the desert air.

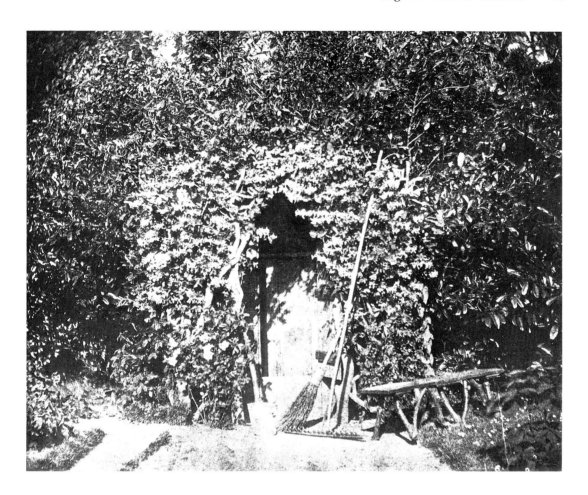

Ela, Rosamond, and little Matilda, named after heroines in the writings of Sir Walter Scott, are flowers of the mother which will fade and wither away.

Fig. 15. *Garden Gateway,* salted-paper print, *c.*1842–43. National Museum of Photography, Film & Television, Bradford. By courtesy of the Board of Trustees of the Science Museum.

In Ripa's *Iconologia*, the personification which illustrates the *Distinction between Good and Evil* is a woman with a rake and sieve: she is the enemy of the Devil, who sows weeds while farmers sleep. In a conversation piece of two children with a small garden cart of rakings by John Zoffany (fig. 17) the theme is made more poignant by infant innocence: no matter how hard one might try, like the Dutch, we know all flesh is hay. Talbot made a version of it using two of his daughters, and his new-born son in a nurse's arms (fig. 18). Garden tools are binomial in their associations – they cut two ways: on the one hand, they represent the implements by which the garden is kept clear of weeds; on the other, they are gravedigger's tools. This is clearly indicated in a detail in another Bentley drawing (which specifically refers to Gray's *Elegy*) in which a spade

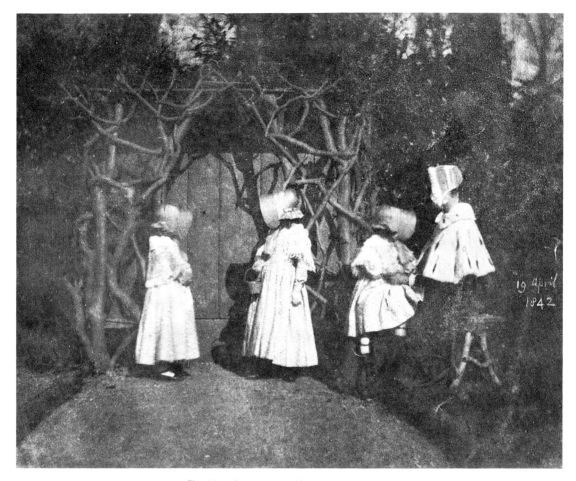

Fig. 16. *Constance and her Daughters*, salted-paper print, 19 April 1842.
National Museum of Photography, Film & Television, Bradford. By courtesy of
the Board of Trustees of the Science Museum.

and skull are placed next to a funerary plinth (fig. 19).
Talbot's photograph of a broom, basket, and spade next to
a wall may be equally deliberate (fig. 20), providing one
feels what Talbot *knows* – that the etymology of the word
coffin is 'a great case of wicker, any kind of box or case'.[17]
His etymologies lead yet further in this direction. In tracing
the word casque (helmet) to the Spanish *casco* (skull), he
concluded that skull and shell were originally the same
word:[18] any protective covering, even a child's bonnet,
could stand in for the skull beneath the skin, and any box
or basket could represent a skeleton inside a coffin.

 Much of the time Talbot's pictures offer little but a show,
something to look at. But in his best-known pictures there
is often a little silent drama taking place, something
pretended. This is Talbot's etymology of *drama*:

17. Bibl. **114**, p. 96–7.
18. Bibl. **114**, p. 91.

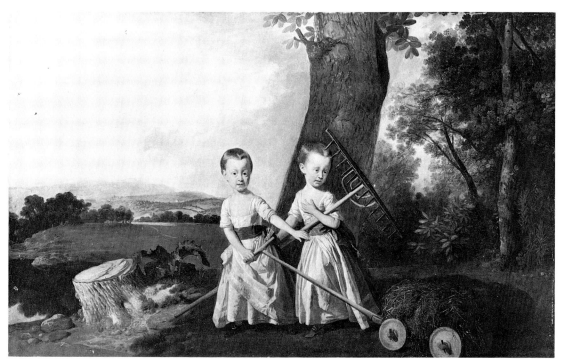

Fig. 17. J. Zoffany, *The Blunt Children*, oil on canvas, c.1768–70. Birmingham Museum and Art Gallery.

Fig. 18. *The Talbot Children and Nurse*, salted-paper print, 5 April 1842.
National Museum of Photography, Film & Television, Bradford. By courtesy of
the Board of Trustees of the Science Museum.

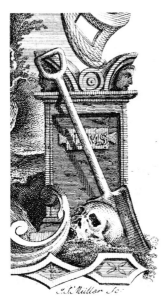

Fig. 19. R. Bentley, *Funerary Plinth*, detail from engraving by Müller, 1753.

It is commonly supposed that the word drama, by which we denote a theatrical representation, meant originally *a thing done: an Action* This is plainly what a *dramatic* representation is *not*. It is not a thing done – it is a thing merely *simulated* or *pretended*. I think it strange, therefore, that the Greeks, who first invented the word, and had choice of so many terms in their copious language, should have chosen one which so ill expresses the character of the thing spoken of. The Latins use a much more aptly chosen word spectaculum, *a show*, a thing which we go *to see*.[19]

With this distinction in mind, perhaps we should consider the possibility that a few of his photographs, at least, contain a staged element, and transcend the documentary.

Talbot's cult of human transitoriness, implying a state of melancholy, constituted for him a kind of religious experience, which he expressed in his photographs sometimes hermetically, sometimes picturesquely, and often simply topographically. His little *oeuvre* is imbued both with gentlemanly sadness and scholarly aspiration, often both at once. In approaching Talbot as an artist rather than as an inventor, perhaps we should consider his own claim in a letter to a friend:

> You say that to encourage true genius each artist should put his name to his own images: that is all very well, but even without the signature one would soon learn to tell them apart, for I find that each Calotypist has a style peculiar to him alone. Even *here* this is already apparent; soon they will be as different as Raphael and Rubens! [20]

Talbot may have been comparing himself with other members of his circle like Calvert Richard Jones, the William Pyne of photography, who made microcosmic studies of naval deck furniture and rigging in a descriptive style. But the images by Talbot which have become most famous, such as *The Open Door*, *The Ladder*, and *The Haystack*, are both symbolic and personal in their ultimate expression. His was a short but glowing career about which can be said, as Gray wrote in his 'Stanzas to Mr Bentley':

> See in their course, each transitory thought
> Fixed by his touch a lasting essence take;
> Each dream, in Fancy's airy colouring wrought
> To local symmetry and life awake!

19. Bibl. **47**, p. 15.
20. Letter to Amélina Petit de Billier, 8 Feb. 1843. Fox Talbot Museum, Lacock. See Bibl. **588**, p. 38.

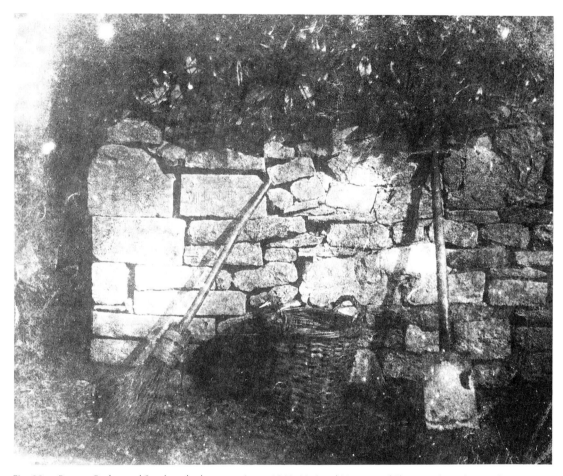

Fig. 20. *Broom, Basket and Spade*, salted-paper print, c.1841. National Museum of Photography, Film & Television, Bradford. By courtesy of the Board of Trustees of the Science Museum.

DOCUMENTS

Picture Hunting in Italy

Christopher Lloyd

The letters which follow were written between the years 1824 and 1829 by the Hon. William Thomas Horner Fox-Strangways (1795–1865), the eldest son by the second wife of the second Earl of Ilchester. Educated at Westminster and Christ Church, Oxford, Fox-Strangways entered the Diplomatic Service immediately upon coming down from the University. He was posted in rapid succession as attaché to St Petersburg (1819), Constantinople (1820), Naples (1822) and The Hague (1824), but the greater part of his early career was spent in Italy, where he served as Secretary of Legation in Florence (1825–28), Naples (1828–32) and Turin (1832), respectively. He held no further posts in Italy after 1832, becoming Secretary to the Embassy in Vienna (1832–35), Under-Secretary of State for Foreign Affairs (1835–40) to Palmerston during Lord Melbourne's second administration and, finally, Minister Plenipotentiary to the Diet of the German Confederacy in Frankfurt (1840–49), after which he resigned from the Diplomatic Service and held no further post in public life. He retired to live in Dorset, where his family owned two houses, at Melbury and Abbotsbury, and succeeded his half-brother as fourth Earl of Ilchester in 1858.

Fox-Strangways, as the course of his career suggests, was

Abridged from Bibl. **478**: Christopher Lloyd. 'Picture Hunting in Italy: Some Unpublished Letters (1824–1829)'. *Italian Studies*, vol. 30 (1975), p. 42–68. Reprint courtesy of *Italian Studies*.

These letters from William Fox-Strangways, addressed in the 1820s to Talbot and to his mother Lady Elisabeth, suggest a shared interest in art, including lithography.

not particularly ambitious and his diffidence in pursuing high office is one of the most frequently discussed topics in his private correspondence. It seems that he regarded the Diplomatic Service more as an unparalleled opportunity to indulge his numerous interests than as the natural path of political advancement. Thus, in St Petersburg he appears to have concerned himself primarily with geology and the study of Slavonic languages, whereas in Italy he set about becoming an authority on Italian flora; indeed, it is as a botanist that Fox-Strangways is best remembered today.

It has long been recognized that the collection of Italian paintings formed by Fox-Strangways, which is now divided between Christ Church, Oxford (gifts of 1828 and 1834) and the Ashmolean Museum (gift of 1850), is important not only on account of the quality of such pictures as the small triptych from the workshop of Duccio (Christ Church) or *The Hunt* by Uccello (Ashmolean), but also because of the comparatively early date of its formation between the years 1827 and 1832.[1] Of the one hundred or so paintings comprising the collection, some of which were retained by the owner and lost in a fire at Abbotsbury in 1913, nearly half can be described as primitives – that is paintings dating from before 1500. Only a few collectors eagerly and single-mindedly sought out examples of early Italian painting in order to form collections of a specialised nature. Previously, little was known about Fox-Strangways beyond the barest details of his life. If on a personal level these letters take us well beyond the tabulated facts of a biographical dictionary, they also, more significantly, provide us with a body of evidence about the motives, aspirations and frustrations of collectors active during the first part of the nineteenth century – aspects which, in too many cases, we have only been able to guess at instead of specifically referring to documentation. In addition, there is a great deal of useful information about the practical problems involved in forming a collection; for example, the names and reputations of dealers, the availability and accessibility of pictures owned by Italian patrician families, prices and other financial matters, the transport of paintings, the status of the copyist, the selection of a particular method of copying, the principles of restoration and the deliberations about the character of the collection to be formed before the necessary purchases were undertaken. When pieced together with the knowledge that can be gleaned from the papers of other collectors of the period, it will be possible to assess with some degree of accuracy the ethics of the Italian art

1. See J.B. Shaw, *Paintings by Old Masters at Christ Church, Oxford*, London, 1967; C Lloyd, *A Catalogue of the Earlier Italian Paintings in the Ashmolean Museum*, Oxford, 1977.

market during these crucial years when so many major collections were being formed. It is easy now to smile at the apparent limitations of taste, or at the reckless attributions proposed for many of the paintings examined by Fox-Strangways and other collectors, but it is noticeable that the great flood of pictures released by the financial hardships following upon the Napoleonic invasions forced connoisseurs more and more to question the theoretical structure which had been imposed upon the development of Italian painting by such writers as, for instance, the Abate Luigi Lanzi in his *Storia pittorica dell'Italia* published in Bassano in 1795–96.

The majority of the letters are addressed to William Henry Fox-Talbot (1800–77), the only son of William Davenport Talbot and Lady Elizabeth Theresa Talbot, the eldest daughter by the first wife of the second Earl of Ilchester. Other letters were written to Fox-Strangways' half-sister, who by this date had become Lady Elisabeth Feilding (d. 1844), on account of her second marriage in 1804 to Rear-Admiral Charles Feilding, after the death of her first husband, William Davenport Talbot, in 1800.

Dear Lily, [Lady Elisabeth]

Henry is just gone to Bologna. He had very bad weather almost all the time he was here & was rather lazy which is not his usual state of being. He means I believe to botanize his way homewards thro Switzerland. . . . Henry has a new taste for pictures & was exceedingly tempted by a Carlo Dolce which tempts everybody, belonging to the Marchesa Grimaldi & is not the only Dolce that tempts people in the house, or at least used to. There are 3 graces which if they had Titian's heads would I am sure fetch *mints*. It is not certain it is a Titian, but I think it a capital Padovanino, who came very near Titian in figures but fell short in heads. We shall see a gallery at Laycock & the Cloisters painted in fresco. I wish you would tell me the prices of Carlo Dolces in England. Here they ask des prix fous for *Carlino*. The new room in the Pitti is open & many treasures brought to light.[2] (6 June [1826])

Dear Henry,

I hope you got the last letter I sent to Basle. I have been to Mr. Wallis who was not here when you were & I recommend you to have the Correggio done by him. His colouring is so very Correggiesque & he has made that master his particular study & once made a copy of the very

2. Many rooms in the Pitti Palace decorated with frescos had been recently opened to the public.

picture in the tribune[3] for Mrs. Otway Cave whose daughter H. Murray is going to marry so you might perhaps get a sight of it in London. He asks 40 Louis. Perhaps the Italian would do it cheaper, but you shd. encourage English artists particularly when they are the best & you pay only half the duty on importation. I think I shall get 2 heads of S. Joseph & the dates done by him.[4] He also has an Ezekiel[5] which he will not sell but would copy it for 30 louis as he did for Sir W. Chatterton. I have not yet decided which is best, his or Colzi's for 25 Ls. Nocchi wants to know if you take the Biliverti in tondo for 50 Ls. Colzi has a fine Vandyk for 20 but one does not come to Italy to buy Vandyks. Mr. Irvine tells me that the Portrait of Scamozzi by Domenichino for 100 Ls is really very good [written above the word cheap which has been crossed through] & the man has a capital specimen of Mengs. Thellusson & I think we shall get round the Marchesa. She now says she has some more good pictures in a loft somewhere . . . (29 June 1826)

Dear Henry,

I hope you got all the letters I directed to Basle. I have got for you the Ezekiel Louis 25 (frame included) & ordered the Correggio i.e. provisionally, as it cannot be done yet – from Wallis. There is a very good Magdalen by a scholar of Vandyke for L.20 which is not dear & I think would tempt you if you saw it . . . (postmarked 5 August 1826)

Dear Henry,

The Marchesa is obdurate & will not give up her picture for less than 600 Louis. She is gone to Venice & that is her last word.

I shall dispatch in a few days the Ezekiel & I think with it the copy of S. Marco[6] if I can get it at my own price. I think that man Colzi may become an eminent painter. I believe you saw his portrait of the Dean of Durham, the likest thing I ever saw. He has now some pretty landscapes which I am cheapening, but it puts me out of patience to see some very nice pictures now & then picked up for a few pauls in the street by people who know what will bear cleaning etc. I went to Ussi the cleaner to see a curious fresco of Giotto's in his studio. He said if a picture had not lost more than half of la testa principale it was recoverable. With a little money & knowledge I am sure a very tolerable collection might be made now. I went to see the famous Tempi

3. The Tribune Gallery is the central gallery in the Uffizi, Florence. The copy referred to here is of *The Virgin Adoring the Child* by Correggio.

4. *The Rest on the Flight into Egypt* by Correggio. Uffizi, Florence (then in the Tribune Gallery).

5. Probably after *The Vision of Ezekiel* by Raphael. Pitti Palace, Florence.

6. The original picture by Fra Bartolommeo is in the Pitti Palace, Florence.

Raphael which I think positively ugly. There is at Casa Mozzi one which cannot be genuine, the same as a print called La Sagra Famiglia . . . (Florence, 17 August 1826)

Dear Henry,

My telling you your pictures wd. soon be packed arose from the American figure of anticipation vulgarly called counting chickens before they are hatched. The Marchesa will not come to terms so there is an end of that till she gets poorer which may be about the time you are going to Sicily. I have been talking to Mr. Irvine about the packing. He has been so good as to recommend me a packer, & a merchant in London & to superintend it himself. The Ezekiel I mean to send with the copy of the Medusa[7] which you saw which I have got for 6 L with the frame. He asked $12L\frac{1}{2}$. I think it not a bad bargain as there is a great deal of work in it & it will be a fit companion to a copy I have with much ado persuaded him to make of his curious Angel by Lion. d V;[8] he thought it would hurt the sale of it but I have convinced him it would promote it. Wallis's will not be ready to go with the Ezekiel. I shall leave him therefore to send it according to the way he is used to with mine. I will enquire about the insurance. I think it should be done in London, but you puzzle me by talking of sending it to Paris. It cannot be in England before the 1 Oct[r]. I think it will be safer in Sackville Street. I hope Kit† has a taste for pictures. He could so conveniently carry home any quantity . . . (29 August 1826)

Dear Henry,

I find Genoa so delightful I should certainly stop here instead of going to Florence if I was perfectly at liberty. It is perfect summer but we have had some tremendous thunderstorms. I like Vivian[9] very much. He seems to have all sorts of information on history, pictures, & languages as well as botany. I have taken some long walks with him to see gardens & frescoes I should never have found out.

. . . Pray tell me how Lacock goes on. When the garden is in order & the walls cleared of ancestors you should come to Italy for plants & pictures to stock them. I met Mr. Irvine at Milan. He told me or rather agreed with me that two most useful sorts of collections were wanting in England & might be made at no great expense & within small compass as to size & numbers. One is that of oil sketches & studies if not of every master of note at least of every school. There are a set of very good ones of

7. Probably the *Head of Medusa*, formerly attributed to Leonardo DaVinci. Uffizi, Florence (then in the Tribune Gallery).
8. Probably the work described by Vasari (*Life of Leonardo da Vinci*, ed. G Milanesi, Florence, 1879, vol. 4, p. 26), now lost, although several studio versions are known.
† Christopher Rice Mansel Talbot, Henry's cousin.
9. Domenico Viviani (1772–1840), Professor of Botany, Genoa University.

Correggio selling at Casa Aldrovandi in Bologna, but rather not buying for the prices are enormous, but so far good that they are of his school & very well done. The other sort of collection is that of Gothic & Greek paintings beginning as high up as you can get them & ending with Giotto, Perugino, Francia, Gianbellino etc. Two such collections with one specimen of each school in its maturity would be a gallery for a king. It would be the skeleton of a collection of any size. There is a dealer here del Vecchio who lives in one of the prettiest houses in Genoa once the house of the famous Salicetti who has some very good things for L 1000 each . . .

. . . Those who want to buy *high priced & high polished* pictures may go to Marchesa Pasqua, a Sard, who will give you a dance of Muses by *Raph.* (the famous one at Florence is only a Julio R.)[10] & other things in proportion ¨ . . (Genoa, 25 October 1827)

Dear Henry,
 . . . Wallis has finished your copy of the Madonna for £40 sterling [written above three words crossed through and rendered indecipherable] & it is to come to me as soon as varnished and dry. What shall I do with it? I will pay him. It is quite worthy of your Zingarella[11] & is the best copy I have seen of the picture. I think it quite beautiful & with the Zingarella will make a beautiful pair. He has a most peculiar talent for copying Correggio. I do not like his Raphaels. There is a good old copy of the fornarina[12] to be sold for 30 Louis. I dare say 15 would secure it, in the house of the man who has the Leonardo. Better than any modern copy I have seen. The old copyists must have had some traditionary skill from the old masters or else they finished their copies by the side of the originals instead of taking them home as they do now. He has some other good pictures. An Onofrio Marinari something like Horatia.[13] There is a famous Salvator exhibiting which was once in the gallery of Card. Fesch to be sold for 350 Louis . . . (Florence, 18 November 1827)

My dear Lily, [Lady Elisabeth]
 . . . Why does not Henry write? I want him here to help me in buying pictures. There are such good ones going so cheap & he has walls to cover . . . In me you see the fate of one who would have made politics & diplomacy a regular study if I had the opportunity & there are not many who do in the profession. When you see the encouragement they

10. Probably *Apollo and the Muses*, now attributed to Giulio Romano. Pitti Palace.
11. A composition of the *Virgin and Child*, known as La Zingarella, by Correggio. Museo Capodimonte, Naples.
12. *Portrait of an Unknown Woman*, known as *La Fornarina*, by Raphael. Galleria Nazionale, Rome.
13. A *Magdalen* by Onofiro Marinari; Horatia was Henry's half-sister.

get & that it is made an Asylum for exlinicurists can you wonder that our Diplomacy is the most irregular, the least serviceable & la moins considérée de l'Europe . . . (Florence, 1 January 1828)

Dear Henry,

. . . My picture gallery increases. Where on earth shall I put them all I don't know. I think a few antiques would suit Lacock very well. Don't you think Cimabue or Giotto might really have painted in the gallery? I advise the English artists to introduce fresco painting into England. May they hold out the hope of employment on the lunette of your cloisters? I am more & more enraged at the supineness of the Govt. in not buying pictures. Pray try to inspire Ld. Dudley with some taste. I saw at Rome the dealer who bought that magnificent Capponi Perugino that was offered to us. He tells me it is safe in the Berlin Gallery. Last week the Tempi Raphael was bought by or for the King of Bavaria (who employs a cunning old German to be always on the look out). It goes to Munich in a few days. There is now a lovely picture of M. Albertinelli to be sold framed & cleaned for 50 louis, after the Salutation in the Gallery,[14] the finest I ever saw. I would rather have it than all C. Dolcis. The dealers that collect for Germany buy old & modern, perfect & imperfect, sketches etc. from 1000 Luigi to 20 scudi so as to make a *school* which is what we shall never have & do not deserve to have. I should like to have 5000L to lay out in pictures. Then when I had made a complete historical collection the Govt. would perhaps condescend to buy it, if the times were not economical . . . (Florence, 25 March 1828)

My dear Henry

. . . When at Florence I got some very good indian ink drawings made of some frescos which have never been engraved. I wish to have them lithographed. Do you recommend Paris, London, or Munich, & have you an idea what it costs? The size large Quarto. (Naples, 21 December 1828)

14. Mariotto Albertinelli, *The Visitation*, 1513. Uffizi.

The Magic Mirror

Henry Fox Talbot

On Arnstein's lofty and majestic brow,
Where the lone Eagle builds her eyrie now—
Where the dark cliffs ne'er echo human tread,
And drear and wild the trackless forests spread—
Where lightning-shatter'd rocks lie bleak and rude,
And Silence reigns, and dismal Solitude . . .
A wond'rous Building rose in days of old!
(The tale to me an aged peasant told.)

Stranger! he said:—It was before my days . . .
There! on that crag it stood where now you gaze!
Nay, doubt me not, but listen . . . you shall hear
Its story, full of mystery and fear;
For dark its fate, and awful is the tale
Whose memory lingers in this peaceful vale.

O'er those wild rocks—at Midnight's gloomy
 hour—
A stern Magician waved his wand of pow'r,
And as he spoke the Spell which mortal ear
May not, except with fearful peril, hear,
In Runic rhymes of strange unearthly sound,
The Pow'rs of Darkness gather'd list'ning round.

Spirits! he said, that viewless round me sweep,
I call ye hither from the boundless Deep
To do my service. On this mountain height
Build ye a Castle, with its wall of might
Fairer than aught that in the world hath been,
Or that a dreamer's eye hath ever seen,
In feudal pride far gleaming o'er the land . . .
Such is my pleasure! such is my command!
And woe betide ye, if the morning sun
When he ariseth, find the work undone!

Scornful they heard—nor heeded the command—
Obey! he cried, and raised his threat'ning wand!
A murmur rose around, and sunk again,
'Twas like the roaring of the troubled Main.
With wrath the wizard saw his pow'r defied . . .
Dare ye resist me? . . . Must I tame your pride,
Rebellious Slaves! . . . A wild and piercing Cry
Burst from the darkness of the midnight sky,
And rushing on him like the Whirlwind's blast,
Vengeance! they scream'd . . . This moment is thy
 last!

In haste he drew a circle's magic form
Ere all around him blew the frantic storm,
And close, and closer still, about his breast
He wrapt his robe with wond'rous Signs imprest,
And words spoke quick and earnestly . . . their
 sound
Was in the howling of the wild wind drown'd.
Hover'd around the form of nameless things,
Sounded the rushing of a thousand wings,
Rain gush'd in floods, and drear the tempest
 wail'd . . .
Yet slow—at length—the powerful Spell prevail'd!

Less shrill the wind swept o'er the blasted heath,
Less piercing now were heard the screams of death,
The stormy gusts more faint and feeble rose,
Then ceased . . . and all around was stern Repose.

Slaves, to your Task! in Triumph loud he said—
The baffled rebels the command obey'd.
They toil'd the long and wear winter night . . .
The work was ended ere the morning light.

Bibl. **14**: 'The Magic Mirror', from *Legendary Tales, in Verse and Prose*, p. 1–20. (London: James Ridgway, 1830).

Despite her father's admonition, Bertha, heroine of this Gothic tale, cannot restrain her desire to unveil the secrets of the Fatal Glass.

With ramparts frowning o'er the mountain side,
A glorious Castle shone in banner'd pride,
The massy walls that compass'd it around
With tow'rs and lofty battlements were crown'd,
The Donjon Keep o'er all majestic rose
As if it lour'd Defiance on its Foes.

Within were courts and feudal banquet halls,
And lavish Fancy deck'd their sculptured walls,
Where giant weapons hung display'd around,
And antler'd heads, the chase's trophies, frown'd;
And blazon'd shields, and imaged tapestry rare,
And banners waving on the lazy air.

Those halls of grandeur and baronial pride
A meek and lowly Chapel rose beside.
It was a peaceful and monastic fane—
Dim flow'd the light through every pictur'd pane—
It breath'd Religion's calm and tranquil sway,
And Silence linger'd in its cloisters gray.

A thousand Architects had reared the pile
In many a varied and conflicting style . . .
Here shone the Grecian—perfect symmetry—
There sprung the Gothic, lofty, bold, and free—
While mingling forms of Asiatic taste,
Domes and tall minarets, the building graced—
And mystic obelisks, whose signs of old
In Egypt's land the fate of kings foretold—
And many a structure—admirably fair—
That form'd or fancied Mortal builder ne'er!—
Here crystal fountains danced in sportive play,
And gardens fair in long perspective lay;
There tow'rs on tow'rs arose grotesquely piled . . .
So beautiful was Arnstein's fortress wild!

Joy dwelt not often in that lordly tow'r,
For oh! at night dark clouds would o'er it low'r,
And shrieks and threat'ning murmurs seem to say,
Its Phantom Builders were not far away.

Care at such times would cloud the Owner's
 brow,
Words would he speak whose meaning none did
 know;
Yet Fear, if such he felt, he knew to hide,
For stern Resolve was his, and stubborn Pride.

Of royal splendour was his festal board,
Where all around was rich Abundance pour'd;
And many a gallant knight and noble dame
To share the Castle's revelry there came:
But more would gaze upon its turrets high . . .
Then sign the cross . . . and mournfully pass by.

II
Twice fifteen years had roll'd in peace away—
Now old, and nigh to death, the Wizard lay.
With his last breath he summon'd to his side
Bertha, his only child, his joy, his pride.
Daughter! he said, this castle's stern command
Must soon be trusted to they feeble hand:

I may not tell thee Who its builders were!
Not of this Earth . . . then O my child beware,
And heed a father's dying counsel well!
In days of yore I framed a charmed Spell,
Which like a shield o'er this enchanted ground,
Sheds its protecting influence around.
Not that by this alone I caused to rise
The might Fabric that around thee lies,
(Far other secrets raised its banner'd wall,)
But in this Talisman they center all!
'Tis like the Clasp of a mysterious Chain,
Which if though rendest . . . all the links are vain.

Behold yon Mirror . . . veil'd! . . . In Secrecy
What it concealeth, seek not Thou to see.
Tempt not the Spirits of the viewless Deep,
Long would'st thou rue it and thy folly weep!
Raise not the veil . . . a thousand forms of Death
And overwhelming Ruin lurk beneath!
But if thou dost . . . 'twere easier in that hour
To chain the wild winds, than arrest Their pow'r!

Thine are these tow'rs, and all this fair domain
Of wide-spread forest and of fertile plain:
Rule as thou wilt—but let my words prevail,
And never, never lift that dreadful Veil!

His voice grew faint, and ere the morrow's sun
His eyes were dim—his earthly race was run.

III
A month—but surely Chronicles must err—
O! could not Prudence watch a single year?
One thoughtless month o'er Bertha's head had
 flown
Since that fair heritage she call'd her own—
Already Pleasure drooped her languid wing,
The weary hours Amusement ceased to bring,
For ah! her days in Folly's wild career
She past, nor cared she Wisdom's voice to hear.
Fill'd was her castle with the gay and proud,
And flatt'rers came, a mercenary crowd:
In song and dance, in feast and wassail high,
The hours were spent, and idle revelry.

It chanced one time that she remain'd alone,
For over was the feast . . . the guests were gone;
It was the bright and sunny month of May,
The hours seem'd long . . . she wearied of the day.
She traversed every hall, then went again,
For Pleasure seeking . . . seeking it in vain . . .
When through the Chamber dim she chanced to
 pass,
Where that dark curtain veil'd the Fatal Glass.

A sudden wish arose . . . she long'd to see . . .
But fear'd her father's words of mystery.
She stopp'd . . . drew nearer to behold the veil . . .
Touch'd it . . . then felt again her courage fail!
Three times she paused . . . but ah! the veil was
 thin,
A glorious Light was streaming from within!

It seems so lovely! Need I fear? she cried,
And with rash hand she flung its folds aside!

IV
What show'd the Mirror? In an azure sky
The Sun was shining, calm and brilliantly,
And on as sweet a Vale he pour'd his beam
As ever smiled in youthful poet's dream:
With murmur soft, a hundred mazy rills
In silver tracks meander'd down the hills
And fed a crystal Lake, whose gentle shore
Was grassy bank with dark woods shadow'd o'er.

Far in the midst a lovely Isle there lay,
Where thousand birds of Indian plumage gay
Flutter'd like sparkling gems from tree to tree,
And caroll'd wild, with Nature's minstrelsy.

A Temple's fair proportion graced the Isle,
The rippling waters that around it smile
Reflect its columns in their sportive play
And glitter in the sun's unclouded ray.

And prints of tiny footsteps on the sand
Betray'd the gambols of some fairy band
Who now were flown, but scatter'd all around
Lay many a rosy chaplet on the ground,
And baskets heap'd with blushing fruits, and
 flow'rs
Fragrant as those which bloom'd in Eden's bow'rs,
And golden harps and timbrels cast away
Spread on the sward in rich confusion lay,
As if that light and airy company
Had shrunk in terror from a Mortal's eye!

In rapture o'er the mirror Bertha hung,
And pleased her fancy stray'd those scenes among;
But, as she gazed, a dimness seem'd to steal
O'er the bright glass, and slowly to conceal
The distant hills: then rolling up the vale
Shrouded it o'er with Vapours wan and pale.
The Lake, the Mountains, fade in mist away,
And lurid Darkness overspreads the day.

Too late repenting, Bertha tried once more
The Mirror's faded brightness to restore:
Alas! alas! it baffles all her skill,
The vapour on the glass falls thicker still.
To chase away the noxious dew she strives . . .
An instant, see! the shadowy scene revives . . .
But ah! how changed a picture doth it show
Of desolation, misery, and woe!

Dark frown'd the Sky, all leafless were the
 woods,
The brooks were swollen into raging Floods—
The gloomy lake, its beauty now no more,
Rolled long and angry billows to the shore—
Voices, not human, rose upon the blast . . .
Forms, not of Earth, across the Darkness past . . .
Fly! cried a whisper to her startled ear,
O haste and fly! the Storm of Death is near!

There shone a dazzling flash with Echoes dread
The distant Thunder roar'd . . . and Bertha fled.

V
She fled in terror down the marble stair,
Rush'd through the portal to the open air—
She listens . . . hark! what distant Cries are those?
Haste! they approach thee . . . haste! the Tumult
 grows!
'Tis louder still . . . it bursts in Uproar wild
On every side! the Saints preserve thee, Child!

Through the wide Gate in frantic fear she fled,
She seized the path that down the mountain led,
Nor stopp'd to breathe, for pealing on the wind
Pursuing voices echoed from behind!

A weary league she downward held her flight,
Then spent with toil and fainting with affright
She reached the wild verge of a mountain stream,
And could she cross it . . . hope began to gleam!
No hour was that to shun the desperate leap,
No hour to shrink from Wildbach's torrent deep:
She sprang into the waves—she stemm'd the
 flood—
She clamber'd up the craggy bank and rude,
Flew o'er the plain with wings that Terror gave,
And sought the refuge of Saint Anselm's cave!
Safe on that holy ground, her eyes she raised,
And pale with horror on the Castle gazed.

The mountain summit like a Furnace glow'd—
Down its rude sides the dazzling Lava flow'd—
A roar of fiendish Triumph smote her ear,
Borne on the distant gale. The Tow'rs of Fear
She sought, and saw not:—darkness o'er them
 hung!
But from the gloom the wrathful lightnings sprung
In vivid tracks of blood-red-streaming light . . .
So stern Vesuvius from his mountain height
Darts the wild flashes of indignant ire,
When clouds obscure his Diadem of Fire.

In terror from the view she turn'd her eyes,
And in the Hermit's grot, with tears and sighs,
Till every bead was told and told again,
Wearied the Saints with invocations vain!

While thus the hours in grief and anguish pass'd,
The day, the weary day, declined at last;
O'er hill and vale the shades of Evening fell,
And Bertha left the heav'n-protected cell.

No sounds were on the breeze but moanings low,
And dim was sunk that fire's unearthly glow;
Yet still it cast throughout the dreary night
O'er Arnstein's rocks a pale and dying light.

The Morning dawn'd and nothing then was seen
That could have told, those Tow'rs had ever been;
And when the Sun uprose, his cheerful ray
Fell but on shatter'd crags and summits gray.

The Antiquity of *Genesis*

Henry Fox Talbot

It may naturally be asked – if the Hebrew Scriptures have the remote antiquity to which they lay claim – how happens it that, full as they are of affecting, wonderful, and attractive narrations, they are nevertheless not quoted by the earliest writers of the heathen world? . . .

I think it can be shewn, by solid arguments: That there remained a memory in heathen lands, of some mysterious Book having been known to their ancestors, though lost long since, and the greater part of its contents forgotten. But that, nevertheless, a recollection had been preserved of the *subject* of the Book: *That it related to the Creation*. And that the very words of the book, by which it commenced, had, by a remarkable chance, been retained in memory; and that these first words were the following ones: *In the Beginning* From which I argue – supposing these facts to be supported by a chain of evidence sufficiently strong – that these mysteries were no other than the Hebrew Scriptures – and that this book was the Book of Genesis.

Authentic history began late among the Greeks, and if we wish to acquire some notions of the preceding events that happened either in Greece itself, or elsewhere in its vicinity, we must make the most of a few scattered legends, which were handed down by oral tradition, and may be

Abridged from Bibl. **74:** *The Antiquity of the Book of Genesis, Illustrated by Some New Arguments*. (London: Longman, Orme, Green, Brown and Longman, [Sept.] 1839).

As a comparative mythologist, Talbot set out to show that the Bible could be reconciled with earlier sacred texts and monuments.

supposed to have a certain portion of truth for their foundation.

But the most interesting field of inquiry is presented by the Grecian Mythology – a singular medley of tales, which have come down to us in great confusion – a tangled web, difficult to unravel – but in which at least thus much may be discerned – that it contains stories, the growth of very different times and countries; and that, mixed with many things, the mere imagining of poets, it has preserved many relics of the real belief – the serious worship – of a prior age.

It is not from the writers of the Augustan age, who flourished at a time when increasing civilization had done much to dispel the deeper shades of heathen superstition; it is not from them – nor from their immediate predecessors – that we can form any true idea of the meaning and import of the religious ceremonies and of the mystical legend of which mythology is composed. For they belonged to an age and to a class of society which had faith in these tales no longer. In earlier times, the rustic who sacrificed to Ceres or to Pan, believed he was addressing a real power, capable of being appeased with gifts, or irritated by neglect – of crowning his fields with plenty, or cursing them with sterility

Let us now throw back our glance about a thousand years – to a period when the ancient religions were flourishing in full splendour and vigour in Italy, Greece, the Lesser Asia, Persia, and all the East. The period I have mentioned is no doubt a vague one; but for the sake of argument it may be admitted for the moment, and we may suppose the scene to be displayed before us which these countries exhibited ten or twelve centuries before the Christian era.

At that time idol-worship was universally prevalent – with the single exception of the land of Israel; and though, undoubtedly, the idea of a Supreme God was never totally erased from the minds of the heathen, yet it was in a great degree obscured by the worship of visible things, and of inferior intelligences. The sun, the moon, the starry host of heaven, the prolific powers of nature, the beings who ruled the ocean, and those, still more mysterious, who were supposed to hold dominion in the shades below – these were the objects before which the nations bowed, adoring them by innumerable names, which, in their different languages, were accounted holy or mystical, or were thought expressive of their greatness, power, and beneficence.

The accounts which remain to us of the worship paid to these false divinities, forms one of the most interesting chapters in the history of man. It shews us the spectacle of a world from which the true light was withheld, wandering in the maze of interminable error, yet not altogether or at all times destitute of noble feelings and of sublime conceptions.

It would, however, lead me too far, if I were to attempt to sketch a general view of the ancient idolatry, and of the position of the human mind while under its influence. I shall, therefore, come at once to some particulars which it is more especially my object at present to advert to.

An attentive and unprejudiced examination of the ancient authorities will, I think, convince every one, that one of the chief objects of heathen worship was the Sun. And what could be a more natural error of the uninstructed mind than to adore the beneficent luminary, the source of all the earth's fertility, and the fountain of perennial light?

To mention a few only of the names by which the Sun was worshipped – he was the Phœbus and the Apollo of the Greeks; the Osiris of Egypt; the Adonis of Syria; the Atys, Attes, or Attin of Phrygia; the Bel or Baal of Phœnicia; and the Mithras of Persia. In the latter country, the worship of the rising sun, in his own natural form, without the intervention of any symbol or image, continued down to later times.

The next great divinity of the heathen, to whom I shall advert, is the goddess of Nature. Of the many names by which she was invoked in different countries, this one appears to me to be the most expressive and significant, and to combine together and explain most clearly the meaning of her multiform attributes. I have therefore adopted it.

She was called in Greece, Rhea, the Great Mother, the Mother of the Gods, Mother Earth, Demeter, Nature. She was the Ceres, Ops, Flora, Pomona of the Romans – the Cybele of Phrygia – the Artemis of the Ephesians – the Isis of the Egyptians. Many other names she had, not at present necessary to be enumerated.

According to a most natural and expressive allegory, these two divinities, the Sun and the Earth, were held to be the original parents of mankind, and of all living things. The Sun was their Great Father, and Nature their Great Mother. This was meant in Phrygia by the loves of Cybele and Attis – in Syria, by those of Venus[1] and Adonis – in Egypt, by the fable of Isis and Osiris.

1. See the existing monuments of the Dea Syria – in no wise different from those of the Ephesian Artemis, or Cybele.

When Hesiod relates (Theogon.45) that Heaven and Earth were the parents of the gods themselves,[2] he only gives us a variation of the same allegory.

But now comes this curious circumstance, already remarked upon by various learned men, that the heathen mythologists have interwoven in their accounts of these allegorical beings, these first parents of gods and men, some circumstances (strangely perverted, indeed), but which seem taken from the Scripture narrative of Adam and Eve in Paradise.

But if they are so (the proofs of which I propose hereafter to inquire into), it is needless to say what important conclusions necessarily follow with respect to the antiquity of the Hebrew narrative. For, if the poet who alludes to it be himself ancient, the sacred original must of necessity be still more so.

For the sake of illustration, I will adduce an example, where (as many think) such a resemblance is clearly manifest. I mean the very ancient and beautiful fable of Pandora, related by Hesiod. Although so well known, I may be excused for repeating it in a few words. It is the story of the woman, *the wife of the first-created man*, upon whom the gods had showered every blessing which it is possible to imagine; but had laid upon her one injunction, had hid from her one secret which she was never to attempt to discover. But, alas! her curiosity tempts her to violate this fatal command! Immediately all happiness flies away from earth; and in its place sorrow, misery, and all manner of evils invade the abode, and embitter the existence of mankind.

Can it be said that the author of this fable had never heard of the temptation of Eve? That he drew the allegory from his own imagination? That the resemblance is casual, and nothing more?

I hold, on the contrary (and the same has often been maintained before), that the *first* author of this beautiful tale, whoever he was, and wherever he lived, must either have had access to the sacred books of the Jews, or at any rate to some Eastern writings, which had immediately or remotely been drawn from the same source. Now, then, I argue thus: – Since this tale is related by Hesiod, one of the most ancient of profane authors, the biblical history of our first parents must be more ancient than *him*.

2. This shews what an exalted idea the ancient mythologists had formed of ΓΑΙΑ, the goddess of the earth. Indeed, *Mater Deum* was one of her most usual appellations.

Early Researches in Photography

Henry Fox Talbot

Part 1: Photogenic Drawing

Having been requested to mention the dates at which my earliest researches in photography were published, and by what successive steps the pictures were improved, I have collected the following notes, which may prove useful, as the scientific journals and other publications of that time are now for the most part out of print, and not easily procurable by the general reader.

It was at one of the Friday evening meetings of the Royal Institution (January 25, 1839) that the new art was first publicly announced by Faraday, and the audience were invited by him to inspect a collection of 'Photogenic Drawings' which were hung around the walls of the upper library. And he explained at the same time that the principal object of this exhibition was to establish a date, in order that, should M. Daguerre's discovery[1] be made public previously to the reading, before the Royal Society, of Mr. Talbot's paper describing his process, no charge of imitation could be brought, in case of identity of process, and that each discovery should be thus proved to be original.[2]

On the Thursday following Faraday's announcement (January 31, 1839) my paper entitled 'Some Account of the Art of Photogenic Drawing' was read to the Royal Society.

1. It wil be remembered, that in January 1839, M. Daguerre had announced to the world his great discovery, the particulars of which, however, were kept a profound secret by himself and his only confidant M. Arago, until 19 August, when his process was disclosed at a sitting of the Academy of Sciences, and proved to be quite different from my 'photogenic drawing'.

2. Bibl. **49**, p. 75.

Bibl. **239**: 'Appendix A, Parts I–II, [p. 346–66] in Gaston Tissandier, *A History and Handbook of Photography*, edited by John Thomson, second and revised edition (London: Sampson, Marston, Low & Searle, 1878).

Just before his death in 1877, Talbot compiled this account of his early work in photography for the English edition of Tissandier's book.



I think I cannot do better than quote some portions of it.[3] In the spring of 1834 I began to put in practice a method which I had devised some time previously, for employing to purposes of utility the very curious property which has been long known to chemists to be possessed by the nitrate of silver; namely, its discoloration when exposed to the violet rays of light. This property appeared to me to be perhaps capable of useful application in the following manner.

I proposed to spread on a sheet of paper a sufficient quantity of the nitrate of silver and then to set the paper in the sunshine, having first placed before it some object casting a well defined shadow. The light, acting on the rest of the paper, would naturally blacken it, while the parts in shadow would retain their whiteness. Thus I expected that a kind of image or picture would be produced, resembling to a certain degree the object from which it was derived. I expected, however, also that it would be necessary to preserve such images in a portfolio, and to view them only by candlelight; because if by daylight, the same natural process which formed the images would destroy them, by blackening the rest of the paper.

Such was my leading idea before it was enlarged and corrected by experience. It was not until some time after, and when I was in possession of several novel and curious results, that I thought of inquiring whether this process had been ever proposed or attempted before? I found that in fact it had; but apparently not followed up to any extent, or with much perseverance. The few notices that I have been able to meet with are vague and unsatisfactory; merely stating that such a method exists of obtaining the outline of an object, but going into no details respecting the best and most advantageous manner of proceeding.

The only definite account of the matter which I have been able to meet with, is contained in the first volume of the 'Journal of the Royal Institution', page 170, from which it appears that the idea was originally started by Mr. Wedgwood, and a numerous series of experiments made both by him and Sir Humphry Davy, which however ended in failure. I will take the liberty of quoting a few passages from this memoir:

> The copy of a painting, immediately after being taken, must be kept in an obscure place. It may indeed be examined in the shade, but in this case, the exposure should be only for a few minutes. No attempts that have been made to prevent the uncoloured parts from being acted upon by light have as yet

3. Bibl. **60**, p. 196.

been successful. They have been covered with a thin coating of fine varnish, but this has not destroyed their susceptibility of becoming coloured. When the solar rays are passed through a print and thrown upon prepared paper, the unshaded parts are slowly copied; but the lights transmitted by the shaded parts are seldom so definite as to form a distinct resemblance of them by producing different intensities of colour.

The images formed by means of a *camera obscura* have been found to be too faint to produce, in any moderate time, an effect upon the nitrate of silver. To copy these images was the first object of Mr. Wedgwood, but all his numerous experiments proved unsuccessful.†

These are the observations of Sir Humphry Davy. I have been informed by a scientific friend that this unfavourable result of Mr. Wedgwood's and Sir Humphry Davy's experiments was the chief cause which discouraged him from following up with perseverance the idea which he had also entertained of fixing the beautiful images of the *camera obscura*. And no doubt when so distinguished an experimenter as Sir Humphry Davy announced that 'all experiments had proved unsuccessful', such a statement was calculated materially to discourage further inquiry. The circumstance, also announced by Davy, that the paper on which these images were depicted was liable to become entirely dark, and that nothing hitherto tried would prevent it, would perhaps have induced me to consider the attempt as hopeless, if I had not (fortunately) before I read it, already discovered a method of overcoming this difficulty, and of *fixing* the image in such a manner that it is no more liable to injury or destruction. This *preserving process* is far more effectual than could have been anticipated. The paper, which had previously been so sensitive to light, becomes completely insensible to it, insomuch that I am able to show the Society specimens which have been exposed for an hour to the full summer sun, and from which exposure the image has suffered nothing, but retains its perfect whiteness.[4]

First Application of this Process. – The first kind of objects which I attempted to copy by this process were flowers and leaves, either fresh or selected from my herbarium. These it renders with the utmost truth and fidelity, exhibiting even the venation of the leaves, the minute hairs that clothe the plant, etc.

It is so natural to associate the idea of *labour* with great complexity and elaborate detail of execution, that one is

† For a reprint, see B. Newhall, *Photography: Essays & Images*, New York, 1980; London, 1981, p. 15–16.

4. Bibl. **60**, p. 200.

more struck at seeing the thousand florets of an *Agrostis* depicted with all its capillary branchlets (and so accurately, that none of all this multitude shall want its little bivalve calyx, requiring to be examined through a lens), than one is by the picture of the large and simple leaf of an oak or a chestnut. But in truth the difficulty is in both the cases the same. The one of these takes no more time to execute than the other; for the objects which would take the most skilful artist days or weeks of labour to trace or to copy, is effected by the boundless powers of natural chemistry in the space of a few seconds.

Another purpose for which I think my method will be found very convenient, is the making of outline portraits or *silhouettes*. These are now often traced by the hand from shadows projected by a candle. But the hand is liable to err from the true outline, and a very small deviation causes a notable diminution in the resemblance. I believe this manual process cannot compare with the truth and fidelity with which the portrait is given by means of solar light.[5]

I now come[6] to a branch of the subject which appears to me very important, and likely to prove extensively useful – the application of my method of delineating objects to the solar microscope. The objects which the microscope unfolds to our view, curious and wonderful as they are, are often singularly complicated. The eye, indeed, may comprehend the whole which is presented to it in the field of view; but the powers of the pencil fail to express these minutiæ of nature in their innumerable details.

What artist could have skill or patience enough to copy them? or granting that he could do so, must it not be at the expense of much most valuable time, which might be more usefully employed?

Contemplating the beautiful picture which the solar microscope produces, the thought struck me, whether it might not be possible to cause that image to impress itself upon the paper, and thus to let Nature substitute her own inimitable pencil for the imperfect, tedious, and almost hopeless attempt of copying a subject so intricate.

My first experiments with the solar microscope were not successful, the paper not being sufficiently sensitive. I, therefore, began a course of experiments with a view to improve it. The result[7] of these experiments was the discovery of a mode of preparation greatly superior in sensibility to what I had originally employed; and by means of this, all those effects which I had before only anticipated as theoretically possible were found to be capable of realisation.

5. At this period (1839) no *camera* portraits had yet been obtained, either by the English process or by the Daguerreotype. These were first obtained towards the end of 1840 by my invention of the Calotype process, and by the employment of *bromine vapour* to increase the sensibility of the Daguerreotype, an improvement due to Mr. Goddard.

6. Bibl. **60**, p. 203.

7. Ibid., p. 204.

When a sheet of this, which I shall call *sensitive paper*, is placed in a dark chamber, and the magnified image of some object thrown on it by the solar microscope, after the lapse of perhaps a quarter of an hour the picture is found to be completed. I have not as yet used high magnifying powers, on account of the consequent enfeeblement of the light. Of course, with a more sensitive paper, greater magnifying power will be come desirable.

On examining one of these pictures which I made about three years and a half ago, I find, by actual measurement of the picture and the object, that the latter is magnified seventeen times in linear diameter, and in surface consequently 289 times. I have others which I believe are considerably more magnified, but I have lost the corresponding objects, so that I cannot here state the exact numbers.

Not only does this process save our time and trouble, but there are many objects, especially microscopic crystallisations, which alter so greatly in the course of three or four days (and it could hardly take any artist less to delineate them in all their details) that they could never be drawn in the usual way.

I will now describe the *degree of sensitiveness* which this paper possesses, premising that I am far from supposing that I have reached the limit of which this quality is capable. On the contrary, considering the few experiments which I have made (few, that is, in comparison with the number which it would be easy to imagine and propose), I think it most likely that other methods may be found, by which substances may be prepared, perhaps as much transcending in sensitiveness the one which I have employed, as that does the nitrate of silver which I used in my first experiments.

But, to confine myself here to what I have actually accomplished. When a sheet of my sensitive paper is brought towards a window, not one through which the sun shines, but looking in the opposite direction, it immediately begins to discolour. Being then thus readily sensitive to the light of a common window, it is of course much more so to the direct sunshine. Indeed, such is the velocity of the effect then produced, that the picture may be said to be ended almost as soon as it is begun.

To give some more definite idea of the rapidity of the process I will state, that after various trials the nearest evaluation which I could make of the time necessary for obtaining the picture of an object, so as to have pretty

distinct outlines, when I employed the full sunshine, was *half a second*.

But perhaps the most curious application of this art is the one I am now about to relate. At least it is that which has appeared the most surprising to those who have examined my collection of pictures formed by solar light.

Everyone is acquainted with the beautiful effects which are produced by a *camera obscura* and has admired the vivid picture of external nature which it displays. It had often occurred to me, that if it were possible to retain upon the paper the lovely scene which thus illuminates it for a moment, or if we could but fix the outline of it, the lights and shadows, divested of all *colour*, such a result could not fail to be most interesting. And, however much I might be disposed at first to treat this notion as a scientific dream, yet when I had succeeded in fixing the images of the solar microscope by means of a peculiarly sensitive paper, there appeared no longer any doubt that an analogous process would succeed in copying the objects of external nature, although indeed they are much less illuminated.

Not having with me in the country a *camera obscura* of any considerable size, I constructed one out of a large box, the image being thrown upon one end of it by a good object-glass fixed in the opposite end. This apparatus being armed with a sensitive paper, was taken out in a summer afternoon, and placed about one hundred yards from a building favourably illuminated by the sun. An hour or two afterwards I opened the box and I found depicted upon the paper a very distinct representation of the building, with the exception of those parts of it which lay in the shade. A little experience in this branch of the art showed me that with a smaller *camera obscura* the effect would be produced in a smaller time. Accordingly I had several small boxes made, in which I fixed lenses of shorter focus, and with these I obtained very perfect, but extremely small pictures, such as without great stretch of imagination might be supposed to be the work of some Lilliputian artist. They require, indeed, examination with a lens to discover all their minutiæ.

In the summer of 1835 I made in this way a great number of representations of my house in the country, which is well suited to the purpose, from its ancient and remarkable architecture. And this building I believe to be the first that was ever yet known to have drawn its own picture.

The method of proceeding was this; having first adjusted the paper to the proper focus in each of these little *cameræ*,

I then took a number of them with me out of doors and placed them in different situations around the building. After the lapse of half an hour I gathered them all up, and brought them within doors to open them. When opened, there was found in each a miniature picture of the objects before which it had been placed.

To the traveller in distant lands, who is ignorant, as too many unfortunately are, of the art of drawing, this little invention may prove of real service; and even to the artist himself, however skilful he may be. For although this natural process does not produce an effect much resembling the productions of his pencil, and therefore cannot be considered as capable of replacing them, yet it is to be recollected that he may often be so situated as to be able to devote only a single hour to the delineation of some very interesting locality. Now, since nothing prevents him from simultaneously disposing, in different positions, any number of these little *cameræ*, it is evident that their collective results, when examined afterwards, may furnish him with a large body of interesting memorials, and with numerous details which he had not had himself time either to note down or to delineate.[8]

The preceding are extracts from my first paper presented to the Royal Society. In my second paper,† presented three weeks later (February 21, 1839),[9] I explained my process of coating paper with a chloride of silver in which the sensibility of the chloride was so much exalted as to render it capable of receiving the images of the *camera obscura*. Also a mode of fixing the pictures by washing them with iodide of potassium, the strength of the solution being so regulated as not to attack the shades of the picture while effectually preserving the lights.

These, however, lose their absolute whiteness, and assume 'a very pale primrose yellow, which has the very remarkable property of turning to a full gaudy yellow whenever it is exposed to the heat of a fire, and recovering its former colour when it is cold.'[10]

These papers, read to the Royal Society in January and February 1839, brought many experimenters into the field, the most distinguished of whom was Sir J. F. W. Herschel, who speedily made a discovery of the highest importance by showing that *hyposulphite of soda* has the property of fixing the pictures by dissolving the chloride of silver on which the light has not acted, and leaving those portions which have been darkened by the action of light. In my method of fixation I had converted the lights of the picture

8. Bibl. **60**, p. 206.

† Talbot took his extracts for the first paper from Bibl. **60**; for the second, from Bibl. **61**.

9. Bibl. **61**, p. 209.

10. Ibid., p. 211. The absolute insensibility to light of perfectly formed *iodide of silver* was here first established. This afterwards gave rise to the *Calotype* process, in which I employed *iodized paper*, not sensitive to light, indeed having been purposely 'sunned' for an hour or two.

into chlorides and iodides of silver, the former nearly, the latter completely insensible to light, but Herschel's method of dissolving them out by the aid of hyposulphite was much superior.

Part 2: The Calotype Process

All the previously related experiments were made in ignorance that there exists a latent image upon the paper after the camera has been in action for a few moments. It must be so, indeed, *theoretically*, but it was not known that by any means the image could be made to appear.

The discovery of the latent image and the mode of its development was made rather suddenly on September 20 and 21, 1840. This immediately changed my whole system of work in photography. The acceleration obtained was so great, amounting to full *one hundred times*, that, whereas formerly it took me an hour to take a pretty large camera view of a building, the same now only took about *half a minute*; so that instead of having to watch the camera for a long period, and guard against gusts of wind and other accidents, I had now to watch it for barely a minute or so.

Portraits were now easily taken in moderate daylight, a condition essential to success. One of the first portraits taken was sent to the French Academy of Sciences, where it excited great interest and was passed from hand to hand, and afterwards to the public in the galleries (my friend Monsieur Biot being my informant).

I soon drew up an account of this new process, which I named the Calotype, and transmitted it to the Royal Society (June 10, 1841). I will here give some extracts from this paper believing that the reader will prefer to read the account in the original words:†

The following is the method of obtaining the Calotype pictures.

Preparation of the Paper. Take a sheet of the best writing paper, having a smooth surface, and a close and even texture.

Dissolve 100 grains of crystallised nitrate of silver in six ounces of distilled water. Wash the paper with this solution with a soft brush, on one side, and put a mark on that side whereby to know it again. Dry the paper cautiously at a distant fire, or else let it dry spontaneously in a dark room. When dry, or nearly so, dip it into a solution of iodide of potassium containing 500 grains of that salt dissolved in one pint of water, and let it stay two or three minutes in this

solution. Then dip it into a vessel of water, dry it lightly with blotting-paper, and finish drying it at a fire, which will not injure it even if held pretty near; or else it may be left to dry spontaneously.

The paper so far prepared I call *iodized paper*, because it has a uniform pale yellow coating of iodide of silver. It is scarcely sensitive to light, but, nevertheless it ought to be kept in a portfolio or a drawer until wanted for use.[11]

This is the first part of the preparation of Calotype paper, and may be performed at any time. The remaining part is best deferred until shortly before the paper is wanted for use.

When that time is arrived, take a sheet of the *iodized paper* and wash it with a liquid prepared in the following manner:–

Dissolve 100 grains of crystallised nitrate of silver in two ounces of distilled water: add to this solution one sixth of its volume of strong acetic acid. Let this mixture be called A.

Make a saturated solution of crystallised gallic acid in cold distilled water. The quantity dissolved is very small. Call this solution B.

When a sheet of paper is wanted for use mix together the liquids A and B in equal volumes, but only mix a small quantity of them at a time, because the mixture does not keep long without spoiling. I shall call this mixture the *gallo-nitrate of silver*.

Then take a sheet of *iodized paper* and wash it over with this *gallo-nitrate of silver* with a soft brush, taking care to wash it on the side which has been previously marked. This operation should be performed by candlelight. Let the paper rest half a minute and then dip it into water. Then dry it lightly with blotting-paper, and finally dry it cautiously at a fire, holding it at a considerable distance therefrom. When dry, the paper is fit for use. I have named the paper thus prepared *Calotype paper* on account of its great utility in obtaining the pictures of objects with the camera obscura. If this paper be kept in a press, it will often retain its qualities in perfection for three months or more, being ready for use at any moment; but this is not uniformly the case, and I therefore recommend that it should be used in a few hours after it has been prepared. If it is used immediately, the last drying may be dispensed with, and the paper may be used moist.

Use of the Paper. The Calotype paper is sensitive to light in an extraordinary degree, which transcends a hundred

11. From this it appears that at the time of reading this paper I was not aware that it was advantageous to *sun* the iodized paper. This was however discovered soon afterwards. I have preserved several quires of iodized paper from that time (1841) to the present day [1877].

times or more that of any kind of photographic paper hitherto described. This may be made manifest by the following experiment.

Take a piece of this paper, and having covered half of it, expose the other half to daylight for the space of *one second* in dark cloudy weather in winter. This brief moment suffices to produce a strong impression upon the paper. But the impression is latent and invisible, and its existence would not be suspected by any one who was not forewarned of it by previous experiments.

The method of causing the impression to become visible is extremely simple. It consists in washing the paper once more with the *gallo-nitrate of silver*, prepared in the way before described, and then warming it gently before the fire. In a few seconds the part of the paper upon which the light has acted begins to darken, and finally grows entirely black, while the other part of the paper retains its whiteness. Even a weaker impression than this may be *brought out* by repeating the wash of gallo-nitrate and again warming the paper. On the other hand, a stronger impression does not require the warming of the paper, for a wash of the gallo-nitrate suffices to make it visible without heat, in the course of a minute or two.

A very remarkable proof of the sensitiveness of the Calotype paper is afforded by the fact that it will take an impression from simple moonlight, not concentrated by a lens. If a leaf is laid upon a sheet of the paper, an image of it may be obtained in this way in from a quarter to half-an-hour.

This paper being possessed of so high a degree of sensitiveness is therefore well suited to receive images in the camera obscura. If the aperture of the object-lens is one inch, and the focal length fifteen inches, I find that *one minute*[12] is amply sufficient in summer to impress a strong image upon the paper of any building upon which the sun is shining. When the aperture amounts to one-third of the focal length, and the object is very white, as a plaster bust, &c., it appears to me that *one second* is sufficient to obtain a pretty good image of it.

The images thus received upon the Calotype paper are for the most part invisible impressions. They may be made visible by the process already related, namely, by washing them with *gallo-nitrate* and then warming the paper. When the paper is quite blank, as is generally the case, it is a highly curious and beautiful phenomenon to see the spontaneous commencement of the picture, first tracing out

12. Subsequent experiments during the summer of 1841 showed that *ten seconds* was the proper time under the circumstances above mentioned (*Note to the original paper*).

the stronger outlines and then gradually filling up all the numerous and complicated details. The artist should watch the picture as it develops itself, and when in his judgment it has attained the greatest degree of strength and clearness he should stop further progress by washing it with the fixing liquid.

In another part of the paper I proceed to explain that I only recommend the Calotype paper for the negative[13] pictures made in the camera, but that the *positive copies* should be made on the paper originally described as *photogenic paper*, being washed first with weak common salt, and then with nitrate of silver. Although these copies take a much longer time to make, their effect is more pleasing and harmonious. I need not say that this division of the photographic process into two parts has been since universally adopted.

13. The terms *positive* and *negative* were introduced by Sir J.F.W. Herschel. They were immediately accepted, and adopted into the language of photography.

Photogenic Drawings Exhibited in 1839

Henry Fox Talbot

<div align="center">

A BRIEF DESCRIPTION

OF THE

PHOTOGENIC DRAWINGS

EXHIBITED AT THE MEETING OF THE

BRITISH ASSOCIATION,

AT BIRMINGHAM,

IN AUGUST, 1839,

BY H. F. TALBOT, ESQ.

</div>

<div align="center">

CLASS I.

</div>

Images obtained by the direct action of light, and of the same size with the objects.

1. The Great Seal of England, copied from an engraving with the Anaglyptograph.
2. Reverse of the same.
3, 4. Copies of Lithography.
6 to 15. Copies of Lace, of various patterns.
16. Muslin.

Bibl. **72:** *A Brief Description of the Photogenic Drawings Exhibited at the Meeting of the British Association at Birmingham in August, 1839.*

This list is suggestive of the uses to which Talbot's photogenic drawing process could be put, both in and out of the camera.

17, 18. Calico.

19. Copy of a Wood Engraving.

20, 21. Coats of Arms, taken from old painted glass.

22. Copy of a Berlin pattern.

23. Jessamine.

24. Grass.

25 and 26. Grass. *Aira caryophyllea.*

27, 28. *Bromus maximus,* native of Genoa.

29. *Agrostis.*

30. Coltsfoot (*Tussilago farfara*). The winged seeds are represented flying away.

31. *Veronica.*

32. *Sisymbrium Cumingianum.*

33, 34. Fern.

35. Campanula.

36. *Kitaibelia vitifolia.*

37. *Orobus vernus.*

38. *Athamanta Matthioli.*

39. *Erodium elegans,* a new species, discovered by the author in the Island of Zante.

40. *Erigeron* and *Aconitum.*

41. *Clypeola Jonthlaspi,* from the Island of Corfu.

42. Leaves of Fig and Pæony.

43. Tansy and Chærophyllum.

44. Horse Chestnut and Pæony.

45. Celandine, *Chelidonium majus.*

46. *Eryngium,* from Corfu.

47. Ladies' Mantle, *Alchemilla.*

48. Various leaves represented on paper of much lighter tint.

49. Rose Leaves.

50. Leaves of Spruce Fir.

51, 52. Feathers.

CLASS II.

Reversed images, requiring the action of light to be TWICE *employed.*[1]

53 to 58. Copies of Lithography.

59, 60. Copies of Transparencies, representing Moonlight among Ruins.

61. Copy of an old Printed Book – The Statutes of King Richard II.

62 to 64. Copies of old Painted Glass.

CLASS III.

Views taken with the Camera Obscura.

The pictures, when taken out of the instrument, represent the scene reversed with respect to right and left, and also with respect to light and shade. This is exemplified in No. 65. Both these defects are remedied at the same time, by exposing the picture first made to the renewed action of light, and thus obtaining from it a *transfer* or reversed image. Such are the following:

66. South front of Lacock Abbey, Wilts.

67. Nearer View of the Tower.

68 to 82. Other Views of the same building.

83 to 86. Windows in ditto, taken from the inside.

CLASS IV.

Images made with the Solar Microscope.

87 to 91. Lace, magnified 100 times in surface.

92, 93. Ditto, magnified 400 times.

1. This is necessary in copying engravings, because the first operation substitutes everywhere light for shade, and *vice versa.* The second operation is, therefore, requisite, in order to bring them back into their proper positions.

Two Letters on Calotype Photogenic Drawing

Henry Fox Talbot

Dear Sir,

It is now two years since I first published a brief account of Photogenic Drawing. During this interval I have taken much pains, and made many experiments, with the hope of rendering the art more perfect and useful. In this way I have obtained a good many improvements, with the mention of which I shall not detain you at present.

I shall confine myself in this letter to a single subject, viz. the discovery which I made last September of a chemical process by which paper may be made far more sensitive to light than by any means hitherto known. It is not easy to estimate exactly how far this increase of sensibility extends; but certainly a much better picture can now be obtained in *a minute* than by the former process in *an hour*.

This increased rapidity is accompanied with an increased sharpness and distinctness in the outlines of the objects – an effect which is very advantageous and pleasing, and at the same time rather difficult to account for.

The shortest time in which I have yet succeeded in impressing an image in the camera obscura has been *eight seconds*; but I do not mean to assign this as the precise limit, for it can only be ascertained by more careful and multiplied experiments.

Bibl. **90**: 'Two Letters on Calotype Photogenic Drawing . . . to the editor of *The Literary Gazette*'. *Philosophical Magazine*, ser. 3, vol. 19, no. 121 (July 1841), p. 88–92.

Until September 1841, Talbot had exposed his sensitized paper for as long as it took an image to appear. Here he announces his discovery of a latent image which could be developed with a solution of gallic acid and silver nitrate after a much shorter exposure.

The production of the image is accompanied with some very extraordinary circumstances, to which I will advert in a subsequent letter. These phænomena are extremely curious; and I have not found in chemical writers any mention of anything similar.

The image, when obtained, must of course be fixed, otherwise the process would remain imperfect. It might be supposed, *a priori*, that this fixation would be very difficult, the paper being so sensitive. But it fortunately happens that, in this instance, what seems a reasonable inference is not borne out by fact, that the new photographs are more easily and perfectly fixed than was the case with the former ones. When fixed, a great many copies may be made from them; and thus the original view can be multiplied with facility.

I think that the art has now reached a point which is likely to make it extensively useful. How many travellers are almost ignorant of drawing, and either attempt nothing, or bring home rude unintelligible sketches! They may now fill their portfolios with accurate views, without much expenditure of time or trouble; and even the accomplished artist will call in sometimes this auxiliary aid, when pressed for time in sketching a building or a landscape, or when wearied with the multiplicity of its minute details.

One of the most important applications of the new process, and most likely to prove generally interesting, is, undoubtedly, the taking of portraits. I made trial of it last October, and found that the experiment readily succeeded. Half a minute appeared to be sufficient in sunshine, and four or five minutes when a person was seated in the shade, but in the open air. After a few portraits had been made, enough to show that it could be done without difficulty, the experiments were adjourned to a more favourable season.

Several photographic processes being now known, which are materially different from each other, I consider it to be absolutely necessary to distinguish them by different names, in the same way that we distinguish different styles of painting or engraving. Photographs executed on a silver plate have received, and will no doubt retain, the name of Daguerréotype. The new kind of photographs, which are the subject of this letter, I propose to distinguish by the name of *Calotype*; a term which, I hope, when they become known, will not be found to have been misapplied.

I remember it was said by many persons, at the time when photogenic drawing was first spoken of, that it was likely to prove injurious to art, as substituting mere

mechanical labour in lieu of talent and experience. Now, so far from this being the case, I find that in this, as in most other things, there is ample room for the exercise of skill and judgement. It would hardly be believed how different an effect is produced by a longer or shorter exposure to the light, and, also, by mere variations in the fixing process, by means of which almost any tint, cold or warm, may be thrown over the picture, and the effect of bright or gloomy weather may be imitated at pleasure. All this falls within the artist's province to combine and to regulate; and if, in the course of these manipulations, he, *nolens volens*, becomes a chemist and an optician, I feel confident that such an alliance of science with art will prove conducive to the improvement of both.

I remain, yours, &c.
H. F. Talbot.

31, Sackville Street, Feb. 5, 1841.

Dear Sir,

I will now proceed to give you some further details, for which I had not room in my last letter, respecting the phænomena which occur during the very singular photographic process to which I have given the name of Calotype. And I may as well begin by relating to you the way in which I disovered the process itself. One day, last September, I had been trying pieces of sensitive paper, prepared in different ways, in the camera obscura, allowing them to remain there only a very short time, with the view of finding out which was the most sensitive. One of these papers was taken out and examined by candlelight. There was little or nothing to be seen upon it, and I left it lying on a table in a dark room. Returning some time after, I took up the paper, and was very much surprised to see upon it a distinct picture. I was certain there was nothing of the kind when I had looked at it before; and, therefore (magic apart), the only conclusion that could be drawn was, that the picture had unexpectedly *developed itself* by a spontaneous action.

Fortunately, I recollected the particular way in which this sheet of paper had been prepared, and was, therefore, enabled immediately to repeat the experiment. The paper, as before, when taken out of the camera, presented hardly anything visible; but this time, instead of leaving it, I continued to observe it by candlelight, and had soon the satisfaction of seeing a picture begin to appear, and all the

details of it come out one after the other.

In this experiment, the paper was used in a moist state; but since it is much more convenient to use dry paper if possible, I tried it shortly afterwards in a dry state, and the result was still more extraordinary. The dry paper *appeared* to be much less sensitive than the moist; for when taken out of the camera after a short time, as a minute or two, the sheet of paper was absolutely blank.

But, nevertheless, I found that the picture existed there, *although invisible*; and by a chemical process analogous to the foregoing, it was made to appear in all its perfection.

After several further experiments, which were requisite in order to come to a right understanding of this unexampled natural process, I found it expedient to abandon the former method of taking views with the camera, in favour of the new one, so far excelling it in rapidity and power. The result of my experience hitherto with this calotype paper is, that if properly prepared, it will keep three or four months, ready for use at any moment, and moreover it is used in a dry state, which is a great convenience.

The time of exposure to light in the camera may be varied, according to circumstances, from a quarter of a minute upwards; and the paper, when taken out of the instrument, appears quite blank, as I said before, but it is impressed with an invisible image. It may be kept in this invisible state for a month or so, if desired, and *brought out*, or rendered visible, when wished for. But, generally, this is done shortly after, or at least on the same day, for fear of accidents (such as a casual gleam of daylight, which would at once annihilate the whole performance). Whenever it is desired to render the picture visible, this is done in a very short time, as from a minute to five or ten minutes, the strongest impressions coming out the easiest and quickest. Very faint impressions (as those obtained when the paper has been only a few seconds in the camera, or the objects have not been luminous enough) take a longer time in coming out; but they should not be despaired of too soon, as many of them exhibit difficulty at first, as if reluctant to appear, but nevertheless end by coming out very well. The operator of course remains in a darkened room, lit by candles only.

I know few things in the range of science more surprising than the gradual appearance of the picture on the blank sheet, especially the first time the experiment is witnessed. The operator ought to watch the progress of the picture,

until, in its strength of colour, sharpness of outline, and general distinctness, it has reached in his judgement the most perfect state. At that moment he stops further progress by washing it over with a fixing liquid. This is washed off with water, the picture is then dried, and the process is terminated.

The picture is found to be very strongly fixed, and from it numerous copies may be taken on common photogenic drawing paper, by the method of superposition in sunshine. The original picture does not readily become altered, or wear out by this exposure to the sun; but in case it does so, as happens sometimes, I find that it may be in general readily *revived*. This *revival*, which is a most curious particularity of the calotype process, not only restores the picture to its pristine strength, but frequently causes fresh details and minutiæ to appear in the picture, which had not appeared before, at the time when it was first *brought out*, or rendered visible (owing to that process having been checked too soon). These details, therefore, had been lying in an invisible state on the paper all this time, *not destroyed* (which is the most extraordinary thing) *by so much exposure to sunshine*. They were protected by the fixing liquid. But no one could have supposed beforehand, or without ocular demonstration, that it could have exerted so complete a protecting power. This is an invaluable property of the calotype – the power of reviving the pictures – not only because it allows so many copies to be made, but because it enables the artist to correct the error of his judgement, in case he has made too faint a picture at first, by stopping it too soon while it was coming out.

Some further details on this subject, and an account of the chemical processes employed, I reserve for a paper which I intend to lay before the Royal Society.†

I am, &c. &c.
H. F. Talbot.

Lacock Abbey, Feb. 19, 1841.

† Bibl. **92**, Bibl. **97**.

Latent Developments from Gallic Acid

R. Derek Wood

In spite of the immediate welcome given by Sir John Herschel and others to Talbot's photogenic drawing technique, it was soon realized that it was not, in fact, a particularly satisfactory method. Talbot's more significant contribution lies after 1839 with the technique of using gallic acid as a developer in the calotype process patented by him in 1841. The origins of his first experiments with gallic acid are therefore of particular interest in the history of early discoveries in photography.

Sir John Herschel on hearing that Daguerre had obtained pictures using light immediately started experiments at the end of January 1839. With admirable ease he had in a few days solved the greatest problem of preservation and fixing by using hypo. Talbot and Herschel corresponded about the new discoveries. Talbot was always very restrained in giving any technical details of his own work – for example, he withheld from telling Herschel of his own inferior method of fixation/stabilization until his paper was to be read at the Royal Society on 21 February. In contrast Herschel was very open about his work. In a long detailed letter to Talbot on 28 February 1839 Herschel wrote:

I had been trying various modes of rendering [silver] nitrated

Abridged from Bibl. **533:** R. Derek Wood. 'Latent Developments from Gallic Acid, 1839'. *Journal of Photographic Science*, vol. 28, no. 1 (Jan.-Feb. 1980), p. 36–42 by permission of the author and The Royal Photographic Society.

The author gives an account of the contribution by Sir John Herschel (1792–1871) to the use of gallic acid in 1839, and his part in the lawsuits in 1854 when Talbot failed to enforce his patent rights.

paper more sensitive – till I read your most curious account of your process, which opens up quite a new view of the subject, and is altogether one of the most singular things I ever saw. You must have hunted down the caprices of these combinations with great perseverance [and] patience. When I read it I gave up further trials, your processes being very simple and complete – I had most hopes of the Gallate of Silver [Silver Nitrate + Gallic Acid], which is affected by light very differently from its other salts[1]

Herschel's experimentation in photographic science was from the beginning thorough and rewarding. He recorded details of Batch preparation of his experimental photosensitive materials in a Photographic Memoranda book from 1839 to 1845 and in 1859.[2] He prepared 670 sensitive papers in 1839, but unfortunately the first one to be dated was not until No. 421 on 26 March 1839. Even so the Photographic Memoranda book does show that Herschel's first experiment with gallic acid was amongst the very earliest photographic work carried out by him. It was his fourteenth preparation of photosensitive material: being recorded on the first page of his Photographic Memoranda book as "14. (Nitr Sil + Gallic Acid) 1 wash.—(anomalous) N.B." Probably this preparation of nitrate of silver and gallic acid was done in the first week of February 1839.

Talbot might easily have missed paying much attention to Herschel's brief words about gallate of silver in a letter packed with interesting details. But he did not do so, especially when the same chemical was mentioned to him again just one month later; as we can learn from some correspondence Talbot had with J. W. Lubbock. Sir John W. Lubbock (1803–65), Treasurer and Vice-President and of considerable influence in the Royal Society, wrote on 27 March 1839 to discuss with Talbot the mode of action of hypo as a fixer. Talbot replied by return of post on Thursday, 28 March 1839:

I am very much obliged to you for the *Comptes Rendus*† which you sent today, as well as for the preceding one. Biot seems to take a great interest in the *sensitive paper*

I recommend to you to try the sensibility of paper washed first with nitrate of silver, & then with gallic acid – the latter to be pure. I have not tried it yet, but it is [sic] has been mentioned to me both by Herschel & another experimenter, so that I think it must be among the best recipes yet found out.

Herschel told me that the hyposulphite *washed out* the

1. Nat'l Mus. of Phot., Film & TV, Bradford.
2. Humanities Research Center, Univ. of Texas, Austin.
† Probably Bibl. **62–63**.

chloride of silver; but I have certainly found that the hypo preserves the [photogenic] drawing if merely spread over it, and not afterwards washed out We leave town next Tuesday [2 April 1839] for Lacock Abbey. When in the country I hope to find more leisure for experimentation on this subject.[3]

Who amongst the known (or now unknown) experimenters was the "another experimenter" who had mentioned gallic acid to Talbot late in March? Some time before the middle of May 1839 Alfred Smee,[4] ophthalmologist in the City of London who took an active interest in many branches of science, had tried gallic acid amongst many substances unsuccessfully tested for fixing (not sensitizing) photographic paper: in view of the use to which he put gallic acid it is unlikely to have been Smee who spoke or wrote about gallic acid to Talbot just before Easter 1839. Indeed, Talbot's contact was, indirectly, the Rev. Joseph Bancroft Reade, F.R.S (1801–70). He was elected a Fellow of the Royal Society early in 1838 and his attendance at their meetings was at its peak in 1839 and the early 1840s. Reade was obviously at the two meetings of the Society when Talbot's papers were read early in February 1839 and saw Talbot's photogenic drawings on view. On 28 February 1839,[5] he wrote to the secretary of the Royal Society a short account of his first trials and modifications of Talbot's photogenic drawing technique, but it was slight work which quite reasonably was not read at the meetings or published by the Society. No information exists concerning the possible refereeing of his letter of 28 February but with Herschel as the obvious man on hand as a referee it is conceivable that it could easily have led to some contact between Reade and Herschel. But there is little doubt that Reade was at the meeting of the Royal Society on 14 March 1839 when Sir John Herschel's fine paper on photography was read. Herschel's paper was of particular importance and influence because hypo as a fixer was suggested in it. But he also mentioned that he had found some silver salts, other than the hardly-sensitive chloride, were especially responsive to light; they were the carbonate, nitrate and acetate and "in which the acid being more volatile . . . imparts greater sensibility to the paper on which they are applied".[6] When his paper was published only nine days later in *The Athenæum* of 23 March 1839 the particular sensitivity-increasing volatile acids that he had in mind were not specified. Herschel

3. Lubbock correspondence. Royal Society, London.
4. Bibl. **251**.
5. Misc. correspondence. (MC3.15). Royal Society, London.
6. J.F.W. Herschel, *Athenaeum*, 23 March 1839, p. 223.

briefly mentioned at the meeting that he had found ferrocyanate not to be suitable as a fixer, and the important item that did not appear in the printed version was exactly in regard to our own interest in the sensitivity-increasing volatile acids where the verbal aside was added "being of animal or vegetable origin (especially the Gallate and Urate)".[7]

J. B. Reade continued experiments on photography during the rest of March and it may have been as late as Tuesday, 26 March 1839,[8] that he first used (or perhaps was first really successful with) a wash of gallic acid onto paper treated immediately before with silver nitrate. Fifteen years later, when he gave evidence at the calotype patent lawsuit of Talbot *v.* Laroche at the end of 1854, Reade stated he had spoken in 1839 to his acquaintance Andrew Ross about the use of gallic acid. Ross, the optical instrument maker whose shop in 1839 was at 33 Regent Street, London, had soon after mentioned the fact to Fox Talbot. Talbot undoubtedly visited Ross's shop in Regent Street on the 20 and 30 March 1839.[9] It therefore seems most likely that it was on the 30 March, when Talbot purchased a solar microscope/camera and an objective lens, that Ross spoke to him about Reade's remarks concerning gallic acid. If so, on 30 March 1839 Talbot must have also gone up Regent Street into Oxford Street, for on this same day he purchased 1 dram of gallic acid in a bottle, at a cost of 1 shilling and 6 pence, from Alexander Garden's chemist shop at 372 Oxford Street.[10] Talbot travelled down to Lacock, in Wiltshire, on 2 April. Within three days he there carried out a test with the gallic acid recently purchased and entered into his Chemical Notebook:[11] "April 5 Lacock" – "Dilute gallic acid & dilute nit silver mixed turn dark in daylight (I believe Mr Reade discovered this)."

In the 1830s it was widely accepted that an organic combination was required for the light sensitivity of silver nitrate. In a strange way, persons with a knowledge of chemistry in the century *before* the invention of photography would not have been surprised to have learnt the important and detailed role given to gelatin by photographic scientists of the twentieth century in connection with the sensitivity of photographic emulsions: indeed, they would have quite expected it. Before 1839, such researchers and writers as R. Scanlan (1838), W. T. Brande (1830) John Davy (1828), Tom Wedgwood (1802) and W. Lewis (1763) paid attention to the importance of

7. See Bibl. **524**, p. 57–60.
8. See A.T. Gill, *Photographic Journal*, vol. 101 (1961), p. 10–13.
9. Statement of account, 1839. Fox Talbot Museum, Lacock.
10. Talbot accounts, 20 March–6 Dec. 1839. Fox Talbot Museum, Lacock.
11. Notebook, 6 Feb. 1939–25 June 1840. Nat'l Mus. of Phot., Film & TV, Bradford.

organic combination of silver salts for sensitivity to light. In 1839 it can be observed in the writings of many experimenters in photography, including, for example, Alfred Smee, J. B. Reade, Alexander Petzholdt and John Herschel, that the same concept was prominent in their minds.

As can be seen from his Photographic Memoranda book, Herschel tested the photographic properties of gallate of silver for the first time in the last week of January or the first week of February 1839. A few weeks later, when his paper 'On the Art of Photography' was read at the Royal Society on 14 March 1839, he stated he had tried salts of silver "in which the acid being more volatile . . . being of an animal or vegetable origin Of these latter several (especially the Gallate and Urate) are still under trial and present remarkable peculiarities) . . . impart much greater sensibility to the paper'. His important parenthetical statement about the gallate was one of the only two facts mentioned at the meeting which did not appear (presumably because it was "still under trial") in the paper when it was published nine days later. Herschel had, of course, mentioned the use of gallate of silver to Talbot in a letter of 28 February 1839, but it was not until Herschel's work was pursued further and reported again at the Royal Society that any published reference to gallic acid appeared by Herschel. He sent a copy – the printed proofs – of this fine paper of February/March 1840 to Talbot before it was actually published in the *Philosophical Transactions*. But even after this lapse of time, Herschel was not able to explain the effect gallic acid had in combination with silver salts; it was in his own words "somewhat problematic".[12]

Herschel's use of gallic acid in 1839 has long been missed in histories of photography in contrast to J. B. Reade's role in the introduction of gallic acid to Talbot which received considerable attention in the past because of his historiographically influencial appearance in the well-known lawsuit of Talbot *v.* Laroche at the end of 1854. Herschel did not make a witness sufficiently partial to either side of the calotype patent dispute in the early 1850s and for several reasons he was not ready to be involved. But involved he was in Talbot *v.* Henderson: for his published remark in his paper of 1840 was invoked as an early use of gallic acid prior to Talbot's inclusion of this chemical in the calotype patent. It was Robert Hunt, in an affidavit sworn on 22 May 1854 in support of Henderson's side of the case against Talbot, who drew attention to Herschel's published

12. J.F.W. Herschel, *Philosoph. Trans. of the Royal Society*, vol. 130 (1840), p. 1–59.

use of gallic acid. Talbot wanted Herschel to give him considerable support, but Herschel had some doubts. He was asked if he would just give a reply to Hunt's statement, and so on 25 May 1854 (with Talbot almost at his elbow) signed an affidavit that he had not originally used gallic acid "for the purpose of developing a dormant picture, not then being aware that such dormant picture then existed, but only with a view to increase the sensitiveness of the paper".[13]

Talbot experimented again with gallic acid in September 1840. In his Chemical Notebook covering the period from 26 June 1840 to April 1843,[14] the first experimental record of the technique which was later to be called the calotype appears on 20–23 September 1840. It is typical of the speculation that arises with this subject that it can now be seen in Talbot's notebook that the very words that must be gallic acid have been carefully cut away with the relevant page with a sharp blade![15] He sealed the title of a patent (No. 8842) for the calotype on 8 February 1841 and enrolled the detailed specification of the technique on 8 August 1841. At the period the title was sealed he also published general articles saying that he had discovered a new process, but waited until the specification was enrolled in August 1841 before publishing the chemical details of the technique. Talbot always concentrated on publishing and patenting specific techniques without discussion of scientific concepts and he was not, for example, interested in writing textbooks to disseminate ideas for future development.

13. *Notes & Queries*, 8 July 1854, p. 35–6.
14. Nat'l Mus. of Phot., Film & TV, Bradford.
15. Reproduced in R.D. Wood, 'J.B. Reade', *Annals of Science*, vol. 27 (1971), pl. 13.

Secret Writing

Michael Gray

At no point in Talbot's writing does he refer to photography in terms of invention; his references are always towards discovery. This places Talbot in the role of the observer, who reveals not what is new but what has been hitherto hidden or latent. There is insufficient documentation to pinpoint clearly the date at which Talbot began his photochemical experiments but, from close examination of Notebooks M and N,[1] it is clear that he was working on a broad range of subjects from 1833 onwards, including optics, light, astronomy, mathematics, chemistry and philology.

It is now accepted that Talbot's first concrete results were achieved in the late summer of 1835, when he made the earliest-known surviving photographic negative of the Oriel Window at Lacock Abbey. Clearly, this was not a result that was immediately realised but represented the culmination of a considerable body of work prior to this date. There is little surviving documentation from this period that relates directly to his photographic experiments, unlike the seminal period leading up to his work on the calotype between 1839 and 1841. However, it now emerges that, firstly, he came extremely close to making the breakthrough in 1834 and 1835; secondly, that the direction of his researches demonstrates an awareness and active experimentation with the concept of latency; and, thirdly, that the origins of this concept were cross-cultural,

1. Notebooks M, N, & Q. Fox Talbot Museum, Lacock.

This note on Talbot's interest in invisible writing is part of a longer unpublished essay, 'The Concept of Latency'.

stemming from a relationship between chemistry (alchemy), mythology and writing.

Between 1833 and 1836 there are intermittent references in Talbot's notebooks to chemical experiments with secret writing, tests that involve writing with a clear colourless liquid, which when dry is treated by the application of a second also transparent solution. The two chemical preparations interact and as a result form an image determined by the manner of the application of the first solution.

The first references to secret writing appear in the following passage from Notebook Q, dated March 1831:

> letters written with Sulph. Chrome when heated are slightly greenish
>
> sulph Nickel. they become raised white and fused
>
> sulph Iron. Brownish black it requires great heat to develop it.
>
> Common salt & Sulph Copper mixed (tho' both dry and slightly damp) immed/y turn green owing to the form/n of muriate of copper [chloride]
>
> letters written with sulph cobalt turn first purple when heated, then brown, lastly a good black.

Prior to 22 March 1836 (Notebook M, p. 6) Talbot returns to the same area of study, the exploration of the latent image, using the written word as a means of applying the second chemical solution: 'try writing with protonitrate mercury on paper steeped in common salt; and then washing with ammonia to make the writing visible and black'.

Between these two entries, separated by a period of some five years, Talbot made the first of his two major discoveries that were to lay the foundations of photography. It is only now with hindsight, through study of his chemical and mathematical notebooks containing occasional and peripheral references to light and ultimately photography, that we realise how close he came to making the breakthrough that he achieved in the late summer of 1840. He came within a hairsbreadth of discovering the use of ferrous sulphate (protosulphate of iron) as a possible developing agent that was to prove to be more reliable than the gallic acid incorporated in his original patents.

The concept of latency, or the emergence of that which was previously hidden, invariably leads back to two

primary sources, one of which relates to birth, the emergence of the child from the womb; and the other to fire, its ability to transmute or convert elements from one state to another. Fire has long been endowed with magical and mystical characteristics: its appearance is seen as the result of hidden or latent forces that are materialised in the form of heat and light.

Retrospectively, Talbot has been reproached and criticised for not concentrating on photography alone, instead of working as he did on a broad range of disciplines. This is arguably somewhat unjustified as the discovery of photography necessitated the linking and interrelation of several distinct concepts. A vital part of Talbot's internal discourse was formed by his extensive knowledge of literature, linguistics, and mythology, and of Renaissance arts and sciences. After long days of practical experiment and empirical research, with periods when no tangible results or satisfactory conclusions were reached, a mixture of lateral and multi-layered thinking allowed him to project and extemporise his creative ideas, however untenable and impracticable they might have at first appeared.

The Pencil of Nature

Henry Fox Talbot

Introductory Remarks

The little work now presented to the Public is the first attempt to publish a series of plates or pictures wholly executed by the new art of Photogenic Drawing, without any aid whatever from the artist's pencil.

The term "Photography" is now so well known, that an explanation of it is perhaps superfluous; yet, as some persons may still be unacquainted with the art, even by name, its discovery being still of very recent date, a few words may be looked for of general explanation.

It may suffice, then, to say, that the places of this work have been obtained by the mere action of Light upon sensitive paper. They have been formed or depicted by optical and chemical means alone, and without the aid of any one acquainted with the art of drawing. It is needless, therefore, to say that they differ in all respects, and as widely as possible, in their origin, from plates of the ordinary kind, which owe their existence to the united skill of the Artist and the Engraver.

They are impressed by Nature's hand; and what they want as yet of delicacy and finish of execution arises chiefly from our want of sufficient knowledge of her laws. When we have learnt more, by experience, respecting the formation of such pictures, they will doubtless be brought

Bibl. **108:** *The Pencil of Nature.* (London: Longman, Brown, Green & Longmans, June 1844–April 1846).

The complete text is given here. The illustrations were provided by The Fox Talbot Museum, Lacock.

much nearer to perfection; and though we may not be able to conjecture with any certainty what rank they may hereafter attain to as pictorial productions, they will surely find their own sphere of utility, both for completeness of detail and correctness of perspective.

The Author of the present work having been so fortunate as to discover, about ten years ago, the principles and practice of Photogenic Drawing, is desirous that the first specimen of an Art, likely in all probability to be much employed in future, should be published in the country where it was first discovered. And he makes no doubt that his countrymen will deem such an intention sufficiently laudable to induce them to excuse the imperfections necessarily incident to a first attempt to exhibit an Art of so great singularity, which employs processes entirely new, and having no analogy to any thing in use before. That such imperfections will occur in a first essay, must indeed be expected. At present the Art can hardly be said to have advanced beyond its infancy – at any rate, it is yet in a very early stage – and its practice is often impeded by doubts and difficulties, which, with increasing knowledge, will diminish and disappear. Its progress will be more rapid when more minds are devoted to its improvement, and when more of skilful manual assistance is employed in the manipulation of its delicate processes; the paucity of which skilled assistance at the present moment the Author finds one of the chief difficulties in his way.

Brief Historical Sketch of the Invention of the Art

It may be proper to preface these specimens of a new Art by a brief account of the circumstances which preceded and led to the discovery of it. And these were nearly as follows.

One of the first days of the month of October 1833, I was amusing myself on the lovely shores of the Lake of Como, in Italy, taking sketches with Wollaston's Camera Lucida, or rather I should say, attempting to take them: but with the smallest possible amount of success. For when the eye was removed from the prism – in which all looked beautiful – I found that the faithless pencil had only left traces on the paper melancholy to behold.

After various fruitless attempts, I laid aside the instrument and came to the conclusion, that its use required a previous knowledge of drawing, which unfortunately I did not possess.

I then thought of trying again a method which I had tried

many years before. This method was, to take a Camera Obscura, and to throw the image of the objects on a piece of transparent tracing paper laid on a pane of glass in the focus of the instrument. On this paper the objects are distinctly seen, and can be traced on it with a pencil with some degree of accuracy, though not without much time and trouble.

I had tried this simple method during former visits to Italy in 1823 and 1824, but found it in practice somewhat difficult to manage, because the pressure of the hand and pencil upon the paper tends to shake and displace the instrument (insecurely fixed, in all probability, while taking a hasty sketch by a roadside, or out of an inn window); and if the instrument is once deranged, it is most difficult to get it back again, so as to point truly in its former direction.

Beside which, there is another objection, namely, that it baffles the skill and patience of the amateur to trace all the minute details visible on the paper; so that, in fact, he carries away with him little beyond a mere souvenir of the scene – which, however, certainly has its value when looked back to, in long after years.

Such, then, was the method which I proposed to try again, and to endeavour, as before, to trace with my pencil the outlines of the scenery depicted on the paper. And this led me to reflect on the inimitable beauty of the pictures of nature's painting which the glass lens of the Camera throws upon the paper in its focus – fairy pictures, creations of a moment, and destined as rapidly to fade away.

It was during these thoughts that the idea occurred to me how charming it would be if it were possible to cause these natural images to imprint themselves durably, and remain fixed upon the paper!

And why should it not be possible? I asked myself.

The picture, divested of the ideas which accompany it, and considered only in its ultimate nature, is but a succession or variety of stronger lights thrown upon one part of the paper, and of deeper shadows on another. Now Light, where it exists, can exert an action, and, in certain circumstances, does exert one sufficient to cause changes in material bodies. Suppose, then, such an action could be exerted on the paper; and suppose the paper could be visibly changed by it. In that case surely some effect must result having a general resemblance to the cause which produced it: so that the variegated scene of light and shade might leave its image or impression behind, stronger or weaker on different parts of the paper according to the

strength or weakness of the light which had acted there.

Such was the idea that came into my mind. Whether it had ever occurred to me before amid floating philosophic visions, I know not, though I rather think it must have done so, because on this occasion it struck me so forcibly. I was then a wanderer in classic Italy, and, of course, unable to commence an inquiry of so much difficulty: but, lest the thought should again escape me between that time and my return to England, I made a careful note of it in writing, and also of such experiments as I thought would be most likely to realize it, if it were possible.

And since, according to chemical writers, the nitrate of silver is a substance peculiarly sensitive to the action of light, I resolved to make a trial of it, in the first instance, whenever occasion permitted on my return to England.

But although I knew the fact from chemical books, that nitrate of silver was changed or decomposed by Light, still I had never seen the experiment tried, and therefore I had no idea whether the action was a rapid or a slow one; a point, however, of the utmost importance, since, if it were a slow one, my theory might prove but a philosophic dream.

Such were, as nearly as I can now remember, the reflections which led me to the invention of this theory, and which first impelled me to explore a path so deeply hidden among nature's secrets. And the numerous researches which were afterwards made – whatever success may be thought to have attended them – cannot, I think, admit of a comparison with the value of the first and original idea.

In January 1834, I returned to England from my continental tour, and soon afterwards I determined to put my theories and speculations to the test of experiment, and see whether they had any real foundation.

Accordingly I began by procuring a solution of nitrate of silver, and with a brush spread some of it upon a sheet of paper, which was afterwards dried. When this paper was exposed to the sunshine, I was disappointed to find that the effect was very slowly produced in comparison with what I had anticipated.

I then tried the chloride of silver, freshly precipitated and spread upon paper while moist. This was found no better than the other, turning slowly to a darkish violet colour when exposed to the sun.

Instead of taking the chloride already formed, and spreading it upon paper, I then proceeded in the following way. The paper was first washed with a strong solution of

salt, and when this was dry, it was washed again with nitrate of silver. Of course, chloride of silver was thus formed in the paper, but the result of this experiment was almost the same as before, the chloride not being apparently rendered more sensitive by being formed in this way.

Similar experiments were repeated at various times, in hopes of a better result, frequently changing the proportions employed, and sometimes using the nitrate of silver before the salt, &c. &c.

In the course of these experiments, which were often rapidly performed, it sometimes happened that the brush did not pass over the whole of the paper, and of course this produced irregularity in the results. On some occasions certain portions of the paper were observed to blacken in the sunshine much more rapidly than the rest. These more sensitive portions were generally situated near the edges or confines of the part that had been washed over with the brush.

After much consideration as to the cause of this appearance, I conjectured that these bordering portions might have absorbed a lesser quantity of salt, and that, for some reason or other, this had made them more sensitive to the light. This idea was easily put to the test of experiment. A sheet of paper was moistened with a much weaker solution of salt than usual, and when dry, it was washed with nitrate of silver. This paper, when exposed to the sunshine, immediately manifested a far greater degree of sensitiveness than I had witnessed before, the whole of its surface turning black uniformly and rapidly: establishing at once and beyond all question the important fact, that a lesser quantity of salt produced a greater effect. And, as this circumstance was unexpected, it afforded a simple explanation of the cause of why previous inquirers had missed this important result, in their experiments on chloride of silver, namely, because they had always operated with wrong proportions of salt and silver, using plenty of salt in order to produce a perfect chloride, whereas what was required (it was now manifest) was, to have a deficiency of salt, in order to produce an imperfect chloride, or (perhaps it should be called) a *subchloride* of silver.

So far was a free use or abundance of salt from promoting the action of light on the paper, that on the contrary it greatly weakened and almost destroyed it: so much so, that a bath of salt water was used subsequently as

a fixing process to prevent the further action of light upon sensitive paper.

This process, of the formation of a subchloride by the use of a very weak solution of salt, having been discovered in the spring of 1834, no difficulty was found in obtaining distinct and very pleasing images of such things as leaves, lace, and other flat objects of complicated forms and outlines, by exposing them to the light of the sun.

The paper being well dried, the leaves, &c. were spread upon it, and covered with a glass pressed down tightly, and then placed in the sunshine; and when the paper grew dark, the whole was carried into the shade, and the objects being removed from off the paper, were found to have left their images very perfectly and beautifully impressed or delineated upon it.

But when the sensitive paper was placed in the focus of a Camera Obscura and directed to any object, as a building for instance, during a moderate space of time, as an hour or two, the effect produced upon the paper was not strong enough to exhibit such a satisfactory picture of the building as had been hoped for. The outline of the roof and of the chimneys, &c. against the sky was marked enough; but the details of the architecture were feeble, and the parts in shade were left either blank or nearly so. The sensitiveness of the paper to light, considerable as it seemed in some respects, was therefore, as yet, evidently insufficient for the purpose of obtaining pictures with the Camera Obscura; and the course of experiments had to be again renewed in hopes of attaining to some more important result.

The next interval of sufficient leisure which I found for the prosecution of this inquiry, was during a residence at Geneva in the autumn of 1834. The experiments of the previous spring were then repeated and varied in many ways; and having been struck with a remark of Sir H. Davy's which I had casually met with – that the *iodide* of silver was more sensitive to light than the *chloride*, I resolved to make trial of the iodide. Great was my surprise on making the experiment to find just the contrary of the fact alleged, and to see that the iodide was not only less sensitive than the chloride, but that it was not sensitive at all to light; indeed that it was absolutely insensible to the strongest sunshine: retaining its original tint (a pale straw colour) for any length of time unaltered in the sun. This fact showed me how little dependance was to be placed on the statements of chemical writers in regard to this particular subject, and how necessary it was to trust to

nothing but actual experiment: for although there could be no doubt that Davy had observed what he described under certain circumstances – yet it was clear also, that what he had observed was some exception to the rule, and not the rule itself. In fact, further inquiry showed me that Davy must have observed a sort of subiodide in which the iodine was deficient as compared with the silver: for, as in the case of the chloride and subchloride the former is much less sensitive, so between the iodide and subiodide there is a similar contrast, but it is a much more marked and complete one.

However, the fact now discovered, proved of immediate utility; for, the iodide of silver being found to be insensible to light, and the chloride being easily converted into the iodide by immersion in iodide of potassium, it followed that a picture made with the chloride could be *fixed* by dipping it into a bath of the alkaline iodide.

This process of fixation was a simple one, and it was sometimes very successful. The disadvantages to which it was liable did not manifest themselves until a later period, and arose from a new and unexpected cause, namely, that when a picture is so treated, although it is permanently secured against the *darkening* effect of the solar rays, yet it is exposed to a contrary or *whitening* effect from them; so that after the lapse of some days the dark parts of the picture begin to fade, and gradually the whole picture becomes obliterated, and is reduced to the appearance of a uniform pale yellow sheet of paper. A good many pictures, no doubt, escape this fate, but as they all seem liable to it, the fixing process by iodine must be considered as not sufficiently certain to be retained in use as a photographic process, except when employed with several careful precautions which it would be too long to speak of in this place.

During the brilliant summer of 1835 in England I made new attempts to obtain pictures of buildings with the Camera Obscura; and having devised a process which gave additional sensibility to the paper, viz. by giving it repeated alternate washes of salt and silver, and using it in a moist state, I succeeded in reducing the time necessary for obtaining an image with the Camera Obscura on a bright day to ten minutes. But these pictures, though very pretty, were very small, being quite miniatures. Some were obtained of a larger size, but they required much patience, nor did they seem so perfect as the smaller ones, for it was difficult to keep the instrument steady for a great length of

time pointing at the same object, and the paper being used moist was often acted on irregularly.

During the three following years not much was added to previous knowledge. Want of sufficient leisure for experiments was a great obstacle and hindrance, and I almost resolved to publish some account of the Art in the imperfect state in which it then was.

However curious the results which I had met with, yet I felt convinced that much more important things must remain behind, and that the clue was still wanting to this labyrinth of facts. But as there seemed no immediate prospect of further success, I thought of drawing up a short account of what had been done, and presenting it to the Royal Society.

However, at the close of the year 1838, I discovered a remarkable fact of quite a new kind. Having spread a piece of silver leaf on a pane of glass, and thrown a particle of iodine upon it, I observed that coloured rings formed themselves around the central particle, especially if the glass was slightly warmed. The coloured rings I had no difficulty in attributing to the formation of infinitely thin layers or strata of iodide of silver; but a most unexpected phenomenon occurred when the silver plate was brought in the light by placing it near a window. For then the coloured rings shortly began to change their colours, and assumed other and quite unusual tints, such as are never seen in the "*colours of thin plates*". For instance, the part of the silver plate which at first shone with a pale yellow colour, was changed to a dark olive green when brought into the daylight. This change was not very rapid: it was much less rapid than the changes of some of the sensitive papers which I had been in the habit of employing, and therefore, after having admired the beauty of this new phenomenon, I laid the specimens by, for a time, to see whether they would preserve the same appearance, or would undergo any further alteration.

Such was the progress which I had made in this inquiry at the close of the year 1838, when an event occurred in the scientific world, which in some degree frustrated the hope with which I had pursued, during nearly five years, this long and complicated, but interesting series of experiments – the hope, namely, of being the first to announce to the world the existence of the New Art – which has been since named Photography.

I allude, of course, to the publication in the month of January 1839, of the great discovery of M. Daguerre, of the

photographic process which he has called the Daguerreo-
type. I need not speak of the sensation created in all parts
of the world by the first annoncement of this splendid
discovery, or rather, of the fact of its having been made
(for the actual method made use of was kept secret for
many months longer). This great and sudden celebrity was
due to two causes: first, to the beauty of the discovery
itself: secondly, to the zeal and enthusiasm of Arago,
whose eloquence, animated by private friendship, delighted
in extolling the inventor of this new art, sometimes to the
assembled science of the French Academy, at other times
to the less scientific judgement, but not less eager
patriotism, of the Chamber of Deputies.

But, having brought this brief notice of the early days of
the Photographic Art to the important epoch of the
announcement of the Daguerreotype, I shall defer the
subsequent history of the Art to a future number of this
work.

Some time previously to the period of which I have now
been speaking, I met with an account of some researches
on the action of Light, by Wedgwood and Sir H. Davy,
which, until then, I had never heard of. Their short memoir
on this subject was published in 1802 in the first volume of
the Journal of the Royal Institution. It is curious and
interesting, and certainly establishes their claim as the first
inventors of the Photographic Art, though the actual
progress they made in it was small. They succeeded,
indeed, in obtaining impressions from solar light of flat
objects laid upon a sheet of prepared paper, but they say
that they found it impossible to fix or preserve those
pictures: all their numerous attempts to do so having failed.

And with respect to the principal branch of the Art, viz.
the taking pictures of distant objects with a Camera
Obscura, they attempted to do so, but obtained no result at
all, however long the experiment lasted. While therefore
due praise should be awarded to them for making the
attempt, they have no claim to the actual discovery of any
process by which such a picture can really be obtained.

It is remarkable that the failure in this respect appeared
so complete, that the subject was soon after abandoned
both by themselves and others, and as far as we can find, it
was never resumed again. The thing fell into entire oblivion
for more than thirty years: and therefore, though the

Daguerreotype as not so entirely new a conception as M. Daguerre and the French Institute imagined, and though my own labours had been still more directly anticipated by Wedgwood, yet the improvements were so great in all respects, that I think the year 1839 may fairly be considered as the real date of the birth of the Photographic Art, that is to say, its first public disclosure to the world.

There is a point to which I wish to advert, which respects the execution of the following specimens. As far as respects the design, the copies are almost facsimiles of each other, but there is some variety in the tint which they present. This arises from a twofold cause. In the first place, each picture is separately formed by the light of the sun, and in our climate the strength of the sun's rays is exceedingly variable even in serene weather. When clouds intervene, a longer time is of course allowed for the impression of a picture, but it is not possible to reduce this to a matter of strict and accurate calculation.

The other cause is the variable quality of the paper employed, even when furnished by the same manufacturers – some differences in the fabrication and in the *sizing* of the paper, known only to themselves, and perhaps secrets of the trade, have a considerable influence on the tone of colour which the picture ultimately assumes.

These tints, however, might undoubtedly be brought nearer to uniformity, if any great advantage appeared likely to result: but, several persons of taste having been consulted on the point, viz. which tint on the whole deserved a preference, it was found that their opinions offered nothing approaching to unanimity, and therefore, as the process presents us spontaneously with a variety of shades of colour, it was thought best to admit whichever appeared pleasing to the eye, without aiming at an uniformity which is hardly attainable. And with these brief observations I commend the pictures to the indulgence of the Gentle Reader.

Plate I

Part of Queen's College, Oxford

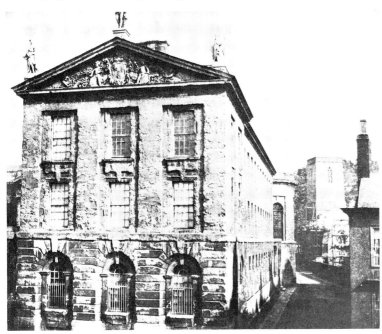

This building presents on its surface the most evident marks of the injuries of time and weather, in the abraded state of the stone, which probably was of a bad quality originally.

The view is taken from the other side of the High Street – looking North. The time is morning.

In the distance is seen at the end of a narrow street the Church of St. Peter's in the East, said to be the most ancient church in Oxford, and built during the Saxon era. This street, shortly after passing the church, turns to the left, and leads to New College.

Plate II

View of the Boulevards at Paris

This view was taken from one of the upper windows of the Hotel de Douvres, situated at the corner of the Rue de la Paix.

The spectator is looking to the North-east. The time is the afternoon. The sun is just quitting the range of buildings adorned with columns: its façade is already in the shade, but a single shutter standing open projects far enough forward to catch a gleam of sunshine. The weather is hot and dusty, and they have just been watering the

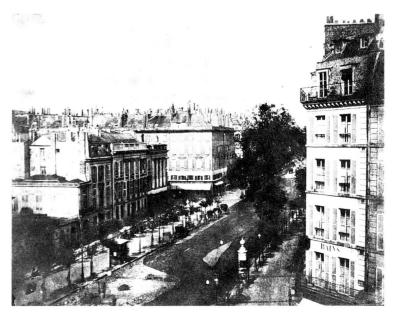

road, which has produced two broad bands of shade upon it, which unite in the foreground, because, the road being partially under repair (as is seen from the two wheel-barrows, &c. &c.), the watering machines have been compelled to cross to the other side.

By the roadside a row of *cittadines* and cabriolets are waiting, and a single carriage stands in the distance a long way to the right.

A whole forest of chimneys borders the horizon: for, the instrument chronicles whatever it sees, and certainly would delineate a chimney-pot or a chimney-sweeper with the same impartiality as it would the Apollo of Belvedere.

The view is taken from a considerable height, as appears easily by observing the house on the right hand; the eye being necessarily on a level with that part of the building on which the horizontal lines or courses of stone appear parallel to the margin of the picture.

Plate III

Articles of China

From the specimen here given it is sufficiently manifest, that the whole cabinet of a Virtuoso and collector of old China might be depicted on paper in little more time than it would take him to make a written inventory describing it in the usual way. The more strange and fantastic the forms of his old teapots, the more advantage in having their pictures given instead of their descriptions.

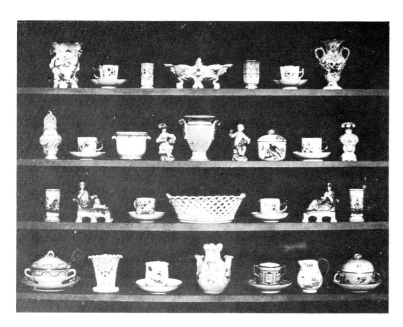

And should a thief afterwards purloin the treasures – if the mute testimony of the picture were to be produced against him in court – it would certainly be evidence of a novel kind; but what the judge and jury might say to it, is a matter which I leave to the speculation of those who possess legal acumen.

The articles represented on this plate are numerous: but, however numerous the objects – however complicated the arrangement – the Camera depicts them all at once. It may be said to make a picture of whatever *it sees*. The object glass is the *eye* of the instrument – the sensitive paper may be compared to the *retina*. And, the eye should not have too large a *pupil*; that is to say, the glass should be diminished by placing a screen or diaphragm before it, having a small circular hole, through which alone the rays of light may pass. When the eye of the instrument is made to look at the objects through this contracted aperture, the resulting image is much more sharp and correct. But it takes a longer time to impress itself upon the paper, because, in proportion as the aperture is contracted, fewer rays enter the instrument from the surrounding objects, and consequently fewer fall upon each part of the paper.

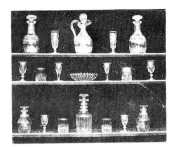

Plate IV

Articles of Glass

The photogenic images of glass articles impress the sensitive paper with a very peculiar touch, which is quite different from that of the China in Plate III. And it may be remarked that white china and glass do not succeed well when represented together, because the picture of the china, from its superior brightness, is completed before that of the glass is well begun. But coloured china may be introduced along with glass in the same picture, provided the colour is not a pure blue: since blue objects affect the sensitive paper almost as rapidly as white ones do. On the contrary, green rays act very feebly – an inconvenient circumstance, whenever green trees are to be represented in the same picture with buildings of a light hue, or with any other light coloured objects.

Plate V

Bust of Patroclus

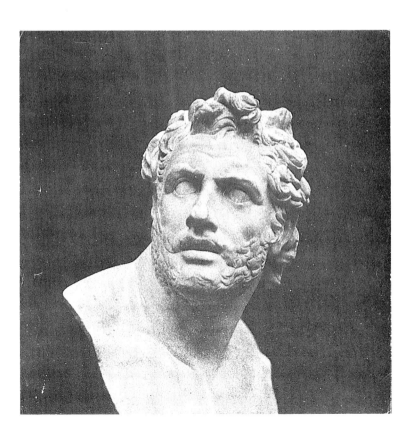

Statues, busts, and other specimens of sculpture, are generally well represented by the Photographic Art; and also very rapidly, in consequence of their whiteness.

These delineations are susceptible of an almost unlimited variety: since in the first place, a statue may be placed in any position with regard to the sun, either directly opposite to it, or at any angle: the directness or obliquity of the illumination causing of course an immense difference in the effect. And when a choice has been made of the direction in which the sun's rays shall fall, the statue may be then turned round on its pedestal, which produces a second set of variations no less considerable than the first. And when to this is added the change of size which is produced in the image of bringing the Camera Obscura nearer to the statue or removing it further off, it becomes evident how very great a number of different effects may be obtained from a single specimen of sculpture.

With regard to many statues, however, a better effect is obtained by delineating them in cloudy weather than in sunshine. For, the sunshine causes such strong shadows as sometimes to confuse the subject. To prevent this, it is a good plan to hold a white cloth on one side of the statue at a little distance to reflect back the sun's rays and cause a faint illumination of the parts which would otherwise be lost in shadow.

Plate VI

The Open Door

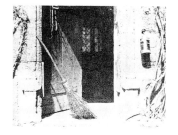

The chief object of the present work is to place on record some of the early beginnings of a new art, before the period, which we trust is approaching, of its being brought to maturity by the aid of British talent.

This is one of the trifling efforts of its infancy, which some partial friends have been kind enough to commend.

We have sufficient authority in the Dutch school of art, for taking as subjects of representation scenes of daily and familiar occurrence. A painter's eye will often be arrested where ordinary people see nothing remarkable. A casual gleam of sunshine, or a shadow thrown across his path, a time-withered oak, or a moss-covered stone may awaken a train of thoughts and feelings, and picturesque imaginings.

Plate VII

Leaf of a Plant

Hitherto we have presented to the reader the representations of distant objects, obtained by the use of a Camera Obscura. But the present plate represents an object of its natural size. And this is effected by quite a different and much simpler process, as follows.

A leaf of a plant, or any similar object which is thin and delicate, is laid flat upon a sheet of prepared paper which is moderately sensitive. It is then covered with a glass, which is pressed down tight upon it by means of screws.

This done, it is placed in the sunshine for a few minutes, until the exposed parts of the paper have turned dark brown or nearly black. It is then removed into a shady place, and when the leaf is taken up, it is found to have left its impression or picture on the paper. This image is of a pale brown tint if the leaf is semi-transparent, or it is quite white if the leaf is opaque.

The leaves of plants thus represented in white upon a dark background, make very pleasing pictures, and I shall probably introduce a few specimens of them in the sequel of this work: but the present plate shews one pictured in the contrary manner, viz. dark upon a white ground: or, speaking in the language of photography, it is a *positive* and not a *negative* image of it. The change is accomplished by simply repeating the first process. For, that process, as above described, gives a white image on a darkened sheet of paper: this sheet is then taken and washed with a fixing liquid to destroy the sensibility of the paper and fix the image on it.

This done, the paper is dried, and then it is laid upon a second sheet of sensitive paper, being pressed into close contact with it, and placed in the sunshine: this second process is evidently only a repetition of the first. When finished, the second paper is found to have received an image of a contrary kind to the first; the ground being white, and the image upon it dark.

Plate VIII

A Scene in a Library

Among the many novel ideas which the discovery of Photography has suggested, is the following rather curious experiment or speculation. I have never tried it, indeed,

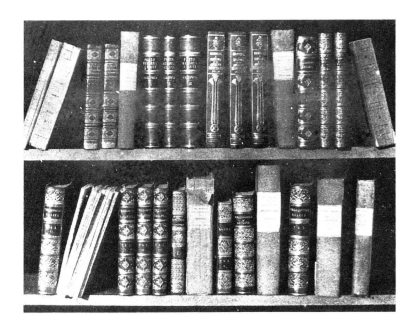

nor am I aware that any one else has either tried or proposed it, yet I think it is one which, if properly managed, must inevitably succeed.

When a ray of solar light is refracted by a prism and thrown upon a screen, it forms there the very beautiful coloured band known by the name of the solar spectrum.

Experimenters have found that if this spectrum is thrown upon a sheet of sensitive paper, the violet end of it produces the principal effect: and, what is truly remarkable, a similar effect is produced by certain *invisible rays* which lie beyond the violet, and beyond the limits of the spectrum, and whose existence is only revealed to us by this action which they exert.

Now, I would propose to separate these invisible rays from the rest, by suffering them to pass into an adjoining apartment through an aperture in a wall or screen of partition. This apartment would thus become filled (we must not call it *illuminated*) with invisible rays, which might be scattered in all directions by a convex lens placed behind the aperture. If there were a number of persons in the room, no one would see the other: and yet nevertheless if a *camera* were so placed as to point in the direction in which any one were standing, it would take his portrait, and reveal his actions.

For, to use a metaphor we have already employed, the eye of the camera would see plainly where the human eye would find nothing but darkness.

Alas! that this speculation is somewhat too refined to be

introduced with effect into a modern novel or romance; for what a *dénouement* we should have, if we could suppose the secrets of the darkened chamber to be revealed by the testimony of the imprinted paper.

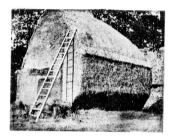

Plate IX

Fac-simile of an Old Printed Page

Taken from a black-letter volume in the Author's library, containing the statutes of Richard the Second, written in Norman French.

To the Antiquarian this application of the photographic art seems destined to be of great advantage.

Copied of the size of the original, by the method of superposition.

Plate X

The Haystack

One advantage of the discovery of the Photographic Art will be, that it will enable us to introduce into our pictures a multitude of minute details which add to the truth and reality of the representation, but which no artist would take the trouble to copy faithfully from nature.

Contenting himself with a general effect, he would probably deem it beneath his genius to copy every accident of light and shade; nor could he do so indeed, without a disproportionate expenditure of time and trouble, which might be otherwise much better employed.

Nevertheless, it is well to have the means at our disposal of introducing these minutiæ without any additional trouble, for they will sometimes be found to give an air of variety beyond expectation to the scene represented.

Plate XI

Copy of a Lithographic Print

We have here the copy of a Parisian caricature, which is probably well known to many of my readers.

All kinds of engravings may be copied by photographic means; and this application of the art is a very important one, not only as producing in general nearly fac-simile copies, but because it enables us at pleasure to alter the

scale, and to make the copies as much larger or smaller than the originals as we may desire.

The old method of altering the size of a design by means of a pantagraph or some similar contrivance, was very tedious, and must have required the instrument to be well constructed and kept in very excellent order: whereas the photographic copies become larger or smaller, merely by placing the originals nearer to or farther from the Camera.

The present plate is an example of this useful application of the art, being a copy greatly diminished in size, yet preserving all the proportions of the original.

Plate XII

The Bridge of Orleans

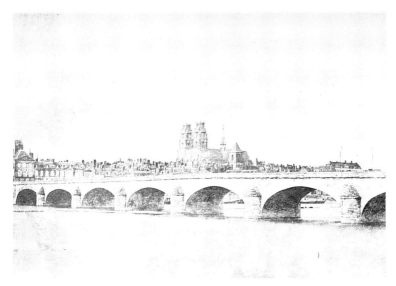

This view is taken from the southern bank of the river Loire, which passes Orleans in a noble stream.

A city rich in historical recollections, but at present chiefly interesting from its fine Cathedral; of which I hope to give a representation in a subsequent plate of this work.

Plate XIII

Queen's College, Oxford. Entrance Gateway

In the first place of this work I have represented an angle of this building. Here we have a view of the Gateway and central portion of the College. It was taken from a window on the opposite side of the High Street.

In examining photographic pictures of a certain degree of perfection, the use of a large lens is recommended, such as elderly persons frequently employ in reading. This magnifies the objects two or three times, and often discloses a multitude of minute details, which were previously unobserved and unsuspected. It frequently happens, moreover – and this is one of the charms of photography – that the operator himself discovers on examination, perhaps long afterwards, that he has depicted many things he had no notion of at the time. Sometimes inscriptions and dates are found upon the buildings, or printed placards most irrelevant, are discovered upon their walls: sometimes a distant dial-plate is seen, and upon it – unconsciously recorded – the hour of the day at which the view was taken.

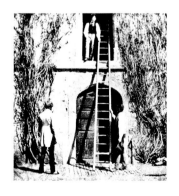

Plate XIV

The Ladder

Portraits of living persons and groups of figures form one of the most attractive subjects of photography, and I hope to present some of them to the Reader in the progress of the present work.

When the sun shines, small portraits can be obtained by my process in one or two seconds, but large portraits require a somewhat longer time. When the weather is dark

and cloudy, a corresponding allowance is necessary, and a greater demand is made upon the patience of the sitter. Groups of figures take no longer time to obtain than single figures would require, since the Camera depicts them all at once, however numerous they may be: but at present we cannot well succeed in this branch of the art without some previous concert and arrangement. If we proceed to the City, and attempt to take a picture of the moving multitude, we fail, for in a small fraction of a second they change their positions so much, as to destroy the distinctness of the representation. But when a group of persons has been artistically arranged, and trained by a little practice to maintain an absolute immobility for a few seconds of time, very delightful pictures are easily obtained. I have observed that family groups are especial favourites: and the same five or six individuals may be combined in so many varying attitudes, as to give much interest and a great air of reality to a series of such pictures. What would not be the value to our English Nobility of such a record of their ancestors who lived a century ago? On how small a portion of their family picture galleries can they really rely with confidence!

Plate XV

Lacock Abbey in Wiltshire

One of a series of views representing the Author's country seat in Wiltshire. It is a religious structure of great antiquity, erected early in the thirteenth century, many parts of which are still remaining in excellent preservation.

This plate gives a distinct view of the Abbey, which is seen reflected in the waters of the river Avon. The spectator is looking to the North West. The tower which occupies the South-eastern corner of the building is believed to be of Queen Elizabeth's time, but the lower portion of it is much older, and coeval with the first foundation of the abbey.

In my first account of "The Art of Photogenic Drawing," read to the Royal Society in January, 1839, I mentioned this building as being the first "that was ever yet known to have drawn its own picture."

It was in the summer of 1835 that these curious self-representations were first obtained. Their size was very small: indeed, they were but miniatures, though very distinct: and the shortest time of making them was nine or ten minutes.

Plate XVI

Cloisters of Lacock Abbey

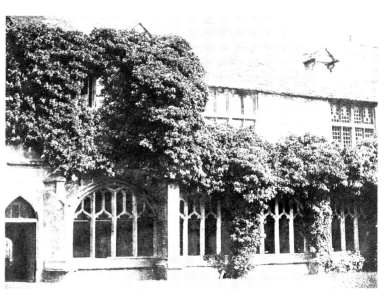

The Abbey was founded by Ela, countess of Salisbury, widow of William Longspee, son of King Henry II. and Fair Rosamond.

This event took place in the year of our Lord 1229, in the reign of Henry III. She was elected to be the first abbess, and ruled for many years with prudence and piety. She lies buried in the cloisters, and this inscription is read upon her tomb:

Infrà sunt defossa Elæ venerabilis ossa,
Quæ dedit has sedes sacras monialibus ædes,
Abbatissa quidem quæ sanctè vixit ibidem,
Et comitissa Sarum virtutum plena bonarum:

The cloisters, however, in their present state, are believed to be of the time of Henry VI. They range round three sides of a quadrangle, and are the most perfect which remain in any private residence in England. By moonlight, especially, their effect is very picturesque and solemn.

Here, I presume, the holy sisterhood often paced in silent meditation; though, in truth, they have left but few records to posterity to tell us now they lived and died. The "liber de Lacock" is supposed to have perished in the fire of the Cottonian library. What it contained I know not – perhaps their private memoirs. Some things, however, have been preserved by tradition, or discovered by the zeal of antiquaries, and from these materials the poet Bowles has composed an interesting work, the History of Lacock Abbey, which he published in 1835.

Plate XVII

Bust of Patroclus

Another view of the bust which is figured in the fifth plate of this work.

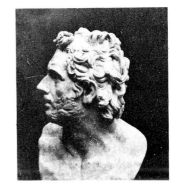

———————

It has often been said, and has grown into a proverb, that there is no royal road to learning of any kind. But the proverb is fallacious: for there is, assuredly, a royal road to *Drawing*; and one of the days, when more known and better explored, it will probably be much frequented. Already sundry *amateurs* have laid down the pencil and armed themselves with chemical solutions and with *cameræ*

obscuræ. Those amateurs especially, and they are not few, who find the rules of *perspective* difficult to learn and to apply – and who moreover have the misfortune to be lazy – prefer to use a method which dispenses with all that trouble. And even accomplished artists now avail themselves of an invention which delineates in a few moments the almost endless details of Gothic architecture which a whole day would hardly suffice to draw correctly in the ordinary manner.

Plate XVIII

Gate of Christchurch

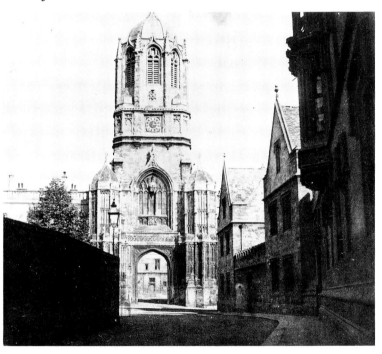

The principal gate of Christchurch College in the University of Oxford.

On the right of the picture are seen the buildings of Pembroke College in shade.

———————

Those who have visited Oxford and Cambridge in vacation time in the summer must have been struck with the silence and tranquillity which pervade those venerable abodes of learning.

Those ancient courts and quadrangles and cloisters look

so beautiful so tranquil and so solemn at the close of a summer's evening, that the spectator almost thinks he gazes upon a city of former ages, deserted, but not in ruins: abandoned by man, but spared by Time. No other cities in Great Britain awake feelings at all similar. In other towns you hear at all times the busy hum of passing crowds, intent on traffic or on pleasure – but Oxford in the summer season seems the dwelling of the Genius of Repose.

Plate XIX

The Tower of Lacock Abbey

The upper part of the tower is believed to be of Queen Elizabeth's time, but the lower part is probably coeval with the first foundation of the abbey, in the reign of Henry III.

The tower contains three apartments, one in each story. In the central one, which is used as a muniment room, there is preserved an invaluable curiosity, an original copy of the Magna Charta of King Henry III. It appears that a copy of this Great Charter was sent to the sheriffs of all the counties in England. The illustrious Ela, Countess of Salisbury, was at that time sheriff of Wiltshire (at least so tradition confidently avers), and this was the copy transmitted to her, and carefully preserved ever since her days in the abbey which she founded about four years after the date of this Great Charter.

Of the Magna Charta of King John several copies are still

extant; but only two copies are known to exist of the Charter of his successor Henry III, which bears date only ten years after that of Runnymede. One of these copies, which is preserved in the north of England, is defaced and wholly illegible; but the copy preserved at Lacock Abbey is perfectly clear and legible throughout, and has a seal of green wax appended to it, inclosed in a small bag of coloured silk, which six centuries have faded.

The Lacock copy is therefore the only authority from which the text of this Great Charter can be correctly known; and from this copy it was printed by Blackstone, as he himself informs us.

From the top of the tower there is an extensive view, especially towards the South, where the eye ranges as far as Alfred's Tower, in the park of Stour-head, about twenty-three miles distant.

From the parapet wall of this building, three centuries ago, Olive Sherington, the heiress of Lacock, threw herself into the arms of her lover, a gallant gentleman of Worcestershire, John Talbot, a kinsman of the Earl of Shrewsbury. He was felled to the earth by the blow, and for a time lay lifeless, while the lady only wounded or broke her finger. Upon this, Sir Henry Sherington, her father, relented, and shortly after consented to their marriage, giving as a reason *"the step which his daughter had taken."*

Unwritten tradition in many families has preserved ancient stories which border on the marvellous, and it may have embellished the tale of this lover's leap by an incident belonging to another age. For I doubt the story of the broken finger, or at least that Olive was its rightful owner. Who can tell what tragic scenes may not have passed within these walls during the thirteenth and fourteenth centuries? The spectre of a nun with a bleeding finger long haunted the precincts of the abbey, and has been seen by many in former times, though I believe that her unquiet spirit is at length at rest. And I think the tale of Olive has borrowed this incident from that of a frail sister of earlier days.

Plate XX

Lace

As this is the first example of a *negative* image that has been introduced into this work, it may be necessary to explain, in a few words, what is meant by that expression,

and wherein the difference consists.

The ordinary effect of light upon white sensitive paper is to *blacken* it. If therefore any object, as a leaf for instance, be laid upon the paper, this, by intercepting the action of the light, preserves the whiteness of the paper beneath it, and accordingly when it is removed there appears the form or shadow of the leaf marked out in white upon the blackened paper; and since shadows are usually dark, and this is the reverse, it is called in the language of photography a *negative* image.

This is exemplified by the lace depicted in this plate; each copy of it being an original or negative image: that is to say, directly taken from the lace itself. Now, if instead of copying the lace we were to copy one of these negative images of it, the result would be a *positive* image of the lace: that is to say, the lace would be represented *black* upon a *white* ground. But in this secondary or positive image the representation of the small delicate threads which compose the lace would not be quite so sharp and distinct, owing to its not being taken directly from the original. In taking views of buildings, statues, portraits, &c. it is necessary to obtain a *positive* image, because the negative images of such objects are hardly intelligible, substituting light for shade, and *vice versâ*. But in copying such things as lace or leaves of plants, a negative image is perfectly allowable, black lace being as familiar to the eye as white lace, and the object being only to exhibit the pattern with accuracy.

In the commencement of the photographic art, it was a matter of great difficulty to obtain good *positive* images, because the original or negative pictures, when exposed to the sunshine, speedily grew opaque in their interior, and consequently would not yield any positive copies, or only a very few of them. But, happily, this difficulty has been long since surmounted, and the negative or original pictures now always remain transparent during the process of copying them.

Plate XXI

The Martyrs' Monument

Oxford has at length, after the lapse of three centuries, raised a worthy monument to her martyred bishops, who died for the Protestant cause in Queen Mary's reign.

And we have endeavoured in this plate to represent it

worthily. How far we have succeeded must be left to the judgment of the gentle Reader.

The statue seen in the picture is that of Bishop Latimer.

Plate XXII

Westminster Abbey

The stately edifices of the British Metropolis too frequently assume from the influence of our smoky atmosphere such a swarthy hue as wholly to obliterate the natural appearance of the stone of which they are constructed. This sooty covering destroys all harmony of colour, and leaves only the grandeur of form and proportions.

This picture of Westminster Abbey is an instance of it; the façade of the building being strongly and somewhat capriciously darkened by the atmospheric influence.

Plate XXIII

Hagar in the Desert

This Plate is intended to show another important application of the photographic art. Fac-similes can be made from original sketches of the old masters, and thus they may be preserved from loss, and multiplied to any extent.

This sketch of Hagar, by Francesco Mola, has been selected as a specimen. It is taken from a fac-simile executed at Munich. The photographic copying process here offers no difficulty, being done of the natural size, by the method of superposition.

Plate XXIV

A Fruit Piece

The number of copies which can be taken from a single original photographic picture, appears to be almost unlimited, provided that every portion of iodine has been removed from the picture before the copies are made. For if any of it is left, the picture will not bear repeated copying, but gradually fades away. This arises from the chemical fact, that solar light and a minute portion of iodine, acting together (though neither of them separately), are able to decompose the oxide of silver, and to form a colourless iodide of the metal. But supposing this accident

to have been guarded against, a very great number of copies can be obtained in succession, so long as great care is taken of the original picture. But being only on paper, it is exposed to various accidents; and should it be casually torn or defaced, of course no more copies can be made. A mischance of this kind having occurred to two plates in our earliest number after many copies had been taken from them, it became necessary to replace them by others; and accordingly the Camera was once more directed to the original objects themselves, and new photographic pictures obtained from them, as a source of supply for future copies. But the circumstances of light and shade and time of day, &c. not altogether corresponding to what they were on a former occasion, a slightly different but not a worse result attended the experiment. From these remarks, however, the difference which exists will be easily accounted for.

Notes on the Photographs in
The Pencil of Nature

Larry J. Schaaf

In the following comments, the plates of the *Pencil* are viewed as much as possible through the eyes of Talbot and his peers. Contemporary reviews, particularly those from the *Art-Union*, the *Athenæum*, and the *Literary Gazette* are utilized, as are comments from Talbot's family and friends.

Dates for negatives refer to the first documented evidence that has been located; many were likely taken earlier. With the exception of Plate XXII, *Westminster Abbey* (which was taken by Nicolaas Henneman), all the negatives are assumed to be by Talbot. Henneman frequently accompanied Talbot and his influence may be suspected in other plates. It is also likely that the advice of Talbot's family and associates held sway on some. All prints were produced by Henneman and his assistants at the Reading Establishment.

I. Part of Queen's College, Oxford

Negative: Calotype, 4 September 1843
Published: Part I, 24 June 1844

Truncating the buildings and celebrating the play of light, this dramatic view of Queen's Lane is boldly photographic

Abridged without illustrations from Bibl. **596**: Larry J. Schaaf. 'Remarks on the Nature of the Plates', p. 45–64 from *Introductory Volume* in *H. Fox Talbot's Pencil of Nature, Anniversary Facsimile*. (New York: Hans P. Kraus, Jr., Inc., 1989). © Larry J. Schaaf.

In these notes, the reactions of public reviewers are given to the six parts of the book as they were issued. The Talbot family letters cited are held in the Fox Talbot Museum, Lacock.

in its composition and effect. The negative resulted from Talbot and Henneman's highly productive trip to Oxford in "exceedingly fine" weather in 1843. Talbot found "the number of picturesque points of view" in Oxford to be "almost inexhaustible" and his wife Constance was delighted that "the views pleased you so much."

Talbot placed his camera in a room above the Angel Inn, one of the numerous coaching inns that were declining rapidly with the advent of the railways. . . . As Talbot's uncle, William Fox-Strangways, 4th Earl of Ilchester, exclaimed when he first saw photogenic drawings: "I wish you could contrive to mend Nature's perspective – we draw objects standing up & she draws them lying down which requires a correction of the eye or mind in looking at the drawing."

II. *View of the Boulevards at Paris*

Negative: Calotype, May 1843
Published: Part I, 24 June 1844

Talbot and Henneman travelled to France in 1843 in an attempt to sell the patent rights for the Calotype. Talbot wrote his mother, Lady Elisabeth, that he chose his hotel room "on account of the view. My sitting room is circular." It is certain that Talbot was familiar with Daguerre's views of Paris, and this direct counter from the inventor of photography on paper invites comparison with the silvered plates. While both excelled at depicting chimney-pots, neither did justice to the activity of the street.

III. *Articles of China*

Negative: Calotype, prior to January 1844
Published: Part I, 24 June 1844
Originally titled: "Articles of China with a Dark Background"

Talbot saw the *Pencil* not so much as a technical manual but rather as a vehicle for exploring the bounds of the new art. That being said, his text was sprinkled with technical explanations which (however obvious they may appear to a reader today) served the valuable function of introducing a radically new medium to a naive audience.

Talbot ordered copies of this image and a similar one with two shelves. He soon complained that Henneman had accidentally printed many copies of this nearly-symmetrical arrangement backwards (none of these appear to have been issued with the *Pencil*).[1]

1. Undated memo. in Talbot's hand, early 1844.

IV. Articles of Glass

Negative: Calotype, prior to June 1844
Published: Part I, 24 June 1844
Originally titled: "Articles of Glass with a Dark Background"

Even though Talbot wrote here of the complications of exposure it was the fine detail of this plate which most strongly struck the critics. *The Spectator* was impressed with the representation of "some articles of cut glass, exhibiting with matchless truth the peculiar quality of the lights on transparent substances"[2] The *Literary Gazette* found "the reflected lights being the most remarkable portion of the spectacle."[3]

V. Bust of Patroclus

Negative: Calotype, 9 August 1842 (dated in the negative)
Published: Part I, 24 June 1844

Patroclus, the noble and hapless defender of Achilles, reigns unchallenged as Talbot's favorite sitter. Through hundreds of trials this patient and reflective figure gave the inventor the opportunity to study the effects of light on his sensitive paper. The *Literary Gazette* found the "bust of Patroclus, really sublime in style and effect. Photography is admirably adapted for sculpture; and a noble gallery of all that is great in that art might readily be produced in such splendid imitations as that now before us. Mr. Talbot's instructions as to the best means for taking these 'likenesses' are of high practical value."[4]

VI. The Open Door

Negative: Calotype, April 1844
Published: Part 2, 29 January 1845

Presented under several names, this image is perhaps the most widely admired one published in the *Pencil of Nature*. It is likely a vision refined by Talbot in several stages with the critical comments of his friends. A rather anaemic and presumably earlier variant was one of Talbot's first calotype negatives and was taken on 21st January 1841. In January, 1842 Lady Elisabeth wrote to him that she had given Mary Cole a copy of "The soliloquy of the Broom." A variant in the National Museum at Bradford is dated 1st March 1843. It is possible that the published image was done in 1843 or earlier but the first definite reference is on 8th May 1844 when Talbot ordered 250 copies for the *Pencil*.[5] It was

2. Bibl. **267**, p. 685.
3. Bibl. **266**, p. 410.
4. Ibid.
5. Talbot notebook, *London*, May 1843–May 1844.

issued from the Reading Establishment as a separate print under the title of a "Stable Yard in Talbot-type" and Talbot exhibited "The Stable Door" at the seminal Society of Arts exhibition in 1852.

VII. *Leaf of a Plant*

Negative: Photogenic Drawing, prior to 14 February 1844
Published: Part 2, 29 January 1845

This text clarifies the role of the negative, one of the main differentations between Talbot's process and Daguerre's. One of Talbot's goals for the *Pencil* was to demonstrate to novices possible applications for photography, but not everyone appreciated the general level of ignorance. One amateur wrote that he had "been much pleased with most of the pictures in your 'Pencil of Nature' which I have purchased . . . but I hope you will not give us any but *camera views* in the next numbers of your work. The leaf in no. 2 is certainly very pretty, but they are not so difficult of execution & consequently not so valuable as camera views."[6] The *Literary Gazette* understood the point better: "the leaf of a plant . . . is nature itself – how valuable for botanical science!"[7]

VIII. *A Scene in a Library*

Negative: Calotype, prior to 22 March 1844
Published: Part 2, January 1845

This was one of Talbot's earliest ideas for a photograph; in 1839 he wrote to Herschel that "a *bookcase* makes a very curious & characteristic picture: the different bindings of the books come out, & produce considerable illusion even with imperfect execution."[8] Looking at the published plate, the *Art-Union* declared that "we are enraptured: it is two shelves of a bookcase, in which the volumes are represented in the most exquisite miniature that can possibly be conceived: yet, small as they are, we can read "Poetae Minores Graeci" – "Lanzi" – "Egyptian Mythology," &c &c."[9]

Since Talbot was not the sort to do something without specific reason, the question has been raised if the book titles he displayed in this picture carried a coded message. André Jammes has suggested it is a self-portrait.[10]

6. Mr. Thompson to Talbot, 4 March 1845.
7. Bibl. **271**, p. 73.
8. Letter, 7 Dec. 1839. Royal Society, London.
9. Bibl. **273**, p. 84.
10. Bibl. **429**, p. 50.

IX. *Fac-simile of an Old Printed Page*

Negative: Photogenic drawing, prior to August 1839
Published: Part 2, 29 January 1845

Several photogenic drawing negatives survive of this page from a 1484 treatise on taxes and penalties.[11] The image demonstrates what Talbot rightly saw as one of the most valuable applications of the new art. His uncle, William Fox-Strangways, suggested copying the Magna Charta then at Lacock Abbey. Jean Baptiste Biot, the French physicist sympathetic to Talbot's work, was "charmed with the distinctness and accuracy" of a reproduction of a Hebrew psalm Talbot sent him and said that several other people who had been studying Arabic, Persian, and Sanscrit confirmed the praise.[12]

X. *The Haystack*

Negative: Calotype, April 1844
Published: Part 2, 29 January 1845

The *Athenæum* recognized that "in the haystack we have a delightful study – the fidelity with which every projecting fibre is given, and the manner in which that part of the stack which has been cut, is shown, with the ladder which almost stands out from the picture, and its sharp and decided shadow, are wonderful; the foliage, however, is very indistinctly made out, and a prop placed against the stack, appears as if cut in two, owing to the large amount of light which has been reflected from the object behind it."[13] The *Art-Union* was even more enthusiastic about the haystack "which is represented with a truth which never could be expected by any skill or trick of Art; and of this let us observe (although the same may be said of the other plates), that with all this minute detail of hay and straw – where not one projecting point is omitted – there is nothing hard or edgy, but the whole is presented with a harmony of parts which at once shows that when detail is associated with undue severity there is a sacrifice of truth."[14] The *Literary Gazette* drew a connection that would strike a chord with modern viewers when it observed that the "haystack resembles the open door [Pl. VI] in general effect."[15]

11. *Nova Statuta*, London 1484.
12. Letter to Talbot, 7 March 1840.
13. Bibl. **272**, p. 202.
14. Bibl. **273**, p. 84.
15. Bibl. **271**, p. 73.

XI. Copy of a Lithographic Print

Negative: Calotype, prior to May 1844
Published: Part 2, 29 January 1845

Original lithographs of Louis Leopold Boilly's (1761–1845) "Réunion de Trente-Cinq Têtes Diverses" measure 37 × 50 cm. Talbot displayed several "copies of lithography" at the *British Association for the Advancement of Science* meeting in August 1839, but these were contact prints the same size as the original. Longmans stressed the fact that this copy was "greatly diminished from the original" in their advertisements for Part 2.[16] It was Talbot's friend Sir John Herschel who first accomplished enlarging and reduction, and Talbot freely gave him credit for the idea.[17]

XII. The Bridge of Orleans

Negative: Calotype, 14 June 1843
Published: Part 2, 29 January 1845

Talbot and Henneman took advantage of their 1843 promotional trip to France to gather negatives of interesting places. The skies were not cooperative, however, and Talbot wrote from Orleans to his half-sister Horatia that "today was splendid weather, being the first summer day we have had since 20th May; twenty four days of weeping skies – and that was a solitary instance, having been preceded by a week of winds and storms. However, today was a grand exception to the usual rule, and I made a good many pictures, tho I lost time in looking for views & rambling about streets unknown to me."

XIII. Queen's College, Oxford. Entrance Gateway

Negative: Calotype, 9 April 1843
Published: Part 3, 14–29 May 1845

The *Athenæum* felt that in this plate "the truth-telling character of photographic pictures is pleasingly shown. It appears by the turret clock, that the view was taken a little after two, when the sun was shining obliquely upon the building. The story of every stone is told, and the crumbling of its surface under the action of atmospheric influences is distinctly marked."[18] The *Literary Gazette* was much more taken with this view, saying that it "appears to us to be a perfect study for the architectural artist. Examined, as recommended by Mr. Talbot, with a

16. Longmans advert., *Art Union*, vol. 7 (1 March 1845), p. 62.
17. Bibl. **535**, p. 199.
18. Bibl. **275**, p. 592–3.

magnifying glass, it is quite a photographic wonder and memorial of realities."[19]

XIV. The Ladder

Negative: Calotype, prior to April 1845
Published: Part 3, 14–29 May 1845

Even though Talbot planned from the start to include portraits in the *Pencil* (both from life and copied from engravings), this is the only published plate with people in it. It is likely that the portraitist and amateur scientist Henry Collen managed to influence the composition of this view. Thomas Malone recalled that "on one occasion . . . Mr. Collen, an artist, was experimenting with Mr. Talbot, and it was proposed that they should take a ladder and a loft door, which was very much above the level of the ground. Mr. Talbot of course pointed the camera up, and produced a very awkward effect, from the peculiar manner in which the lens was placed with reference to the object. Mr. Collen said, 'You are not going to take it so, surely!' Mr. Talbot replied, 'We cannot take it any other way'; and, then Mr. Collen said, 'As an artist, I would not take it at all.' "[20]

 Henry Collen had probably been persuaded on this point of perspective by their mutual friend, Sir John Herschel. Herschel stressed to Talbot that "in looking at photographic pictures from Nature . . . they are hardly one in fifty perspective representations *on a vertical plane.* In consequence perpendicular lines all condense upwards or downwards which is a great pity. . . . When a high station can be chosen this is not the case & this is a reason for chusing a station half way up to the height of the principal object to be represented."[21] Talbot promised to "always endeavour if I can to do what you recommend, place the instrument on a level with the central part of the object, or the first or second story of the building. It is however a pity that artists should object to the convergence of vertical parallel lines, since it is founded in nature and only violates the *conventional* rules of Art."[22]

XV. Lacock Abbey in Wiltshire

Negative: Calotype or photogenic drawing, prior to
 September 1844, possibly prior to May 1840
Published: Part 3, 14–29 May 1845

"In my first account of 'The Art of Photogenic Drawing,'

19. Bibl. **274**, p. 365.
20. Bibl. **359**, p. 33.
 21. Letter to Talbot, 23 Oct. 1847. Science Museum Library, London.
 22. Letter to Herschel, 26 Oct. 1847. Royal Society, London.

read to the Royal Society in January, 1839, I mentioned this building as being the first 'that was ever yet known to have drawn its own picture.' "[23] Talbot was obviously unaware of Nicéphore Niépce's 1827 view of his courtyard when he made his statement to the Royal Society. The Abbey was a natural early subject; in May 1840, Talbot sent Jean Baptiste Biot a photogenic drawing of Lacock's West front reflected in the River – possibly this very image.[24]

XVI. *Cloisters of Lacock Abbey*

Negative: Calotype, 1842
Published: Part 4, 21 June 1845

The *Art-Union* found "the most striking feature" of the Cloisters "is the ivy, which has grown up to and over the roof, and thickly overhangs the stone mullions below. Nothing in Art can equal the beauty and truth of this representation – the foliage being most perfect in character, dense, abundantly luxuriant, and well rounded in its masses, which are brought out by deep shadows inimitably liquid and transparent. The subject is extremely simple, and hence are its exceeding truth and force the more striking. The detail, as usual, is rendered with the most curious accuracy; the roofing, for example, is beyond the imitation of the pencil or the engraving tool."[25]

XVII. *Bust of Patroclus*

Negative: 9 August 1843 (dated in the negative)
Published: Part 4, 21 June 1845

Frustration with the camera lucida motivated Talbot to invent photography in the first place. In a rare public display of humor he expressed his confidence in his new art by parodying Captain Basil Hall's well known praise of the camera lucida: "if Dr. Wollaston, by this invention, have not actually discovered a Royal Road to Drawing, he has at least succeeded in Macadamising the way already known."[26]

XVIII. *Gate of Christchurch*

Negative: Calotype, prior to September 1844
Published: Part 4, 21 June 1845

This view of the Gate remains nearly the same today. All but the footing of the wall outside St. Aldate's Church at the left has been taken down, but Pembroke is very little

23. Bibl. **51**.
24. Talbot notebook, *Memoranda*, 8 May 1840.
25. Bibl. **278**, p. 325.
26. *Forty Etchings, from Sketches Made with the Camera Lucida in North America*, Edinburgh 1829, preface.

altered. The fountain and a copy of Mercury now framed by the gate were added in 1928.

XIX. *The Tower of Lacock Abbey*

Negative: Calotype, prior to February 1845
Published: Part 5, 13–22 December 1845

Just prior to the commencement of the *Pencil*, Talbot's uncle William Fox-Strangways suggested that "the fac-similes are just the thing. Could you not make some of Magna Charta & publish it, with a vignette of Lacock, or at least of the Tower where it is kept?"

XX. *Lace*

Negative: none involved†
Published: Part 5, 13–22 December 1845

Lace and the leaves of plants formed convenient "negatives" right from the start of Talbot's experiments. He displayed, for example, a number of "copies of Lace, or various patterns" at the British Association Meeting in August, 1839. This particular piece must have been very well-starched indeed for there is almost no variation in the delicate threads from copy to copy of this print. Perhaps the lace was mounted on glass with clear varnish or affixed to a piece of mica.

XXI. *The Martyrs' Monument*

Negative: Calotype, 7 September 1843
Published: Part 5, 13–22 December 1845

While many of Talbot's photographs depict the stability of medieval ruins, a correspondingly large number document scenes of construction and change. Oxford, the site of his great successes with Henneman, was undergoing a building boom during the time he calotyped there. The Ashmolean Museum (which would have been over Talbot's left shoulder as he photographed the Monument) was erected between 1841 and 1845. The monument was erected by public subscription between 1841 and 1843, near the square where the three martyrs were burnt in 1555 and 1556.

† See Talbot's description, p. 100–01.

XXII. *Westminster Abbey*

Negative: Calotype, prior to May 1844, by Nicolaas Henneman
Published: Part 6, April 1846

Henneman's view of the gate is a powerful treatment of the mass if not the detail of Westminster. The *Literary Gazette* thought this to be "a rich view of Westminster Abbey, curiously affected by atmospheric tints."[27] Lady Elisabeth wrote to her son that "the 'Westminster Abbey' meets with boundless praise & is said to be far more beautiful than those published. Indeed I wish you had inserted it in number 2ᵈ [part 2]."

XXIII. *Hagar in the Desert*

Negative: Photogenic drawing, prior to March 1844
Published: Part 6, April 1846

"Hagar" is particularly interesting as an example of one medium extending the circulation of another which in turn was extending the life of the original. Johann Nepomuk Strixner's lithograph, published in 1816, was a fairly early example of that reproductive art.[28] A comparison of it, the original, and Talbot's copy underlines one of the virtues of photography. Strixner had to copy the Mola by hand onto his lithographic stone. It is quite clear that he did not copy it slavishly (some would argue that he improved on the original). Talbot's copy of Strixner, however, is exact, which Henry's mother found to be a drawback. After viewing the copy of the Boilly (Pl. XI), she wrote her son that "before you chuse for No. 3 I would suggest that copies of Prints are what *take* the least, because of course they copy exactly *all* the inaccuracies & the great merit of this invention is its extreme accuracy, & truth to nature." She applied the classic contrast between nature's perfection (photography) and man's imperfection (lithography).

XXIV. *A Fruit Piece*

Negative: Calotype, prior to June 1845
Published: Part 6, April 1846

This curious combination of tropical fruit and a Scottish tartan is one of at least two variants drawing on the exact same elements. Talbot's connections with Scotland were strong already and had probably recently been bolstered while photographing for *Sun Pictures in Scotland*; the

27. Bibl. **281**, p. 433.
28. *Les Oeuvres Lithographiques*, Munich 1811–16, part 68, pl. 4.

pineapple was a status symbol of the upper classes.[29] Lady Elisabeth sent one of her son's prints to the Duke of Devonshire, saying "I think the *view of a Pine apple* will be approved of by Mr. Paxton, who will pronounce it a true *New Providence*."[30]

29. Bibl. **571**, p. 116.
30. Letter to Duke of Devonshire, summer 1845. Chatsworth House, Bakewell.

Views of Scotland

Graham Smith

The view of Loch Katrine (fig. 21) is one of more than twenty calotypes taken by Talbot during an excursion to Scotland in October 1844, for an album of views related to the life and writings of Sir Walter Scott. Entitled *Sun Pictures in Scotland* (fig. 22), this volume was issued in July 1845, between the publication of the fourth and fifth fascicles of Talbot's *The Pencil of Nature*. With one relatively minor exception, *Sun Pictures in Scotland* was, then, the second book to be illustrated with photographs. Despite its significance for the history of books and the history of photography, *Sun Pictures in Scotland* has been given much less attention than *The Pencil of Nature*, and appears not to have been well received when it first appeared. Indeed, even Talbot's mother, Lady Elisabeth, gave it a rather cool reception. In a letter to Talbot dated July 31, 1845, she wrote: "Many people think the 3rd and 4th numbers of Pencil of Nature worth all the Scotch views, and there certainly is more clearness in them owing I suppose to your having been in Scotland so late in the season."[1]

Sun Pictures in Scotland was published in an edition of 120, and, from the lists of subscribers made by Lady Elisabeth, it appears that something in the region of one hundred copies of the album were sold when it first

1. Bibl. **498**, pl. 157–58.

Abridged with reduced illustrations from Bibl. **576**: Graham Smith. 'William Henry Fox Talbot's Calotype Views of Loch Katrine'. *Bulletin of the University of Michigan Museums of Art and Archaeology*, vol. 7 (1984–85) [published in 1987], p. 49–77. © 1986 by the Regents of The University of Michigan. Reprinted with permission of the author and the publisher.

Talbot's photographic tour of the Scottish Borders and Perthshire Highlands in 1844 followed the footsteps of artists who illustrated Sir Walter Scott's works.

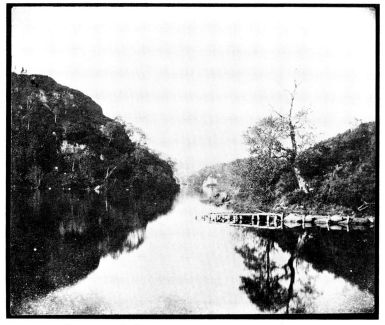

Fig. 21. *Loch Katrine*, salted-paper print, plate 11 from *Sun Pictures in Scotland*, London, 1845. University of Michigan Museum of Art.

SUN PICTURES IN SCOTLAND.

Preparing for publication in 1 vol. royal 4to.

TWENTY-THREE PHOTOGRAPHIC VIEWS

IN

SCOTLAND,

BY

H. FOX TALBOT, Esq.

Price to Subscribers, One Guinea.

Subscribers names will be received by J. Rodwell, Bookseller, New Bond Street, London.

Most of the views represent scenes connected with the life and writings of Sir Walter Scott. Among them will be found—

ABBOTSFORD,	LOCH KATRINE,
MELROSE ABBEY,	DRYBURGH ABBEY,
DOUNE CASTLE,	HERIOT'S HOSPITAL,
SIR W. SCOTT'S MONUMENT, EDINBURGH.	

Fig. 22. Subscription advertisement for *Sun Pictures in Scotland*, 1845.

appeared. Copies of *Sun Pictures in Scotland* are uniform, being composed of a title page, a list of plates, and twenty-three photographic views.[2] Of the twenty-three photographs, thirteen are large calotypes which are mounted individually on the royal quarto pages, whereas the remaining ten views are much smaller and are displayed two to a page. Like *The Pencil of Nature*, each copy of *Sun Pictures in Scotland* contains a *Notice to the Reader* which announces: "The plates of the present work are impressed by the agency of Light alone. They are the sun-pictures themselves, and not, as some persons have imagined, engravings in imitation." Unlike *The Pencil of Nature*, *Sun Pictures in Scotland* contains no text, but, as is evident from the list of plates and as was stated explicitly in the publication announcement, "most of the views represent scenes connected with the life and writings of Sir Walter Scott."

In fact, the calotypes represent architecture and scenery from three distinct regions of Scotland – Edinburgh, the Borders, and the Perthshire Highlands in the west of Scotland. Edinburgh is represented by two plates. The first depicts Heriot's Hospital, an institution founded in the early seventeenth century from the estate of George Heriot for the purpose of educating the sons of Edinburgh freemen. The second Edinburgh view shows George Meikle Kemp's monument to Scott, as it appeared when nearly finished, in October 1844. The first three views from the Borders depict Abbotsford, Scott's extravagant mansion in the Scottish Baronial style overlooking the River Tweed. Also part of the Abbotsford group is a calotype of an effigy of Scott's favourite dog, Maida. Next are three calotypes of Melrose Abbey, a Cistercian foundation located three miles from Abbotsford. In addition, there are three small views of Melrose mounted on the last two pages of *Sun Pictures in Scotland*. The last plate from the Borders represents Dryburgh Abbey, situated a few miles to the east of Melrose, where Scott was buried in 1832.[3] Three large views of Loch Katrine are inserted between the calotypes of Melrose Abbey and Dryburgh. Two show the east end of the loch, with its rustic pier, while the third is a view of the main loch, looking to the southwest to the base of Ben Venue. The remaining calotypes are all small views taken in the Perthshire Highlands. Four depict Loch Katrine and its surroundings. Two of those duplicate large views, but the others are different images, representing a thatched hut or

2. For reprinted illus. of the plates, see in addition to Bibl. **576** also Bibl. **562**, cat. no. 12.

3. Scott frequently took guests to visit the ruins of Melrose Abbey, but in *The Lay of the Last Minstrel* he recommended that it be seen alone and by night (Canto Second, I).

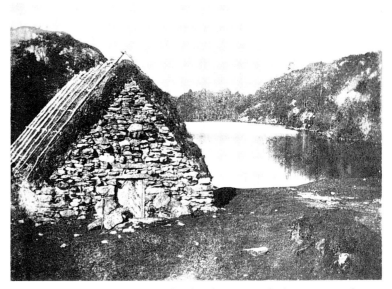

Fig. 23. *Highland Hut on the Banks of Loch Katrine*, salted-paper print, plate 14 from *Sun Pictures in Scotland*, London, 1845. J. Paul Getty Museum.

boathouse built on the west shore of the loch (fig. 23). Of the three remaining views, two show Doune Castle in the vicinity of Loch Katrine, and the last is an idyllic pastoral scene representing "A Mountain Rivulet which flows at the foot of Doune Castle."

The publication of *Sun Pictures in Scotland* coincided precisely with the apotheosis of Sir Walter Scott in Scotland. While the Scott Monument and Sir John Robert Steell's sculpture are the most tangible products of this phenomenon, *Sun Pictures in Scotland* should be recognized as another manifestation of the contemporary urge to commemorate and celebrate the "Wizard of the North." It may be that there was also an element of opportunism in Talbot's decision to publish *Sun Pictures in Scotland* rather than concentrate on the publication of *The Pencil of Nature*. Perhaps Talbot hoped to capitalize on Scott's fame to promote the calotype process. *Sun Pictures in Scotland*, however, is also contemporary with a general growth in interest in Scottish architecture and scenery, and particularly in the sublime, tremendous, and even terrifying aspects of the landscape of Scotland.

So, *Sun Pictures in Scotland* was a highly topical publication in 1845, both because of its association with Scott and because of its relationship to the discovery of the picturesque and romantic elements in Scotland's architecture and scenery. In fact, these aspects of Talbot's

publication are complementary, since the growth in appreciation of the monuments and landscape of Scotland was in large part due to the writings of Sir Walter. Scott himself was obsessed with the beauty of the isolated, bleak landscapes of the Borders and Perthshire Highlands, and did a great deal to generate a similar enthusiasm in his contemporaries.

The photographs in *Sun Pictures in Scotland* that best reflect Scott's impact on his native landscape are those of Loch Katrine. Today Loch Katrine is one of the most popular beauty spots in Scotland, but it is important to realize that originally its popularity was due largely, although not exclusively, to associations with Scott. Early in his career Scott braved the wild country around Loch Katrine to execute a summons in the Braes of Balquidder. He described this odyssey some years later in the introduction to *Rob Roy*:

> An escort of a sergeant and six men was obtained from a Highland regiment lying in Stirling; and the author, then a writer's apprentice, equivalent to the honourable situation of an attorney's clerk, was invested with the superintendence of the expedition, with directions to see that the messenger discharged his duty fully, and that the gallant sergeant did not exceed his part by committing violence or plunder. And thus it happened, oddly enough, that the author first entered the romantic scenery of Loch Katrine, of which he may perhaps say he has somewhat extended the reputation, riding with all the dignity of danger, with a front and rear guard, and loaded arms.[4]

The principal connection between Scott and Loch Katrine lies in *The Lady of the Lake*, however. *The Lady of the Lake* created a sensation on its publication in May 1810, and marked the peak of Scott's popularity as a poet. The first edition was sold out almost immediately, and more than 20,000 copies of the poem were sold within months of its publication. The setting of *The Lady of the Lake* was Loch Katrine and its surroundings, and, as a result of the poem, Loch Katrine itself became a popular success. Robert Cadell, Scott's friend and editor, gave a lively sense of this when he recalled the excitement caused by the appearance of *The Lady of the Lake*:

> The whole country rang with praises of the poet – crowds set off to view the scenery of Loch Katrine, till then comparatively

4. D. Daiches, *Sir Walter Scott and his World*, London, 1971, p. 41–42.

unknown; and as the book came out just before the season for excursions, every house and inn in the neighbourhood was crammed with a constant succession of visitors. It is a well-ascertained fact, that from the date of the publication of *The Lady of the Lake*, the post-horse duty in Scotland rose to an extraordinary degree, and indeed it continued to do so regularly for a number of years, the author's succeeding works keeping up the enthusiasm for our scenery which he had thus originally created.[5]

The publication of *The Lady of the Lake* not only created a flood of casual visitors to Loch Katrine, as Cadell described, but also caused a number of artists to explore and record the beauties of Loch Katrine and the Trossachs. For example, an album entitled *Views in Scotland Drawn from Nature . . . and Selected from Scenery described by Sir Walter Scott*, which was ready for publication in June 1830, contains some half-dozen lithographs representing Loch Katrine and the Trossachs, as well as a dramatic view of Doune Castle at night.[6] J.M.W. Turner visited Loch Katrine late in the summer of 1831 in connection with his commission to provide designs for Cadell's projected edition of *The Poetical Works of Sir Walter Scott*. The resulting watercolour was engraved and published in 1834 as the frontispiece to the seventh volume of *The Poetical Works*. Similarly, John Ruskin visited Loch Katrine in July 1838, while touring Scotland with his parents, and produced a pencil sketch of the east end of the loch.

It is evident, then, that Talbot followed a well-trodden path when he set out for Loch Katrine in the autumn of 1844. Nor was the idea of illustrating views connected with Scott's writings a novel one. On the other hand, Talbot's calotypes certainly were the first photographic views of Loch Katrine and its surroundings, and together they constitute the first photographic essay in the history of the medium. Although Talbot probably knew Turner's illustrations for *The Poetical Works*, he seems not to have been influenced directly by the engraving of Loch Katrine. Nor was he affected by the earlier views mentioned above. Talbot's calotypes emphasize the expanse of the loch, the massiveness of the mountains, and the wildness of the trees and scrub. Rather than bringing to mind Nasmyth or Claude, the bare, tumbled trees in the calotypes recall James Robertson's "aged weeping birches" clinging to barren, rocky slopes, whose nakedness they try to cover with their "venerable locks."[7]

5. D. Daiches, *Sir Walter Scott and his World*, London, 1971, p. 41–42.

6. A proof copy of this album is preserved in Princeton Univ. Library.

7. J.R. Watson, *George Washington Wilson*, Edinburgh, 1978, p. 7.

Whatever their relationship to contemporary landscape traditions in painting and the graphic arts, Talbot's photographs of Loch Katrine are as much literary as artistic views. In the mid-nineteenth century the educated traveller was bound to view landscape with its historical and literary associations in mind. Consequently, it is reasonable to assume that Talbot intended his calotypes at least to evoke the action and settings of *The Lady of the Lake*. For example, the view over the loch to the base of Ben Venue conjures up Scott's description of the King's first sight of Loch Katrine:

> And thus an airy point he won,
> Where, gleaming with the setting sun,
> One burnish'd sheet of living gold,
> Loch Katrine lay beneath him roll'd
> In all her length far winding lay,
> With promontory, creek, and bay,
> And islands that, empurpled bright,
> Floated amid the livelier light,
> And mountains, that like giants stand,
> To sentinel enchanted land.

Similarly, the views of the east end of Loch Katrine conjure up Fitz-James's first sight of Ellen, when she came into view in her skiff "from underneath an aged oak, that slanted from the islet rock," before landing on the famous "silver strand."

Almost as important as Scott for the discovery of Scotland was Queen Victoria. The Queen made short visits to the Scottish Highlands in 1842, 1844, and 1847, and in the autumn of 1848 spent her first holiday at Balmoral. In 1842, Queen Victoria's journey through Perthshire was carefully managed so that "the greatest possible amount of rich scenery might come within the range of the royal vision – that landscape of the most various character, and severally amongst the best of their order, might pass rapidly before the view, and melt into one another like the hues of the rainbow – and that no intrusion of equipage and ceremoniousness should occur to disturb the royal mind's banqueting on beauty."[8] Victoria was deeply affected by the beauty and wildness of the Scottish landscape, and enjoyed especially the peace and sense of solitude that it offered.

In October 1857 the Queen and Prince Albert visited Loch Katrine, and we can assume that they approached it

8. J. Holloway & L. Errington, *The Discovery of Scotland*, Edinburgh, 1978, p. 105.

with Scott and *The Lady of the Lake* in mind. They may also have thought fleetingly of Talbot and photography, since "Her Majesty the Queen" appears first among the *Subscribers to the Talbotype Sun Pictures in Scotland* in 1845.[9]

Sun Pictures in Scotland was not the first attempt to create images related to the writings of Sir Walter Scott. Nor was it the first book to be illustrated with photographs. As the first publication devoted to Scott to employ photographs, however, it applied a quite new and absolutely modern medium to a phenomenon of considerable social, cultural, and economic significance to the nineteenth century – the discovery of Scotland with Scott as eloquent cicerone.

9. List in Nat'l Mus. of Phot., Film & TV, Bradford.

The Photomechanical Processes

Eugene Ostroff

The system devised by Talbot, linking the negative–positive photographic image to the photomechanical technique (patented by him in 1852 and 1858)[1] inaugurated a vast new field offering rapid, mass visual communication of graphic information. Shortly after this technological breakthrough of 1852 a deluge of different "systems" poured forth. Some of these approaches adapted and varied Talbot's techniques but many were completely new. Within 25 years various photomechanical approaches began to gain acceptance in the printing industry, eventually proving adaptable to large-scale, high-speed production techniques.

An outstanding feature of Talbot's first photomechanical patent (1852) was the use of a potassium bichromate-sensitized gelatin emulsion, coated on a steel plate. This coating displayed the essential characteristics of hardening and becoming insoluble when exposed to light. Talbot's earliest photomechanical approach employed pieces of lace, leaves or sprigs which were contact printed onto the emulsion for $\frac{1}{2}$–5 minutes of sunlight. The plate was then dipped in water for 1–2 minutes to remove unexposed, unhardened emulsion and then etched in a solution of acidified bichloride of platina (platinum dichloride), a relatively safe etchant. It should be noted that until this time hand-made plates were chemically etched with the

1. British Patent 565 (29 October 1852); 875 (21 April 1858).

Abridged without illustrations from Bibl. **458:** Eugene Ostroff. 'Photography and Photogravure: History of Photomechanical Reproduction'. *Journal of Photographic Science*, vol. 17, no. 4 (July–Aug. 1969), p. 101–15 by permission of the author and The Royal Photographic Society.

Talbot used various methods to produce cross-line screens and resin-particle grounds to hold the ink in photogravure printing, which he invented in 1852.

125

highly corrosive and dangerous nitric acid.

After a water rinse all remaining gelatin was removed by sponging. Plate inking and printing was done in the same manner as with heliogravures and etched daguerreotypes, that is, the surface was wiped clean of surplus ink before an impression was taken. Except for line work this procedure suffered from the same shortcomings of tonal fidelity as did the heliogravures – intermediate tones could not be reproduced. In all etched areas, except those corresponding to narrow image lines where ink is confined and protected, it proved almost impossible to prevent some image ink from being removed during the ink-wiping operation. This resulted in an unpredictable tonal shift.

Talbot found that contact cross-line screens could be used as a means of dividing the image into very small elements which, when etched into the plate, provided ink-holding reservoirs, or cells. Each of these elements, theoretically, should be capable of holding an ink volume necessary to produce an imprint density matching a corresponding area in the original, contact-printed subject matter. In practice however this was not the case and inaccurate tonal rendition had to be corrected by using etching solutions of different concentrations and the local application of etchants.

Another of Talbot's earliest efforts resulted in a photo-mechanical image illustrating his first screen – which was a piece of gauze. He then applied the screen concept to silhouette-type subjects and demonstrated that black tones could be uniformly reproduced throughout an image area. After contact printing the screen onto the sensitized plate a leaf or a sprig was substituted for a second exposure. These experiments confirmed the practicability of using cross-line contact screens to produce ink retaining cells in the printing plate. Not being satisfied with silhouette images, he modified his technique and used, for the second exposure, continuous tone paper prints which were waxed or varnished; these coatings increased base translucency and reduced exposure time.

Talbot found that results were greatly improved by using two or three layers of gauze, each at a different angle. His early approach of using a single screen resulted in a coarse, geometrically uniform pattern which could be observed on the finished photomechanical print. This rectangular screen pattern, frequently larger than some image detail, inter-fered with definition and proved to be very distracting. Talbot corrected this problem by using several screen

exposures, or several layers of gauze, each at a different angle. This divided the image into a larger number of smaller components which, geometrically, were more complicated, making it less likely that the eye would resolve and distinguish any pattern when the print was inspected at a normal distance. This method significantly improved definition.

Talbot in 1852 also proposed other devices for segmenting the image: a line screen ruled on glass; powdered opaque particles on glass; or a plate coated with an aquatint before the gelatin coating is applied. Modifications of these latter two approaches were part of a technique variation covered in his 1858 patent.

Talbot was obviously dissatisfied with the gauze-screen techniques described in his 1852 patent. In a letter published in 1853 he stated that "two thicknesses of . . . gauze is but a rude attempt at a photographic veil . . . it would be proper to fabricate a much finer material, and to employ five or six thicknesses . . . or . . . to cover a sheet of glass . . . with . . . innumerable . . . fine lines, or else with dots and specks, which must be opake and distinct from each other." In this same letter he proposed using an aquatint ground to achieve the same result – a concept covered in his patent of 1858 – but was not enthusiastic about such an approach because of the difficulty in applying the ground to each plate.[2]

A fundamental shortcoming of Talbot's 1852 photo-mechanical system was openly cited by him in a letter published 9 April, 1853.[3] He had found, when producing a photogravure plate, that "the gradations of shadow and the depth of the etching upon the plate do not follow the same law as they do upon the original photograph . . . the shadows are too deep and the highlights are too strong." These were problems he was working upon and hoped to solve as "the process shall be better understood." Talbot concentrated on this problem and achieved success within a relatively short period. The corrective approach appeared in his 1858 patent: etching with solutions of different concentrations and using these solutions for selective local etching.

Long before photomechanical techniques were introduced printmakers had developed various methods of producing tiny ink-holding cells in hand-engraved images. One of these approaches – the aquatint ground – was adapted to the photomechanical field by Talbot and others. No records exist about the arrangement and equipment

2. Bibl. **138**, p. 532–33.
3. Bibl. **135**, p. 450–51.

actually used by Talbot and his engravers for applying resin to the bichromated surface, but we know that hand engravers of that period applied resin ground in two different forms, as a dust and as a liquid.

Sometimes the finely powdered resin was tied in a muslin bag and shaken over the plate. Another method consisted of placing the resin at the bottom of a box with the plate suspended horizontally. A bellows then created a dust cloud which settled on the plate. By mildly heating the plate the resin grains were softened just enough to make them adhere to the plate surface.

When etchant was applied it reached the plate through spaces between resin grains, each particle representing a barrier to the solution. It was important for all grains to be the same size so that the final etched pattern would consist of a uniform texture. Etching (biting) had to be done carefully in many stages because the acid not only corroded downward but also sideways, undercutting the resin particles. If undermined too far the walls separating the small cells were destroyed, and large cavities, as noted earlier, lost their ability to retain ink during the wiping stage, thereby ruining the plate.

Talbot, in his patent of 1858, introduced the technique of selective local etching using solutions of different concentration to control the extent of the etch more accurately. At this time he also introduced the principle of laying an aquatint ground on a bichromated gelatin emulsion, a technique which enhanced control of the middle and dark tones of the image. His technique of selective local etching using solutions of different concentration enabled him to control the extent of the etch with highly improved accuracy.

The application of an aquatint ground directly onto the bare metal plate before emulsion coating was described by Talbot in his patent of 1852. This approach was modified in May 1853 and incorporated into the heliogravure process devised by Claude Félix Abel Niépce de Saint-Victor (cousin of Nicéphore Niépce) and Augustin François Lemaître. Their technique called for resin dusting the partially etched heliograph plate which was then mildly heated to soften the resin particles and adhere them to the surface. The plate was then etched to completion.

These resin-resist techniques were modified still further by Talbot in 1858 who, after contact printing his subject matter, e.g., a flat object or positive photographic print, for one to several minutes, dusted onto the emulsion a small

amount of finely-powdered copal. The plate was then mildly heated to soften the resin and adhere it to the plate.

Talbot later improved his technique of applying the resin ground as a liquid (aquatint) by dissolving resin and camphor in chloroform which was poured onto the exposed plate. The chloroform rapidly evaporated as did the camphor when the plate was heated; the resin remained in a well distributed pattern.[4]

At least as early as March 1860 Talbot used the services of W. Banks & Son, engraving and printing firm in Edinburgh, Scotland to produce his photoengravings. Mr. Banks often discussed with Talbot routine practices followed in the print shop which might improve Talbot's photomechanical technique. In response to written instructions from Talbot, Banks also experimented with various approaches and would proffer suggested improvements as he thought of them. Even though Talbot could arrange to be with Banks only on rare occasions, the close working relationship pursued through correspondence undoubtedly helped resolve some of the problems encountered with the process.[5]

Banks, in March 1860, pointed out to Talbot that he should allow a margin of at least one inch around the image area of the engraved plate so that the plate surface could be rapidly wiped clean of ink without accidentally removing any image ink.

One of the first plates sent by Talbot to Banks was rejected by the engraver as being "of the softest sort, and very bad in quality." Banks suggested that the best steel to use for photoengravings was obtained in Sheffield. It could be converted in Edinburgh, by "one house in particular," into printing plates for the finer class of work. These plates, Banks pointed out, were tempered to suit the type of work.

One of the great advantages of steel over copper was the improved durability for longer printing runs. Banks constantly searched on behalf of Talbot for improved materials; in April 1860 Talbot authorized Banks to order specially prepared steel plates; at least as early as January 1861, they tried using case-hardened plates.

The experimental approaches used by Talbot indicate that he was a perfectionist. Only when his technique was capable of producing reasonably reproducible results in long "runs" did Talbot feel that he wanted to publicly demonstrate the advantages of his process. This approach, combined with the enthusiastic, sympathetic co-operation

4. Bibl. **386**, p. 372.
5. Fox Talbot Museum, Lacock.

of William Crookes, editor of *The Photographic News*, led to the publication of Talbot's photogravure prints in the 12 November, 1858 issue of that journal. The copies each contained one print by Talbot with seven different subjects being used in the run because, according to the editor, (1) production could be hastened by printing from several different plates at the same time (2) they could illustrate "the extent and variety of this new branch of art" and (3) they could include the highest quality prints because "when many thousands of copies are printed from the same plate, it gradually wears out, the last thousand prints being less sharp and delicate than the first." Thus only the first part of the run from the plates was presented to the readers. This approach also offered sales appeal for the publication because the readers also were encouraged to obtain different prints by purchasing additional copies containing the subjects they desired.[6]

6. Bibl. **350**.

The Talbot Collection at Bradford

Roger Taylor and Larry J. Schaaf

The Talbot Collection in the National Museum of Photography, Film and Television is the largest, richest, and most varied testimony to Henry Talbot's vision. Comprising more than 10,000 items, it is a broad and representative cross-section of works by Talbot and those he influenced. Much of its strength, paradoxically, derives from the almost casual nature of its foundation. It was, quite literally, an undisturbed slice of photographic history that came from Lacock Abbey.

In the summer of 1934, Miss Matilda Talbot organised at Lacock Abbey a Centenary Celebration of her grandfather's first success in photography. Miss Talbot was tireless in her efforts to have Henry Talbot's pioneering work properly recognised and this was certainly the largest group of Talbot material ever displayed before or since. Its breadth fired the enthusiasm of Alexander Barclay, a Keeper in the Science Museum. Miss Talbot encouraged him to make 'a selection' of Talbot's work for the Museum's collections. In his subsequent trips to Lacock, Barclay discovered that even more historical material was hidden away in a disused part of the Abbey. He was understandably overwhelmed by what he saw and found a rational curatorial selection to be impossible during his brief visits. On November 23rd, 1934, with Miss Talbot's full encouragement, a lorry from the Science Museum collected a treasure trove now unequalled in the world of photography.

Previously unpublished, this note describes the Talbot Collection of the National Museum of Photography, Film & Television, Pictureville, Bradford BD1 1NG, U.K.

The original intention was to sift through this material when time was available in order to make a final and more limited selection. Had Barclay or anyone else made a curatorial selection more than fifty years ago, based on prevailing pictorial standards and the then-current understanding of the history, literally thousands of critical images might have been passed by but the massive grouping of prints was preserved with great care by the staff of the Science Museum in London. Favourite images were fed into publications and exhibitions, but relatively few researchers had an interest in the early history of photography, and the demands on the collection were happily moderate. Had conservation efforts been applied that were common in post-war years (however well intentioned), many of these images would probably have been destroyed. The resources and basis for extensive cataloguing were not available; fortunately, there was never any pressure to rationalise the collection.

By the time of the 150th anniversary of photography in 1989, both knowledge and interest in the early history of photography had grown substantially and the collection was transferred to the National Museum of Photography, Film and Television. A preliminary item-level cataloguing, the first ever undertaken, produced many immediate surprises. It rapidly emerged that much of what had been commonly thought and published about Talbot was at least incomplete, and in many cases, widely off the mark. Talbot worked with a coterie of photographers, including Nicolaas Henneman and the Reverend Calvert Jones, and many favourite 'Talbot' photographs in fact proved to be by his associates, making the collection all the more complex, interesting, and historically valuable. Virtually all the items came from Lacock Abbey and must have been owned by Henry Talbot himself. While Miss Talbot's bequest makes up the vast majority of the holdings, some derive from other collections that came to the Science Museum, and a few came from the transfer of the Kodak Museum. The provenance is being preserved in catalogue records.

Silver Prints and Negatives: There are more than 6500 silver images on paper, both negative and positive. Perhaps half of these are by Talbot and half by photographers connected to him. While many prints exist in several copies, none of these are considered duplicates, and much has been learned already by comparison. These are individually sleeved and have been catalogued at the item level. At the present

time, this catalogue exists on paper files and in a comprehensive but abbreviated inventory list. A complete computer database will be established.

Manuscript Holdings: This particular group is much more selective. It is rich in items of obvious significance but not nearly as broad as the holdings of the Fox Talbot Museum at Lacock. Included are Talbot's notebooks 'P' and 'Q', covering the period from 1839 to 1843, which are the most complete record of his photographic research. Also included is virtually all of Talbot's correspondence with several key figures, such as Sir John Herschel, Sir David Brewster, Antoine Claudet, and Jean-Baptiste Biot. Many of the records of Henneman's Reading Establishment and subsequent London photographic studio are preserved. A finding guide is available. Correspondence has been catalogued at the item level and manuscripts at the folder level.

Photomechanical: Talbot spent more years of research on the reproduction of photographs in printer's ink than he did on photography itself. Barclay had a particular interest in this aspect and gathered approximately 3000 plates and prints related to Talbot's experiments in photographic and photoglyphic engraving. Many of these are extensively annotated. More than half of these items have been entered in a preliminary item-level catalogue. There are also hundreds of pages of manuscript notes, generally arranged chronologically.

Equipment: There are some fifteen items of equipment which relate to Talbot's interest in optics, drawing and photography. It is possible to see the development of his thinking and engagement with photography through these items, from his Camera Lucida and Camera Obscura to the early experimental cameras, through to larger-format cameras used in his later work. All items are catalogued.

BIBLIOGRAPHY

Works Written by or Connected with Henry Fox Talbot

1 *Plants indigenous to Harrow: Flora Harroviensis*, Compiled by Fox Talbot and Walter Calverley Trevelyan. Unpublished manuscript, 1814–15, with supplementary notes added by Trevelyan in 1871. 8 pp.

> The Harrow School Archivist writes: 'This manuscript consists of two sheets of paper folded together, of which the first five are numbered and the last is left blank. It has been bound together with annotated blue sheets of paper, and was presented to the school by Trevelyan in September 1871.'

2 *Trochaici graeci praemio Porsoniano quotannis proposito dignati, et in Curia Cantabrigiensi recitati, A.D. MDCCCXX (Auctore Gulielmo H.F. Talbot)*, [p. 21–27] in Henry Nelson Coleridge, *Carmen graecum numismate annuo dignatum, et in Curia Cantabrigiensi recitatum comitiis maximis A.D. MDCCCXX*, (Cambridge: University Press, 1820. 27 pp.).

> Talbot won the Porson Prize for his translation of *Macbeth*, Act 1, Scene 7, into Greek verse.

3 'Sur la comète de 1821'. *Correspondance astronomique, géographique, hydro-graphique et statistique du Baron de Zach* (Genoa), vol. 6, no. 6 (1822), p. 568–73.

4 'Questions Résolues: Rectification de l'énoncé du problème de géométrie proposé à la page 321 du XII volume des *Annales*, et traité à la page 115 du présent volume, et solution complète de ce problème. Extrait d'une lettre au Rédacteur des *Annales*, Florence, le 11 octobre 1822'. *Annales de Mathématiques Pures et Appliqués* (Nîmes), vol. 13, no. 7 (1 Jan. 1823), p. 242–47.

> In the Royal Society Catalogue of Scientific Papers (Bibl. **367**) the title is given as 'On the properties of a certain curve derived from the equilateral hyperbola'.

5 'Démonstrations diverses du théorème de géométrie enoncé à la page 212 du présent volume'. *Annales de Mathématiques Pures et Appliqués* (Nîmes), vol. 13, no. 10 (1 April 1823), p. 319–20.

> In the Royal Society Catalogue of Scientific Papers (Bibl. **367**) the title is given as 'Demonstration of a property of the equilateral hyperbola'.

6 'Démonstration du théorème de géométrie enoncé à la page 248 du

présent volume'. *Annales de Mathématiques Pures et Appliqués* (Nîmes), vol. 13, no. 10 (1 April 1823), p. 329–30.

In the Royal Society Catalogue of Scientific Papers (Bibl. **367**) the title is given as 'Solution of the problem: "To find the point in a given plane, the sum of whose distances to three given points external to the plane is a minimum". '

7 'Questions Résolues: Solutions des problèmes d'analise transcendante, proposés à la page 247 du XIII volume du présent recueil'. *Annales de Mathématiques Pures et Appliqués* (Nîmes), vol. 14, no. 3 (1 Sept. 1823), p. 88–95.

In the Royal Society Catalogue of Scientific Papers (Bibl. **367**) the title is given as 'On the sums of certain trigonometrical series'.

8 'Seconde solution, présentant la démonstration d'un théorème'. *Annales de Mathématiques Pures et Appliqués* (Nîmes), vol. 14, no. 4 (1 Oct. 1823), p. 123–28.

In the Royal Society Catalogue of Scientific Papers (Bibl. **367**) the title is given as 'Theorems concerning a right cone, and the projection of a conic section upon the base on the cone'.

9 'Analise Transcendante. Note sur l'article de la page 88 du présent volume. Milan, octobre 1823'. *Annales de Mathématiques Pures et Appliqués* (Nîmes), vol. 14, no. 6 (1 Dec. 1823), p. 187–90.

In the Royal Society Catalogue of Scientific Papers (Bibl. **367**) the title is given as 'On the sums of certain trigonometrical series'.

10 'Questions Résolues: Addition à l'article [by Roche] de la page 207 du présent volume'. *Annales de Mathématiques Pures et Appliqués* (Nîmes), vol. 14, no. 12 (1 June 1824), p. 380–81.

In the Royal Society Catalogue of Scientific

Papers (Bibl. **367**) the title is given as 'On a curve, the arcs of which represent Legendre's Elliptic Functions of the first kind'.

11 'Some Experiments on Coloured Flames'. (Dated March 1826). *Edinburgh Journal of Science* vol. 5, no. 1 (June 1826), p. 77–82.

12 'Einige Versuche über gefärbte Flammen'. *Jahrbuch der Chemie und Physik* (Halle) vol. 3, no. 4 (1826), p. 445–52.

13 'On Monochromatic Light'. *Quarterly Journal of Science, Literature and the Arts*, vol. 22 (Dec. 1826), p. 374.

14 *Legendary Tales, in Verse and Prose.* (London: James Ridgway, 1830. 253 pp.).

The contents include 'The Magic Mirror'*; 'Conrad; or, a Tale of the Crusades'; 'The Presentiment'; 'A Danish Legend'; 'Rosina'; 'Sir Edwin; or, the Zauber-Thal'; 'Rubezahl; or, the Mountain Spirit'; 'The Pearls'; 'The Bandit Chief'.

15 *To the Independent Freemen* (Chippenham: Broadside privately printed by Richard Alexander, 29 March 1831).

16 *To the Independent Freemen* (Chippenham: Pamphlet privately printed by Richard Alexander, 5 April 1831. 3 pp.).

17 'Etymology of Γύλιππος', 'Conjecture on a passage of Aeschylus', 'Correction of a passage of Euripides'. *The Philological Museum*, vol. 1, no. 3 ([May] 1832), p. 687–89.

18 'Remarks on Chemical Changes of Colour'. *Philosophical Magazine*, ser. 3, vol. 2, no. 11 (May 1833), p. 359–60.

19 'Remarks upon an Optical Phenomenon, seen in Switzerland'. *Philosophical Magazine*, ser. 3, vol. 2, no. 12 (June 1833), p. 452.

This article refers to one by L. Nacker, *Philosophical Magazine*, ser. 3, vol. 1, no. 5 (Nov. 1832).

20 'Bemerkungen über chemische Veränderungen von Farben'. *Notizen aus dem Gebiete der Natur- und Heilkunde* (Erfurt and Weimar), vol. 37, no. 798 (June 1833), columns 83–85.

21 'On a Method of obtaining Homogeneous Light of great intensity'. *Philosophical Magazine*, ser. 3, vol. 3, no. 13 (July 1833), p. 35.

22 'Methode homogenes Licht von grosser Intensität zu erhalten'. *Annalen der Chemie und Pharmacie* (Lemgo and Heidelberg), vol. 10, no. 2 (1834), p. 129.

23 'Proposed Philosophical Experiments: 1. On the Velocity of Electricity. 2. Proposed Method of Ascertaining the Greatest Depth of the Ocean'. *Philosophical Magazine*, ser. 3, vol. 3, no. 14 (Aug. 1833), p. 81–82.

'T.R.F.' critiques the second proposal in *Philosophical Magazine*, ser. 3, vol. 3, no. 17 (Nov. 1833), p. 352.

24 'On a new property of the Arcs of the Equilateral Hyperbola'. (Read 16 Jan. 1834). *Proceedings of the Royal Society of London*, vol. 3 (1830–37), no. 15 (1833–34), p. 258.

25 'Facts relating to Optical Science, No. I'. *Philosophical Magazine*, ser. 3, vol. 4, no. 20 (Feb. 1834), p. 112–14.

The subtitles of this article are: 1. Microscopic Cleavages in Talc or Mica. 2. Optical Properties of Chromium. 3. Purple Crystals from a green Liquid. 4. A Body in rapid Motion, yet apparently at rest. 5. On the Flame of Lithia. 6. On the Flame of Cyanogen.

26 'Facts relating to Optical Science, No. II'. *Philosophical Magazine*, ser. 3, vol. 4, no. 22 (April 1834), p. 289–90.

The subtitle of this article is: 7. On Mr Nicol's Polarizing Eye-piece.

27 'On the Arcs of certain Parabolic Curves'. (Read 12 June 1834). *Proceedings of the Royal Society of London*, vol. 3 (1830–37), no. 16 (1833–34), p. 287–88.

28 'Experiments on Light'. *Proceedings of the Royal Society of London*, vol. 3 (1833–34), no. 17 (15 May 1834), p. 298.

29 'Experiments on Light'. *Philosophical Magazine*, ser. 3, vol. 5, no. 29 (Nov. 1834), p. 321–34.

Errata for this article are to be found in Bibl. **36**.

30 'Anwendung des polarisierten Lichts zu mikroskopischen Beobachtungen'. (Report). *Annalen der Physik und Chemie* (Leipzig), vol. 35, no. 6 (1835), p. 330.

31 'On the Nature of Light'. *Philosophical Magazine*, ser. 3, vol. 7, no. 38 (Aug. 1835), p. 113–18, 157.

32 'On the Repulsive Power of Heat. On the Vaporisation of Sulphur. On the Vaporisation of Arsenic. Note on Radiant Heat'. *Philosophical Magazine*, ser. 3, vol. 8, no. 46 (March 1836), p. 189–91.

33 'Researches in the Integral Calculus, Part One'. (Read 10 March 1836). *Philosophical Transactions of the Royal Society of London*, vol. 126, part 1 (1836), p. 177–215.

34 'On the Optical Phenomena of certain Crystals'. (Received 20 April, read 5 May 1836). *Philosophical Transactions of the Royal Society of London*, vol. 127, part 1 (1836), p. 25–27.

35 'Extrait d'une lettre de M. Talbot à M. Arago sur les cristaux de borax'. *Comptes Rendus hebdomadaires des Séances de l'Académie des Sciences* (Paris), vol. 2 (first semester, 1836), p. 472–73.

36 'Facts relating to Optical Science, No. III'. *Philosophical Magazine*, ser. 3, vol. 9, no. 51 (July 1836), p. 1–4.

 The subtitles of this article are: [1.] Optical Properties of the Iodide of Mercury. [2.] On Prismatic Spectra. [3.] Spectra of various Galvanic Flames.

37 'On the Optical Phenomena of certain Crystals'. *Philosophical Magazine*, ser. 3, vol. 9, no. 54 (Oct. 1836), p. 288–91.

38 'Facts relating to Optical Science, No. IV'. *Philosophical Magazine*, ser. 3, vol. 9, no. 56 (Dec. 1836), p. 401–07.

 This article includes: 1. Experiments on the Interference of Light. 2. Experiments on Diffraction. 3. Remarkable Property of the Iodide of Lead.

39 'Researches in the Integral Calculus, Part Two'. (Received 26 October, read 17 November 1836). *Philosophical Transactions of the Royal Society of London*, vol. 127, part 1 (1837), p. 1–18.

40 'Further Observations on the Optical Phenomena of Crystals'. (Received 26 October, read 15 December 1836). *Philosophical Transactions of the Royal Society of London*, vol. 127, part 1 (1837), p. 29–35.

41 'Further Observations on the Optical Phenomena of Crystals'. *Proceedings of the Royal Society of London*, vol. 3, no. 28 (1836), p. 455–56.

42 'A brief Account of some Researches in the Integral Calculus'. *British Association for the Advancement of Science, Report for 1836*, vol. 5, part 2 (1837), p. 1–4.

43 'An Experiment on the Interference of Light'. *Philosophical Magazine*, ser. 3, vol. 10, no. 62 (May 1837), p. 364.

44 'On a new Property of Nitre'. *Philosophical Magazine*, ser. 3, vol. 12, no. 73 (Feb. 1838), p. 145–48.

45 'On a new Property of the Iodide of Silver'. *Philosophical Magazine*, ser. 3, vol. 12, no. 74 (March 1838), p. 258–59.

46 'Some Account of the Art of Photogenic Drawing, or the Process by which Natural Objects may be made to delineate themselves without the aid of the Artist's Pencil'. (Report of paper given 31 January 1839). *Proceedings of the Royal Society of London*, vol. 4 (1837–43), no. 36 (1838 [sic]), p. 120–21.

47 *Hermes: or Classical and Antiquarian Researches, No. 1.* (London: Longman, Orme, Green, Brown & Longman, 1838). *No. 2.* (London: Longman, Orme, Green, Brown and Longmans, 1839. 199 pp. [continuous pagination]).

48 'On Analytic Crystals'. *Philosophical Magazine*, ser. 3, vol. 14, no. 85 (Jan. 1839), p. 19–21. 3 illus. (coloured).

49 'The New Art'. *Literary Gazette*, no. 1150 (2 Feb. 1839), p. 72–75.

 This includes a letter from Talbot claiming priority for the invention of photography.

50 'Procédé de M. Daguerre'. *Comptes Rendus hebdomadaires des Séances de l'Académie des Sciences*, vol. 8, no. 5 (first semester, 1839), p. 171.

This letter from Talbot to François Arago, dated 29 Jan. 1839, of which an identical copy was sent to Jean-Baptiste Biot, makes a formal claim for priority over Daguerre. Comments by Arago, and a letter from Biot to Talbot follow, to p. 174.

51 *Some Account of the Art of Photogenic Drawing, or the Process by which Natural Objects may be made to Delineate Themselves without the Aid of the Artist's Pencil. Read before the Royal Society, January 31, 1839.* (London: Privately printed by R. & J. E. Taylor, 1839. 13 pp.). Reprinted [p. 23–33] in *Photography: Essays & Images*, Edited by Beaumont Newhall (London: Secker & Warburg, 1980; Boston: New York Graphic Society, 1980. 328 pp. 190 illus. bibliog. index). Reprinted [p. 36–48] in *Photography in Print*, Edited by Vicki Goldberg (New York: Simon and Schuster, 1981. 570 pp.).

52 'Photogenic Drawing: Some Account of the Art of Photogenic Drawing, or the Process by which Natural Objects may be made to delineate themselves without the aid of the Artist's Pencil'. *Athenaeum*, no. 589 (9 Feb. 1839), p. 114–17.

53 'Photogenic Drawing'. *Literary Gazette*, no. 1151 (9 Feb. 1839), p. 90.

54 'Photogenic Drawing: Some Account of the Art of Photogenic Drawing, or the Process by which Natural Objects may be made to delineate themselvcs without the aid of the Artist's Pencil'. *Mechanics' Magazine*, vol. 30, no. 810 (16 Feb. 1839), p. 345–51.

55 'Photogenic Drawing'. *Mechanics' Journal of Science and Art*, vol. 1, no. 27 (16 Feb. 1839), p. 430–32; no. 28 (23 Feb. 1839), p. 436–40.

56 'An Account of the Processes employed in Photogenic Drawing. In a letter to S. Hunter Christie, Sec. R.S.'. (Read 21 Feb. 1839). *Proceedings of the Royal Society of London*, vol. 4 (1837–43), no. 37 (1839), p. 124–26.

57 'Scientific and Literary: Royal Society Feb. 21. An Account of the Processes employed in Photogenic Drawing in a letter to S. H. Christie, Esq., Sec. R. S.'. *Athenaeum*, no. 591 (23 Feb. 1839), p. 156.

58 'Photogenic Drawing: Further Discoveries', *Literary Gazette*, no. 1153 (23 Feb. 1839), p. 123–24. Reprinted [p. 30–31] in *Photography: Essays & Images*, Edited by Beaumont Newhall (London: Secker & Warburg, 1981. 328 pp. 190 illus. bibliog. index).

59 'Communication de deux lettres de M. Talbot à M. Biot, contenant l'exposition de son procédé pour faire le *sensitive paper*' (letters dated 20 and 21 Feb. 1839). *Comptes Rendus hebdomadaires des Séances de l'Académie des Sciences*, vol. 8, no. 8 (first semester, 1839), p. 302–05.

60 'Some Account of the Art of Photogenic Drawing'. *Philosophical Magazine*, ser. 3, vol. 14, no. 8 (March 1839), p. 196–208.

61 'An account of the processes employed in Photogenic Drawing, in a letter to Samuel H. Christie, Esq., Sec. R. S.'. *Philosophical Magazine*, ser. 3, vol. 14, no. 88 (March 1839), p. 209–11.

62 'M. Biot communique l'extrait suivant d'une lettre que M. Talbot vient de lui adresser' (dated 1 March 1839). *Comptes Rendus hebdomadaires des Séances de l'Académie des Sciences*, vol. 8, no. 9 (first semester, 1839), p. 341.

Talbot recommends Herschel's hyposulphite of soda as the best method for fixing the photographic image.

63 'M. Biot communique la lettre suivante qu'il a reçue hier de M. Talbot' (dated 15 March 1839). *Comptes Rendus hebdomadaires des Séances de l'Académie des Sciences*, vol. 8, no. 11 (first semester, 1839), p. 409–10.

This letter about Talbot's sensitive paper is followed by remarks by Biot to p. 412.

64 'The Photogenic Art'. *Literary Gazette*, no. 1158 (30 March 1839), p. 202–04.

This article about Daguerre's claim to priority includes a letter from Talbot, referring to an article, 'Photogenic Drawing', *Literary Gazette*, no. 1157 (23 March 1839), p. 187.

65 'Sul metodo di render permanenti le immagini formate al fuoco di una camera oscura'. *Biblioteca Italiana, Giornale di Letteratura, Scienze ed Arti* (Milan), vol. 93 (Jan., Feb., March 1839), p. 132–44.

This report includes three letters from Talbot to Biot, p. 140–44.

66 'New Discovery – Engraving, and Burnet's Cartoons'. *Blackwood's Edinburgh Magazine*, vol. 45, no. 281 (March 1839), p. 382–91.

This includes a letter from Talbot, p. 385–87.

67 'Note respecting a new kind of Sensitive Paper'. *Proceedings of the Royal Society of London*, vol. 4 (1837–43), no. 37 (1839), p. 134.

68 'Scientific and Literary: Royal Society March 21. Notes respecting a new kind of Sensitive Paper'. *Athenaeum*, no. 597 (6 April 1839), p. 260.

69 'Photogenic Art'. *Literary Gazette*, no. 1160 (13 April 1839), p. 235–36.

This includes a letter from Talbot, dated 8 April 1839.

70 'The Pencil of Nature: A New Discovery'. *Corsair: A Gazette of Literature, Art, Dramatic Criticism, Fashion & Novelty*, vol. 1, no. 5 (13 April 1839), p. 70–72.

71 'Report of the 9th Meeting of the British Association for the Advancement of Science'. *Athenaeum*, no. 618 (31 Aug. 1839), p. 643–44.

This includes Talbot's remarks on Daguerre's process.

72 *A Brief Description of the Photogenic Drawings Exhibited at the Meeting of the British Association at Birmingham in August, 1839*. 2 pp.*

This is a hand list of the 93 photographs shown.

73 'Mr. Talbot's Remarks on the Daguerreotype'. *Magazine of Science and School of Arts*, vol. 1, no. 23 (Sept. 1839), p. 182–84.

74 *The Antiquity of the Book of Genesis, Illustrated by Some New Arguments*. (London: Longman, Orme, Green, Brown and Longman, [Sept.] 1839. 76 pp.).*

75 'Remarks on M. Daguerre's Photogenic Process'. (Read 26 August 1839). *British Association for the Advancement of Science, Report for 1839*, vol. 8, pt. 2 (1840), p. 3–5.

76 'Communication de dessins photo-géniques de M. Talbot'. *Comptes Rendus hebdomadaires des Séances de l'Académie des Sciences*, vol. 10, no. 6 (first semester, 1840), p. 247–48.

77 'Annonce d'un procédé qui abrège considérablement le temps nécessaire pour la formation des images photo-graphiques sur papier' (undated letter from Talbot to Biot). *Comptes Rendus hebdomadaires des Séances de l'Académie des Sciences*, vol. 12, no. 3 (first semester, 1841), p. 182–83.

78 'Nouveaux détails sur les papiers impressionnables communiqués à M. Biot par M. Talbot'. *Comptes Rendus hebdomadaires des Séances de l'Académie des Sciences*, vol. 12, no. 5 (first semester, 1841), p. 225–27.

79 'Lettre de M. Talbot à M. Biot, relative à des dessins opérés par les radiations, sur des papiers impression-nables'. *Comptes Rendus hebdomadaires des Séances de l'Académie des Sciences*, vol. 12, no. 11 (first semester, 1841), p. 492.
 Talbot sent Biot a Calotype portrait made in one minute.

80 'Lettre de M. Talbot à M. Biot, sur la confection de papiers sensibles'. *Comptes Rendus hebdomadaires des Séances de l'Académie des Sciences*, vol. 12, no. 23 (first semester, 1841), p. 1055–58.

81 *Specimen of the Calotype Process, Invented by H.F. Talbot Esq., as enrolled in the Year 1841*. (London: Printed by Cox (Bros.) and Wyman, [February] 1841. 8 pp.).

82 'Carte sensibili alla Luce'. *Annali di Fisica, Chimica e Matematiche* (Milan), vol. 1 (Feb. 1841), p. 173–74.

83 'Calotype (Photogenic) Drawing'. (Dated 5 February 1841). *Literary Gazette*, no. 1256 (13 Feb. 1841), p. 108.

84 'Fine Arts: Calotype (Photogenic) Drawing'. (Dated 19 February 1841). *Literary Gazette*, no. 1258 (27 Feb. 1841), p. 139–40.

85 'For improvements in producing or obtaining motive power'. (Patent enrolled 1 April 1841). *Mechanics' Magazine*, vol. 34, no. 923 (17 April 1841), p. 319–20.

86 'An account of some recent improve-ments in Photography'. (Read 10 June 1841). *Proceedings of the Royal Society of London*, vol. 4, no. 48 (1841), p. 312–16.

87 *The Process of Calotype Photogenic Drawing. Communicated to the Royal Society, June 10th, 1841*. (London: J.L. Cox and Sons, 1841. 4 pp.). Reprinted [p. 33–35] in *Photography: Essays and Images*, Edited by Beaumont Newhall (Boston: New York Graphic Society, 1980; London: Secker & Warburg, 1981. 328 pp. 190 illus. bibliog. index).

88 'Calotype (Photogenic) Drawing'. *Literary Gazette*, no. 1273 (12 June 1841), p. 379.

89 'Photography'. (Dated 5 July 1841). *Literary Gazette*, no. 1277 (10 July 1841), p. 445.

90 'Two Letters on Calotype Photogenic Drawing . . . to the editor of *The Literary Gazette*'. *Philosophical Magazine*, ser. 3, vol. 19, no. 121 (July 1841), p. 88–92.*

91 *Two Letters on Calotype Photogenic*

Drawing. Reprinted from *The Literary Gazette* (5 Feb. 1841; 19 Feb. 1841). 3 pp. See Bibl. **579**, p. 83.

92 'Royal Society: An Account of Some Recent Improvements in Photography'. *Athenaeum*, no. 716 (17 July 1841), p. 540–41.

93 'Calotype Pictures'. *Magazine of Science and School of Arts*, vol. 3, no. 18 (31 July 1841), p. 139–41.

94 'Talbot's [sic] elektromagnetischer Kraftapparat'. *Polytechnisches Journal* (Stuttgart), vol. 81, no. 3 (1841), p. 233.

95 'Ueber photogenische Kalotyp-Zeichnungen'. *Polytechnisches Journal* (Stuttgart), vol. 81, no. 5 (1841), p. 356–60.
Talbot refers back to *Polytechnisches Journal* vol. 71, p. 468– , and vol. 72, p. 224.

96 'Bereitung des Kalotyppapiers und Gebrauch desselben'. *Polytechnisches Journal* (Stuttgart), vol. 81, no. 5 (1841), p. 360–63.

97 'Proceedings of the Royal Society: An account of some Recent Improvements in Photography'. *Philosophical Magazine*, ser. 3, vol. 19, no. 122 (Aug. 1841), p. 164–68.

98 'Calotype'. *The Civil Engineer and Architect's Journal*, vol. 4, no. 47 (Aug. 1841), p. 286–87.

99 'For improvements in coating or covering metals, and in colouring metallic surfaces'. (Patent enrolled 9 June 1842). *Mechanics' Magazine*, vol. 36, no. 984 (18 June 1842), p. 496.

100 'For improvements in obtaining pictures or representations of objects'. (Patent sealed 8 February, enrolled [7] August 1841). *London Journal and Repertory of Arts, Sciences and Manufactures*, conjoined ser., vol. 19, no. 118 (1842), p. 189–97. Reprinted [p. 204–06] in Gail Buckland, *Fox Talbot and the Invention of Photography* (Bibl. **512**) together with Talbot's Disclaimer, dated 27 February 1854, for the part of his invention for obtaining 'photogenic images upon copper'.

101 'Calotype'. *Journal of the Franklin Institute*, ser. 3, vol. 3, no. 2 (Feb. 1842), p. 89–93.

102 'On the Iodide of Mercury'. *Philosophical Magazine*, ser. 3, vol. 21, no. 139 (Nov. 1842), p. 336–37.
This article refers to one by Robert Warington, secretary of the Chemical Society, 'On the Change of Colour in the Biniodide of Mercury', *Philosophical Magazine*, ser. 3, vol. 21, no. 137 (Sept. 1842), p. 192–97.

103 'The Telescope – Multiplication of Specula by means of the Electrotype'. *Mechanics' Magazine*, vol. 37, no. 987 (9 July 1842), p. 26–28.

104 'On the Improvement of the Telescope'. (Read June 1842). *British Association for the Advancement of Science, Report for 1842*, vol. 11, pt. 2 (1843), p. 16–17.

105 'On the Iodide of Mercury'. *Philosophical Magazine*, ser. 3, vol. 22, no. 145 (April 1843), p. 297–98.
This article refers to one by Robert Warington, secretary of the Chemical Society, 'On the Biniodide of Mercury', *Philosophical Magazine*, ser. 3, vol. 22, no. 144 (March 1843), p. 209–12.

106 John Walter Jr. *Record of the Death Bed of C.M.W.* (Reading: The Talbotype Establishment, 1844. [n.p.]. 1 illus.).

107 'Improvements in Photography'. *Chemist*, new ser., vol. 2, no. 15 (March 1844), p. 115–17.

108 *The Pencil of Nature.* (London: Longman, Brown, Green & Longmans, June 1844 – April 1846 [issued in six fascicles]. 80 pp. 24 salted-paper prints).* Reprinted [p. 77–105] in *Image*, vol. 8, no. 2 (June 1959); reprinted in facsimile, introduction by Beaumont Newhall (New York: Da Capo Press, 1969, 140 pp. 24 illus.); reprinted in reduced size (first fascicle only) (Firenze: Mycron, 1976); reprinted in translation [p. 45–89] in *Die Wahrheit der Photographie: Klassische Bekenntnisse zu einer neuen Kunst*, Edited by Wilfried Wiegand (Frankfurt am Main: S. Fischer, 1981. 304 pp.); reprinted in facsimile (Hamburg: The Calotype Company, 1984, edition of 125 copies, 24 illus. [modern salted paper prints]); reprinted as *H. Fox Talbot's The Pencil of Nature: Anniversary Facsimile* (New York: Hans P. Kraus, Jr. Inc., 1989, [80 pp.]. 24 illus. [tritone photolithographs]), together with Larry Schaaf, *Introductory Volume* ('Historical Sketch', 'Notes on the Plates', 'Census'), 93 pp. 40 illus.

109 'On the Coloured Rings produced by Iodine on Silver, with Remarks on the History of Photography'. (Dated 21 December 1842). *Philosophical Magazine*, ser. 3, vol. 22, no. 143 (Feb. 1843), p. 94–97.

110 'Patent Granted for Improvements in Photography'. (Sealed 1 June 1843). *Chemical Gazette*, vol. 2, no. 30 (15 Jan. 1844), p. 55–56.

111 *Sun Pictures in Scotland.* (Reading: The Talbotype Establishment [published by subscription], [Autumn] 1845. 2 pp. 23 illus. [salted-paper prints]). Reprinted in reduced size [cat. no. 12] in Hans P. Kraus, Jr. *Sun Pictures: Early British Photographs on Paper* Catalogue One (New York: Hans P. Kraus, Jr., [1985]); and Graham Smith, 'William Henry Fox Talbot's Calotype Views of Loch Katrine', *Bulletin of the University of Michigan Museums of Art and Archaeology*, vol. 7 (1984–85) [published in 1987], p. 72–77.

112 '[Talbotype]'. *Art Union* vol. 8, no. 91 (1 June 1846), facing p. 143.
'We may take this opportunity of stating that the whole of the Talbotypes issued with the June number of the *Art union* were taken from the actual objects they represent; they were, strictly, copies from *Nature*; in no case had a print been made use of for the purposes of transfer.' (p. 195).

113 'On a New Principle causing Crystallization'. *Athenaeum*, no. 1028 (July 1847), p. 744.

114 *English Etymologies.* (London: J. Murray, 1847. 492 pp.).

115 'The Reviewer Reviewed', *Literary Gazette*, no. 1615 (1 Jan. 1848), p. 3.
Talbot answers a vicious review [by J.W. Croker] of *English Etymologies* in the *Quarterly Review*, vol. 81 (Sept. 1847), p. 500–25.

116 'On a new Principle of Crystallization'. *British Association for the Advancement of Science, Report for 1847*, vol. 16, pt. 2 (1848), p. 58–59.

117 'Mr. Fox Talbot's Late Improvements in Photography'. *Photographic Art*

Journal, vol. 1, no. 1 (Jan. 1851), p. 51–52.

118 'Photogenic Drawing'. *Daguerrean Journal*, vol. 1, no. 5 (15 Jan. 1851), p. 129–38.

119 'On the Coloured Rings Produced by Iodine on Silver, with Remarks on the History of Photography'. *Daguerrean Journal*, vol. 1, no. 12 (1 May 1851), p. 357–59.

120 'Note on instantaneous Photographic Images'. (Dated 19 June 1851). *Proceedings of the Royal Society of London*, vol. 7 (1850–54), p. 82.

121 'On the Production of Instantaneous Photographic Images'. *Athenaeum*, no. 1258 (6 Dec. 1851), p. 1286–87. Reprinted [p. 109] in Gail Buckland, *Fox Talbot and the Invention of Photography* (Bibl. **512**).

122 'Observations on the Total Eclipse of the Sun on July 28, 1851. Marienburg, Prussia'. [Together with Talbot's translation from *Berlinische Nachrichten* (1 August 1851, supplement p. 1)]. *Memoirs of the Royal Astronomical Society*, vol. 21, pt. 1 (1851–52), p. 107–13.

> Talbot observed the eclipse with a low-powered telescope of 3-inch aperture with a focal length of 36 inches.

123 'Sur la production des images photographiques instantanées'. (Dated 24 November 1851). *Comptes Rendus hebdomadaires des Séances de l'Académie des Sciences*, vol. 33, no. 22 (second semester, 1851), p. 623–27.

124 *Remarks on M. Foucault's Pendulum Experiment*. (Privately printed, 1851).

This item is recorded without further information in H.J.P. Arnold, *William Henry Fox Talbot* (Bibl. **498**), p. 366.

125 'On the Production of instantaneous Photographic Images'. *Philosophical Magazine*, ser. 4, vol. 3, no. 15 (Jan. 1852), p. 73–77.

126 'Photography'. *Athenaeum*, no. 1262 (3 Jan. 1852), p. 22–23.

> This includes a letter on Talbot on priority of invention.

127 'Catalysotype and Amphitype'. *Photographic Art Journal*, vol. 3, no. 4 (April 1852), p. 242–46.

> This includes an exchange of letters between Talbot and Thomas Woods about priority of invention.

128 'On the Production of Instantaneous Photographic Images'. *Humphrey's Journal*, vol. 4, no. 1 (15 April 1852), p. 1–4.

129 'Uber die augenblickliche Erzeugung photographischer Bilder'. *Journal für praktische Chemie* (Leipzig), vol. 55, no. 5 (1852), p. 280–84.

130 'Photographie'. *Cosmos: Revue Encyclopédique Hebdomadaire des Progrès des Sciences* (Paris), vol. 1, no. 18 (29 Aug. 1852), p. 420–22.

131 'Resignation of the Photographic Patents'. *Art Journal* (1 Sept. 1852), p. 270–71.

132 'Photographie: La Chambre noire du voyageur. Lettre de M. Fox Talbot'. *Cosmos: Revue Encyclopédique Hebdomadaire des Progrès des Sciences*, vol. 2, no. 3 (11 Dec. 1852), p. 52–54.

133 'Talbot's Patent in England'. *Humphrey's Journal*, vol. 4, no. 22 (1 March 1853), p. 350–51.

134 'Gossip'. *Photographic Art Journal*, vol. 5, no. 4 (April 1853), p. 252–53.
This report includes letters between Talbot and Sir Charles Eastlake about patent rights.

135 'Photographic Engraving'. *Athenaeum*, no. 1328 (9 April 1853), p. 450–51.

136 'Photographic Engraving'. *Athenaeum*, no. 1329 (16 April 1853), p. 481–82.

137 'Photographic Engraving'. *Journal of the Photographic Society*, vol. 1, no. 3 (21 April 1853), p. 42–44.

138 'Photographic Engraving'. *Athenaeum*, no. 1331 (30 April 1853), p. 532–33.

139 'Photographie'. *Cosmos: Revue Encyclopédique Hebdomadaire des Progrès des Sciences* (Paris), vol. 2, no. 24 (8 May 1853), p. 560–68.
This contains Talbot's description of his photographic engraving process, p. 560–63.

140 'Photographic Engraving'. *Humphrey's Journal*, vol. 5, nos. 2–3 (1 May–15 May 1853), p. 34–36.

141 'Photographic Engraving'. *Journal of the Photographic Society*, vol. 1, no. 5 (21 May 1853), p. 62–64.

142 'Photographic Engraving'. *Humphrey's Journal*, vol. 5, no. 4 (1 June 1853), p. 49–52.

143 'Gravure photographique sur l'acier'. *Comptes Rendus hebdomadaires des Séances de l'Académie des Sciences*, vol. 36, no. 18 (first semester, 1853), p. 780–84.
To this article are appended remarks from François Arago and Eugène Chevreul on the claims to priority of invention of photogravure by Niépce de Saint-Victor.

144 'Photographische Gravierung auf Stahl'. *Journal für praktische Chemie* (Leipzig), vol. 59, no. 7 (1853), p. 410–13.

145 'Photographic Engraving'. *Photographic Art Journal*, vol. 6, no. 1 (July 1853), p. 54–56.

146 'Specification of the Calotype Photographic Process . . . as enrolled in the Year 1841'. *Notes and Queries*, vol. 10, no. 255 (16 Sept. 1854), p. 230–31.

147 *Notes on the Assyrian Inscriptions.* ([London]: Privately printed, 1854).

148 'Talbot v. La Roche'. [2 November 1854]. *Common Bench Reports: Cases Argued and Determined in the Courts of Common Pleas and Exchequer Chamber*, vol. 15 (Michaelmas Term 1855), p. 310–21.
The presentation of the case included Talbot's patent specification.

149 'On the Assyrian Inscriptions [No. 1]'. (Dated October 1855). *Journal of Sacred Literature and Biblical Record*, ser. 2, vol. 2, no. 4 (Jan. 1856), p. 414–25.

150 'On the Assyrian Inscriptions, No. 2'. (Dated February 1856). *Journal of Sacred Literature and Biblical Record*, ser. 2, vol. 3, no. 5 (April 1856), p. 188–94.

151 'On the Assyrian Inscriptions,

No. 3'. (Dated May 1856). *Journal of Sacred Literature and Biblical Record*, ser. 2, vol. 3, no. 6 (July 1856), p. 422–26.

152 'On the Assyrian Inscriptions, No. 4'. (Dated August 1856). *Journal of Sacred Literature and Biblical Record*, vol. 4, no. 7 (Oct. 1856), p. 164–70.

153 *Assyrian Texts Translated, No. 1.* (London: Printed by Harrison and Sons for private distribution, 1856. 32 pp.).

154 'On the Origin of the Word Sabbath'. *Journal of Sacred Literature and Biblical Record*, vol. 5, no. 9 (April 1857), p. 175.

> Talbot's etymology is vigorously denied by 'W.W.' (Dublin), *Journal of Sacred Literature*, vol. 5, no. 10 (July 1857), p. 440–42.

155 'On Fermat's Theorem'. (Read 7 April 1856). *Transactions of the Royal Society of Edinburgh*, vol. 21, part 3 (1857), p. 403–06.

156 'Specification of Mr Fox Talbot's Calotype Patent', *Liverpool and Manchester Photographic Journal*, new ser., vol. 1, no. 11 (1 June 1857), p. 114–16.

> This a transcription from the Chancery copy dated 29 July 1841, enrolled 7 August 1841.

157 'History of Photography. The Calotype or Talbotype', *Liverpool and Manchester Photographic Journal*, new ser., vol. 1, no. 15 (1 Aug. 1857), p. 163–64; no. 16 (15 Aug. 1857), p. 174–76.

> This is a reprint of Talbot's introduction to *The Pencil of Nature*. The editor of the journal, Thomas Augustine Malone, includes an editorial footnote of some interest: 'In a lecture at the Royal Institution we mentioned this statement of Mr Talbot's

[that silver iodide was not light-sensitive], whereupon, at the conclusion of the discourse, Mr Faraday was good enough to inform us that Davy certainly knew of the *insensitiveness* of iodide of silver, for he had mentioned the fact in Mr Faraday's presence, while discussing with Gay-Lussac of Paris the nature of iodine, then recently discovered. Davy produced this fact as proving that iodine was not likely to be a modification of chlorine; the chloride of silver being readily altered by the light, while he alleged iodide remained unchanged' (p. 175).

158 'History of Photography – Photographic Engraving', *Liverpool and Manchester Photographic Journal*, new ser., vol. 1, no. 18 (15 Sept. 1857), p. 200–02.

159 'Photographic Engraving'. *Photographic and Fine Art Journal*, vol. 10, no. 12 (Dec. 1857), p. 356–57.

160 *Inscription of the Tiglath Pileser I, King of Assyria, B.C. 1150, as translated by Sir Henry Rawlinson, Fox Talbot, Esq., Dr Hincks, and Dr Oppert.* (London: Royal Asiatic Society, 1857. 73 pp.).

161 *Observations on a Babylonian Cylinder, belonging to Sir Thomas Phillipps, Bart., Middle Hill,* [preceded by a letter from Talbot dated 8 January 1857] (Privately printed, 1857. 3 pp.).

162 'Description of Mr Fox Talbot's New Process of Photoglyphic Engraving'. *Photographic News*, vol. 1, no. 7 (22 Oct. 1858), p. 73–75.

163 [Photoglyph]. *Photographic News*, vol. 1, no. 10 (12 Nov. 1858), between p. 114–15.

Each copy of this issue contained one gravure of seven different subjects, which were distributed throughout the run: Bridge over the Moldau, Prague; Congress of Deputies, Madrid; Court in the Alhambra, Granada; Palace of the Duc de Montpensier, Seville; The New Louvre, Paris; The Gate of the Cathedral of San Gregorio, Valladolid; The Institute of France.

164 *Description of Mr Fox Talbot's New Process of Photoglyphic Engraving. Extracted from the "Photographic News", October 22, 1858.* (London: Petter and Galpin, [1858]. 8 pp.). Reprinted [p. 207–09] in Gail Buckland, *Fox Talbot and the Invention of Photography* (Bibl. **530**).

165 'Specification of Mr. Fox Talbot's New Process of Photoglyphic Engraving'. *Liverpool and Manchester Photographic Journal*, new ser., vol. 2, no. 21 (1 Nov. 1858), p. 269–71.

166 'Specification of the Patent Granted to William Henry Fox Talbot . . . for Improvements to the Art of Engraving'. *Journal of the Photographic Society of London*, vol. 5, no. 72 (6 Nov. 1858), p. 58–61.

167 'Photo-Glyphic Engraving'. *Photographic and Fine Art Journal*, vol. 11, no. 11 (Nov. 1858), p. 333–36.

168 'Specification of Mr. Fox Talbot's New Process of Photoglyphic Engraving'. *American Journal of Photography and the Allied Arts and Sciences*, new ser., vol. 1, no. 13 (1 Dec. 1858), p. 200–06.

169 'The Annals of Esarhaddon. Translated from two cylinders in the British Museum'. *Journal of Sacred Literature and Biblical Record*, vol. 9, no. 17 (April 1859), p. 68–79.

170 'Early Researches on the Spectra of Artificial Light, [compiled] from different sources'. *Chemical News and Journal of Science*, vol. 3, no. 73 (27 April 1861), p. 261–63.

171 'On the Theory of Numbers'. (Read 21 April 1862). *Transactions of the Royal Society of Edinburgh*, vol. 23, part 1 (1861–62), p. 45–52.

172 'On Fagnani's Theorem'. (Read 20 April 1863). *Transactions of the Royal Society of Edinburgh*, vol. 23, part 2 (1862–63), p. 285–98.

173 'Photoglyphic Engravings of Ferns; with Remarks. A Summary with a photoglyph, plate XIV'. *Transactions of the Botanical Society* (Edinburgh), vol. 7 (June 1863), p. 569.

174 'Letters'. *Journal of the Photographic Society of London*, vol. 8, no. 1 (15 Jan. 1864), p. 430–31.
 These are two letters by Talbot in answer to a question about a photograph taken in 1841 or 1842.

175 'The First Use of Bromine in Photography'. *British Journal of Photography*, vol. 11, no. 212 (15 April 1864), p. 127–28.
 This includes letters from Talbot and Biot.

176 'Note on Confocal Conic Sections'. (Read 17 April 1865). *Transactions of the Royal Society of Edinburgh*, vol. 24, part 1 (1864–65), p. 53–57.

177 'Researches on Malfatti's Problem'. (Read 20 March 1865). *Transactions of the Royal Society of Edinburgh*, vol. 24, part 1 (1864–65), p. 127–38.

178 'Ancient Photography'. *Philadelphia*

Photographer, vol. 3, no. 32 (Aug. 1866), p. 248–50.

The title refers to Talbot's writings on Daguerre.

179 'A Translation of Some Assyrian Inscriptions: 1. A Grammatical Tablet in the British Museum. 2. An Inscription of Sargon. 3. An Inscription of Esarhaddon.' (Read 6 January 1864). *Transactions of the Royal Society of Literature of the United Kingdom*, ser. 2, vol. 8 (1866), p. 105–37.

180 'Assyrian Translations: [1.] A Battle Scene, in the British Museum [4 illus.]. [2.] The Inscription of Khammurati. [3.] A Clay Tablet in the British Museum. [4.] The Siege of Madakta. [5.] Fragment concerning a War in Syria. [6.] On Ineffable Names. [7.] Further Remarks on an Inscription of Esarhaddon. [8.] On the Antiquity of Coined Money'. (Read 7 June 1865). *Transactions of the Royal Society of Literature of the United Kingdom*, ser. 2, vol. 8 (1866), p. 230–95.

181 'On the Eastern Origin of the Name and Worship of Dionysus'. (Read 18 January 1865). *Transactions of the Royal Society of Literature of the United Kingdom*, ser. 2, vol. 8 (1866), p. 296–307.

182 'A New Translation of the Inscription of Bellino, containing Annals of Two Years of the Reign of Sennacherib'. (Read 21 March 1866). *Transactions of the Royal Society of Literature of the United Kingdom*, ser. 2, vol. 8 (1866), p. 369–433.

183 'Note on *Vellozia elegans*, from the Cape of Good Hope'. *Transactions of the Botanical Society* (Edinburgh), vol. 9, Proceedings for January 1867, p. 79.

Talbot presented a living specimen of this plant to the Royal Botanic Garden, Edinburgh.

184 'Some Mathematical Researches'. (Read 29 April 1867). *Transactions of the Royal Society of Edinburgh*, vol. 24, pt. 3 (1866–67), p. 573–90.

185 'Contributions towards a Glossary of the Assyrian language [Part I]'. *Journal of the Royal Asiatic Society of Great Britain and Ireland*, new ser., vol. 3 (1868), p. 1–64.

186 'Contributions towards a Glossary of the Assyrian Language [Part II]'. *Journal of the Royal Asiatic Society of Great Britain and Ireland*, new ser., vol. 4 (1870), p. 1–80.

187 'Note on some Anomalous Spectra, and on a simple direct-vision Spectroscope'. *Proceedings of the Royal Society of Edinburgh*, vol. 7, no. 82 (1870–71), p. 408–12.

188 'Note on the Early History of Spectrum Analysis; On Some Optical Experiments; On the Nicol Prism'. *Proceedings of the Royal Society of Edinburgh*, vol. 7, no. 82 (1870–71), p. 461–70.

189 'On a Method of Estimating the Distances of some of the Fixed Stars'. *British Association for the Advancement of Science, Report for 1871*, vol. 41 (1872), p. 34–36.

Talbot proposes calculation by means of spectrum analysis.

190 'On an Ancient Eclipse'. (Read 4 April 1871). *Transactions of the Society of Biblical Archaeology*, vol. 1, part 1 (Jan. 1872), p. 13–19.

191 'Note on the Religious Belief of the

Assyrians, Part I'. *Transactions of the Society of Biblical Archaeology*, vol. 1, part 1 (Jan. 1872), p. 106–15.

192 'A Fragment of Ancient Assyrian Mythology'. (Read 2 April 1872). *Transactions of the Society of Biblical Archaeology*, vol. 1, part 2 (Dec. 1872), p. 271–80.

193 'On the Mazzaroth of Job (xxxviii, 32)'. (Read 2 July 1872). *Transactions of the Society of Biblical Archaeology*, vol. 1, part 2 (Dec. 1872), p. 339–42.

194 'A Prayer and a Vision, from the Annals of Assurbanipal, King of Assyria'. (Read 5 November 1872). *Transactions of the Society of Biblical Archaeology*, vol. 1, part 2 (Dec. 1872), p. 346–48.

195 'Additions [to "On an Ancient Eclipse"]'. *Transactions of the Society of Biblical Archaeology*, vol. 1, part 2 (Dec. 1872), p. 348–53.

196 'On the Religious Belief of the Assyrians, Part II'. (Read 5 November 1872). *Transactions of the Society of Biblical Archaeology*, vol. 2, part 1 (July 1873), p. 29–49.

197 'On the Religious Belief of the Assyrians, Part III'. (Read 1 April 1873). *Transactions of the Society of Biblical Archaeology*, vol. 2, part 1 (July 1873), p. 50–79.

198 'Legend of Ishtar descending to Hades'. (Read 3 June 1873). *Transactions of the Society of Biblical Archaeology*, vol. 2, part 1 (July 1873), p. 179–212.

199 'On the Religious Belief of the Assyrians, Part IV'. (Read 2 December 1873). *Transactions of the Society of Biblical Archaeology*, vol. 2, part 2 (Dec. 1873), p. 346–52.

200 'Illustrations of the Prophet Daniel from the Assyrian Writings'. (Read 6 January 1874). *Transactions of the Society of Biblical Archaeology*, vol. 2, part 2 (Dec. 1873), p. 360–64.

201 'Contributions towards a Glossary of the Assyrian Language, Part III'. *Journal of the Royal Asiatic Society of Great Britain and Ireland*, new ser., vol. 6 (1873), p. i-lxxx [appended at end of vol.].

202 *Contributions towards a glossary of the Assyrian Language*. (London: Reprinted from *Journal of the Royal Asiatic Society of Great Britain and Ireland*, 3 parts bound as one, 1874).

203 'Revised Translation of Ishtar's Descent, with a further Commentary'. (Read 5 May 1874). *Transactions of the Society of Biblical Archaeology*, vol. 3, part 1 (June 1874), p. 118–35.

204 'Addenda to paper on the "Descent of Ishtar" '. *Transactions of the Society of Biblical Archaeology*, vol. 3, part 1 (June 1874), p. 357–60.

205 'Assyrian Notes – No. 1'. (Read 2 June 1874). *Transactions of the Society of Biblical Archaeology*, vol. 3, part 2 (Dec. 1874), p. 430–41.

206 'Four New Syllabaries, and a Bilingual Tablet'. (Read 3 November 1874). *Transactions of the Society of Biblical Archaeology*, vol. 3, part 2 (Dec. 1874), p. 496–529.

207 'Inscription of Khammurabi', [p. 5–9] in *Records of the Past, being*

English Translations of the Assyrian and Egyptian Monuments, vol. 1 (1874), Edited by Samuel Birch (London: Samuel Bagster under the sanction of the Society of Biblical Archaeology, 12 volumes, 1874–81).

208 'Bellino's Cylinder of Sennacherib', [p. 23–32] in *Records of the Past, being English Translations of the Assyrian and Egyptian Monuments*, vol. 1 (1874), Edited by Samuel Birch (London: Samuel Bagster under the sanction of the Society of Biblical Archaeology, 12 volumes, 1874–81).

209 'Taylor's Cylinder of Sennacherib', [p. 33–53] in *Records of the Past, being English Translations of the Assyrian and Egyptian Monuments*, vol. 1 (1874), Edited by Samuel Birch (London: Samuel Bagster under the sanction of the Society of Biblical Archaeology, 12 volumes, 1874–81).

210 'Legend of Ishtar descending into Hades', [p. 141–49] in *Records of the Past, being English Translations of the Assyrian and Egyptian Monuments*, vol. 1 (1874), Edited by Samuel Birch (London: Samuel Bagster under the sanction of the Society of Biblical Archaeology, 12 volumes, 1874–81).

211 'Inscription of Esarhaddon', [p. 101–02] in *Records of the Past, being English Translations of the Assyrian and Egyptian Monuments*, vol. 3 (1874), Edited by Samuel Birch (London: Samuel Bagster under the sanction of the Society of Biblical Archaeology, 12 volumes, 1874–81).

212 'Second Inscription of Esarhaddon', [p. 109–24] in *Records of the Past, being English Translations of the Assyrian and*

Egyptian Monuments, vol. 3 (1874), Edited by Samuel Birch (London: Samuel Bagster under the sanction of the Society of Biblical Archaeology, 12 volumes, 1874–81).

213 'Assyrian Sacred Poetry', [p. 131–38] in *Records of the Past, being English Translations of the Assyrian and Egyptian Monuments*, vol. 3 (1874), Edited by Samuel Birch (London: Samuel Bagster under the sanction of the Society of Biblical Archaeology, 12 volumes, 1874–81).

214 'Assyrian Talismans and Exorcisms', [p. 139–44] in *Records of the Past, being English Translations of the Assyrian and Egyptian Monuments*, vol. 3 (1874), Edited by Samuel Birch (London: Samuel Bagster under the sanction of the Society of Biblical Archaeology, 12 volumes, 1874–81).

215 'Commentary on the Deluge Tablet'. (Read 4 May 1875). *Transactions of the Society of Biblical Archaeology*, vol. 4, part 1 (June 1875), p. 49–83.

216 'Essay towards a General Solution of Numerical Equations of all Degrees having Integer Roots'. (Read 17 May 1875). *Transactions of the Royal Society of Edinburgh*, vol. 27, part 3 (1874–75), p. 303.

217 'A Tablet relating apparently to the Deluge'. (Read 6 July 1875). *Transactions of the Society of Biblical Archaeology*, vol. 4, part 1 (June 1875), p. 129–31.

218 *Commentary on the Deluge Tablet, together with a second tablet in the British Museum relating apparently to the Deluge*. (London: Privately printed by Harrison and Sons, 1875).

219 'Notice of a very ancient Comet'. (Read 7 December 1875). *Transactions of the Society of Biblical Archaeology*, vol. 4, part 2 (Dec. 1875), p. 257–62.

220 'The Revolt in Heaven'. (Read 1 February 1876). *Transactions of the Society of Biblical Archaeology*, vol. 4, part 2 (Dec. 1875), p. 349–62.

221 'Legend of the Infancy of Sargina I', [p. 1–4] in *Records of the Past, being English Translations of the Assyrian and Egyptian Monuments*, vol. 5 (1875), Edited by Samuel Birch (London: Samuel Bagster under the sanction of the Society of Biblical Archaeology, 12 volumes, 1874–81).

222 'Inscription of Nabonidus, King of Babylon', [p. 143–48] in *Records of the Past, being English Translations of the Assyrian and Egyptian Monuments*, vol. 5 (1875), Edited by Samuel Birch (London: Samuel Bagster under the sanction of the Society of Biblical Archaeology, 12 volumes, 1874–81).

223 'Inscription of Darius at Nakshi Rustam', [p. 149–53] in *Records of the Past, being English Translations of the Assyrian and Egyptian Monuments*, vol. 5 (1875), Edited by Samuel Birch (London: Samuel Bagster under the sanction of the Society of Biblical Archaeology, 12 volumes, 1874–81).

224 'War of the Seven Evil Spirits Against Heaven', [p. 161–66] in *Records of the Past, being English Translations of the Assyrian and Egyptian Monuments*, vol. 5 (1875), Edited by Samuel Birch (London: Samuel Bagster under the sanction of the Society of Biblical Archaeology, 12 volumes, 1874–81).

225 'The Fight between Bel and the Dragon, and the Flaming Sword which Turned Every Way (Gen. iii, 24)'. (Read 7 March 1876). *Transactions of the Society of Biblical Archaeology*, vol. 5, part 1 (June 1876), p. 1–21.

226 'Ishtar and Isdubar, being the Sixth Tablet of the Izdubar Series. Translated from the Cuneiform'. (Read 4 April 1876). *Transactions of the Society of Biblical Archaeology*, vol. 5, part 1 (June 1876), p. 97–121.

227 'Standard Inscription of Ashur-akh-bal', [p. 9–14] in *Records of the Past, being English Translations of the Assyrian and Egyptian Monuments*, vol. 7 (1876), Edited by Samuel Birch (London: Samuel Bagster under the sanction of the Society of Biblical Archaeology, 12 volumes, 1874–81).

228 'Monolith of Ashur-akh-bal', [p. 15–20] in *Records of the Past, being English Translations of the Assyrian and Egyptian Monuments*, vol. 7 (1876), Edited by Samuel Birch (London: Samuel Bagster under the sanction of the Society of Biblical Archaeology, 12 volumes, 1874–81).

229 'A Prayer and a Vision from the Annals of Assurbanipal, King of Syria', [p. 65–68] in *Records of the Past, being English Translations of the Assyrian and Egyptian Monuments*, vol. 7 (1876), Edited by Samuel Birch (London: Samuel Bagster under the sanction of the Society of Biblical Archaeology, 12 volumes, 1874–81).

230 'Senkereh Inscription of Nebuchad-nezzar', [p. 69–72] in *Records of the Past, being English Translations of the Assyrian and Egyptian Monuments*, vol. 7 (1876),

Edited by Samuel Birch (London: Samuel Bagster under the sanction of the Society of Biblical Archaeology, 12 volumes, 1874–81).

231 'The Birs-Nimrud Inscription of Nebuchadnezzar', [p. 73–78] in *Records of the Past, being English Translations of the Assyrian and Egyptian Monuments*, vol. 7 (1876), Edited by Samuel Birch (London: Samuel Bagster under the sanction of the Society of Biblical Archaeology, 12 volumes, 1874–81.).

232 'The Revolt in Heaven', [p. 123–28] in *Records of the Past, being English Translations of the Assyrian and Egyptian Monuments*, vol. 7 (1876), Edited by Samuel Birch (London: Samuel Bagster under the sanction of the Society of Biblical Archaeology, 12 volumes, 1874–81).

233 'The Chaldean Account of the Creation'. (Read 4 January 1876). *Transactions of the Society of Biblical Archaeology*, vol. 5, part 2 (June 1877), p. 426–40.

234 'On the Cypriote Inscriptions'. (Read 6 February 1877). *Transactions of the Society of Biblical Archaeology*, vol. 5, part 2 (June 1877), p. 447–55.

235 'Chaldean Account of the Creation', [p. 115–18] in *Records of the Past, being English Translations of the Assyrian and Egyptian Monuments*, vol. 9 (1877), Edited by Samuel Birch (London: Samuel Bagster under the sanction of the Society of Biblical Archaeology, 12 volumes, 1874–81).

236 'Ishtar and Izdubar', [p. 119–28] in *Records of the Past, being English Translations of the Assyrian and Egyptian*

Monuments, vol. 9 (1877), Edited by Samuel Birch (London: Samuel Bagster under the sanction of the Society of Biblical Archaeology, 12 volumes, 1874–81).

237 'The Fight between Bel and the Dragon', [p. 135–40] in *Records of the Past, being English Translations of the Assyrian and Egyptian Monuments*. vol. 9 (1877), Edited by Samuel Birch (London: Samuel Bagster under the sanction of the Society of Biblical Archaeology, 12 volumes, 1874–81).

238 'The Defence of the Magistrate Falsely Accused. From a Tablet in the British Museum'. (Read 5 June 1877). *Transactions of the Society of Biblical Archaeology*, vol. 6, part 1 (Jan. 1878), p. 289–304.

239 'Appendix A, Parts I–II'*, [p. 346–66] in Gaston Tissandier, *A History and Handbook of Photography*, Edited by John Thomson, second and revised edition (London: Sampson, Marston, Low & Searle, 1878. 400 pp. 20 illus.). Reprinted (New York: Arno Press, 1973).
 Part III [p. 368–78], on photoglyphic engraving, was written by Talbot's son, Charles Henry Talbot.

240 René Colson, Editor. *Mémoires originaux des créateurs de la photographie: Nicéphore Niépce, Daguerre, Bayard, Talbot, Niépce de Saint-Victor, Poitevin*. (Paris: Gauthier-Villars, 1898.).
 This collection includes translations of letters on photogenic drawing paper (p. 84–90), on the Calotype (p. 91–93), the patent specification for the Calotype (p. 94–100), letters on instantaneous photography (p. 101–03), and the patent specification for photoglyphic engraving (p. 104–14).

Works Written about Henry Fox Talbot

241 Rev. W. L. Bowles and J. B. Nicholls. *Annals and Antiquities of Lacock Abbey*. (London: J. B. Nicholls and Son, 1835).

242 Joseph-Antoine-Ferdinand Plateau. 'Betrachtungen über ein von Hrn Talbot vorgeschlagenes photometrisches Princip'. *Annalen der Physik und Chemie* (Leipzig), vol. 35, no. 7 (1835), p. 457–68.

These observations were reprinted from *Bulletin de l'Académie royale des sciences et belles-lettres de Bruxelles*, no. 2, p. 52; and no. 3, p. 89.

243 Anon. 'Our Weekly Gossip'. *Athenaeum*, no. 588 (2 Feb. 1839), p. 96.

244 Anon. 'Photogenic Drawing'. *Literary Gazette*, no. 1151 (9 Feb. 1839), p. 90.

245 Anon. 'Photogenic Drawing'. *Literary Gazette*, no. 1157 (23 March 1839), p. 187.

This discussion sparked a controversy with Talbot about the priority of his invention.

246 Anon. 'Painting by the Action of Light'. *Chambers's Edinburgh Journal*, vol. 8, no. 374 (30 March 1839), p. 77–78.

247 Anon. 'The Photogenic Art'. *Literary Gazette*, no. 1159 (6 April 1839), p. 215.

248 Anon. 'On Photogenic Drawing'. *Saturday Magazine*, vol. 14, no. 435 (13 April 1839), p. 138–39.

249 Anon. 'Daguerre – Photogenic Drawings'. *Foreign Quarterly Review*, vol. 23, no. 45 (April 1839), p. 213–18.

250 Anon. 'The New Art – Photography. Part 1–Part 4'. *Mirror of Literature*, vol. 33, nos 946–47, 949–50 (27 April–25 May 1839), p. 262–63, 281–83, 317–18, 333–35.

251 Alfred Smee. 'Photogenic Drawing'. *Literary Gazette*, no. 1162 (18 May 1839), p. 314–16.

252 Anon. 'Photogenic Drawings. Part 1–Part 4'. *Magazine of Science and School of Arts*, vol. 1, no. 1, 4–5, 8 (1 April, 27 April, 1 May, 25 May 1839), p. 18–20, 25–27, 33–35, 59–60.

253 J.C. Constable. 'On the Use of Ammonia in Fixing Photographs'. *Philosophical Magazine* ser. 3, vol. 14, no. 91 (June 1839), p. 474–75.

254 Alfred S. Taylor. *On the Art of Photogenic Drawing*. (London: Jeffrey, 7 George Yard, Lombard Street, 1840. 37 pp.).

255 Jean-Baptiste Biot. 'Note sur des dessins photogéniques de M. Talbot'. *Comptes Rendus hebdomadaires des Séances de l'Académie des Sciences*, vol. 10, no. 12 (first semester, 1840), p. 483–88.

256 Anon. 'Photogenic Drawings'. *Literary Gazette*, no. 1217 (16 May 1840), p. 315–16.
An album and separately framed specimens of photogenic drawings were shown at a large meeting of the Graphic Society on 13 May.

257 [T.B. Jordan]. 'Réclamation de priorité en faveur de M. Jordan pour l'application des procédés photographiques aux besoins de la météorologie'. *Comptes Rendus hebdomadaires des Séances de l'Académie des Sciences*, vol. 11, no. 14 (second semester, 1840), p. 574.
This claim for a recording device by Jordan using photographic paper was forwarded by Talbot himself.

258 Anon. 'Miglioramenti portati da Taylor al processo Talbot'. *Annali di Fisica, Chimica e Matematiche* (Milan), vol. 1 (Feb. 1841), p. 221.
This short notice, published in the *Bollettino dell'Industria meccanica e chimica* as an appendix to the *Annali di Fisica*, refers to Alfred Swaine Taylor, *On the Art of Photogenic Drawing*, London: Jeffrey, 1840. See Bibl. **254**.

259 Anon. 'Our Weekly Gossip'. *Athenaeum*, no. 711 (12 June 1841), p. 461.

260 Anon. 'Calotype'. *American Repertory of Arts, Sciences and Manufactures*, vol. 4, no. 1 (Aug. 1841), p. 47–48.

261 Anon. 'Calotypes'. *Literary Gazette*, no. 1312 (12 March 1842), p. 184.

262 Anon. 'Things of the Day. No. III. Photography.' *Blackwood's Edinburgh Magazine*, vol. 51, no. 318 (April 1842), p. 517–18.

263 [Sir David Brewster]. 'Photogenic Drawing or Drawing by the Agency of Light'. *Edinburgh Review*, vol. 76, no. 154 (Jan. 1843), p. 309–44.

264 Anon. 'Note: "We have just heard of a curious & interesting practical application of a recent scientific discovery . . ."' *Athenaeum*, no. 794 (14 Jan. 1843), p. 39.

265 George S. Cundell. 'On the practice of the Calotype Process of Photography'. *Philosophical Magazine* ser. 3, vol. 24, no. 160 (May 1844), p. 321–32.

266 [William Jerdan]. 'The Pencil of Nature. No. 1.'. *Literary Gazette*, no. 1432 (29 June 1844), p. 410.

267 Anon. 'The Pencil of Nature'. *Spectator* (London), vol. 17, no. 838 (20 July 1844), p. 685.

268 Anon. [Review of *The Pencil of Nature No. 1*]. *The Critic: Journal of British & Foreign Literature and the Arts*, vol. 2, no. 15 (new ser. vol. 1, no. 1) (15 Aug. 1844), p. 12.

269 Anon. 'The Pencil of Nature. No. 1'. *Art Union*, vol. 6, no. 69 (Aug. 1844), p. 223.

270 Anon. 'The Pencil of Nature'. *Littell's Living Age*, no. 18 (14 Sept. 1844), p. 337.

271 [William Jerdan]. 'The Pencil of Nature. No. II'. *Literary Gazette*, no. 1463 (1 Feb. 1845), p. 73.

272 Anon. ' "The Pencil of Nature", by Henry Fox Talbot, F.R.S. Parts I and II. Longman & Co.'. *Athenaeum*, no. 904 (22 Feb. 1845), p. 202–03.

273 Anon. 'The Pencil of Nature. No. 2'. *Art Union*, vol. 7, no. 78 (1 March 1845), p. 84.

274 [William Jerdan]. 'The Pencil of Nature. No. III'. *Literary Gazette*, no. 1481 (7 June 1845), p. 365.

275 Anon. ' "The Pencil of Nature", by Henry Fox Talbot, Esq, F.R.S. Part III. Longman & Co.'. *Athenaeum*, no. 920 (14 June 1845), p. 592–93.

276 [William Jerdan]. 'The Pencil of Nature. No. IV.'. *Literary Gazette*, no. 1488 (26 July 1845), p. 500.

277 Anon. 'The Pencil of Nature. No. 3.'. *Art Union*, vol. 7, no. 85 (Sept. 1845), p. 296.

278 Anon. 'The Pencil of Nature. No. 4.'. *Art Union*, vol. 7, no. 86 (1 Oct. 1845), p. 325.

279 Sir David Brewster. 'An Improvement in the Method of Taking Positive Talbotypes (Calotypes)'. *British Association for the Advancement of Science, Report for 1845*, vol. 14, part 2 (1846), p. 10–11.

280 [William Jerdan]. 'The Pencil of Nature. No. V.'. *Literary Gazette*, no. 1512 (10 Jan. 1846), p. 38–39.

281 [William Jerdan]. 'The Pencil of Nature. No. VI.'. *Literary Gazette*, no. 1529 (9 May 1846), p. 433.

282 Anon. 'The Talbotype – Sun Pictures'. *Art Union*, vol. 8, no. 91 (1 June 1846), frontispiece, p. 143–44.
This text which accompanied an original Talbotype as frontispiece stated that the photographs could be purchased from Gambart and Co. and Ackermann and Co. in London, and ordered from printsellers everywhere.

283 Anon. 'The Application of the Talbotype'. *Art Union*, vol. 8, no. 92 (July 1846), p. 195.

284 Anon. 'The Talbotype: Sun Pictures'. *Littell's Living Age*, vol. 10 (July–Sept. 1846), p. 213–16.

285 Anon. 'New Publications: 'The Pencil of Nature', by H. Fox Talbot, F.R.S. No. 6.'. *Athenaeum*, no. 985 (12 Sept. 1846), p. 939.

286 Anon. 'Reviews of New Books: "English Etymologies", by H. Fox Talbot, Esq.'. *Literary Gazette*, no. 1566 (23 Jan. 1847), p. 57–58.

287 Anon. 'Mr. Fox Talbot's English Etymologies. [In Continuation]'. *Literary Gazette*, no. 1567 (30 Jan. 1847), p. 87–89.

288 Anon. 'Mr. Talbot's English

Etymologies. [Concluded]'. *Literary Gazette*, no. 1568 (6 Feb. 1847), p. 109–11.

289 Anon. 'English Etymologies, by H. Fox Talbot'. *Athenaeum*, no. 1027 (3 July 1847), p. 693–95.

290 [Sir David Brewster]. 'Photography'. *North British Review*, vol. 7, no. 14 (Aug. 1847), p. 465–504; American edition p. 248–69. Reprinted *Eclectic Magazine*, vol. 12, no. 2 (Oct. 1847), p. 230–49.

291 [J.W. Croker]. [Review of *English Etymologies*]. *Quarterly Review*, vol. 81 (Sept. 1847), p. 500–25.

292 William Stirling. *Annals of the Artists of Spain – Talbotype Illustrations to the Annals of the Artists of Spain*. [calotypes of engravings] Executed under the supervision of [Sir] William Stirling [-Maxwell] by Nicolaas Henneman. (London: Ollivier, 1847. 62 leaves of plates (1 fold). 66 illus. 25 copies printed).

293 Anon. 'Photographic Club'. *Art Union*, vol. 10, no. 118 (Apr. 1848), p. 130–31.

294 Anon. 'Annals of the Artists of Spain'. *Art Union*, vol. 10, no. 122 (Aug. 1848), p. 240.

295 Thomas Augustine Malone. 'Photography on Paper and on Glass'. *Art Journal* (1 Aug. 1850), p. 261.

296 Anon. 'The Patent of Mr. Fox Talbot'. *Art Journal* (1 Aug. 1850), p. 261–62.

297 N. Whitlock. 'Photographic Drawing Made Easy; A Plain and Practical Introduction to Drawing and Writing by the Action of Light'. *Photographic Art Journal*, vol. 1, no. 2 (Feb. 1851), p. 96–101.

298 Anon. 'Mr. Fox Talbot's Patents in England'. *Photographic Art Journal*, vol. 1, no. 5 (May 1851), p. 300–04.

299 Anon. 'Instantaneous Photogenic Images'. *Athenaeum*, no. 1235 (28 June 1851), p. 688.

300 Anon. 'Instantaneous Photographic Impressions on Paper'. *Art Journal* (1 Aug. 1851), p. 217–18.

301 *The Great Exhibition of the Works of Industry of all Nations, 1851. Reports by the Juries. Official Descriptive and Illustrated Catalogue, by authority of the Royal Commission*. Nine volumes. (London: Spicer Brothers, Wholesale Stationers; William Clowes and Sons, Printers, 1852).

> Nicolaas Henneman made a hundred and fifty-four prints on Talbot's silver chloride paper, from negatives made on albumenized glass plates by Ferrier and on Calotype paper by Hugh Owen. Although not published by him, Talbot received fifteen sets of the publication for the use of his process.

302 Anon. 'Photography'. *Art Journal* (1 Feb. 1852), p. 65.

303 Anon. 'Fine Art Gossip'. *Athenaeum*, no. 1288 (29 May 1852), p. 610.

304 Anon. 'Fox Talbot's Patents – Amphitype Pictures on Glass – Archer's Collodion Process'. *Humphrey's Journal*, vol. 4, no. 1 (15 April 1852), p. 13–15.

305 Anon. 'Photography and Its Patents'. *Photographic Art Journal*, vol. 4, no. 1 (July 1852), p. 41–45.

306 Anon. 'Photography and Its Patents'. *Humphrey's Journal*, vol. 4, no. 6 (1 July 1852), p. 84–88.

307 Anon. 'Whitlock's Application of Photography to the Purposes of Drawing'. *Humphrey's Journal*, vol. 4, no. 8 (1 Aug. 1852), p. 125–26.

308 Anon. 'Photographie'. *Cosmos: Revue Encyclopédique Hebdomadaire des Progrès des Sciences* (Paris), vol. 1, no. 18 (29 Aug. 1852), p. 420–21.
This includes Talbot's resignation of his patent.

309 Anon. 'Resignation of the Photographic Patents'. *Art Journal* (1 Sept. 1852), p. 270–71.

310 Anon. 'Chemical Gleanings: Mr. Talbot's Patent'. *Humphrey's Journal*, vol. 4, no. 11 (15 Sept. 1852), p. 175.

311 Anon. 'Reservations made by Mr. Talbot in throwing up his Patent, with remarks upon it'. *Humphrey's Journal*, vol. 4, no. 13 (15 Oct. 1852), p. 197.

312 Anon. 'Talbot and His Process'. *Humphrey's Journal*, vol. 4, no. 16 (1 Dec. 1852), p. 251–52.

313 Erich Stenger. 'Humboldt als Gegner Talbots und der Ausgleich'. *Zeitschrift für wissenschaftliche Photographie, Photophysik und Photochemie* (Leipzig), vol. 49, nos 1–6 (1953), p. 17–24.

314 Anon. 'Talbot's Patent in England'. *Humphrey's Journal*, vol. 4, no. 22 (1 March 1853), p. 350–51.

315 Robert Hunt. 'The Calotype'. *Humphrey's Journal*, vol. 5, no. 1 (15 April 1853), p. 1–6.

316 Anon. 'Engraving Photographs on Steel'. *Illustrated London News*, vol. 22, no. 620 (7 May 1853), p. 359.

317 Anon. 'Fine-Art Gossip'. *Athenaeum*, no. 1337 (11 June 1853), p. 711.

318 Anon. 'Daguerreotype on Porcelain'. *Humphrey's Journal*, vol. 5, no. 12 (1 Oct. 1853), p. 187–89.

319 [Hugh Welch] Diamond. 'On the Simplicity of the Calotype Process'. *Journal of the Photographic Society* (21 Nov. 1853), p. 130.

320 [R.S.N.]. 'Mr. Fox Talbot's Patent of 1841'. *Journal of the Photographic Society of London*, vol. 1, no. 18 (21 June 1854), p. 222.

321 Anon. 'The Photographic Patents'. *Art Journal* (1 Aug. 1854), p. 236–38.

322 Sir David Brewster, Sir J.F.W. Herschel. 'Extracts of Affidavits Respecting the Calotype Photographic Process'. *Liverpool Photographic Journal*, vol. 1, no. 8 (12 Aug. 1854), p. 110.

323 S.D. Humphrey. 'Talbot's Patent'. *Humphrey's Journal*, vol. 6, no. 9 (15 Aug. 1854), p. 137.

324 Alfred Boulongne. *Photographie et gravure héliographique: histoire et exposé des divers procédés employés dans cet art depuis Joseph Niépce et Daguerre jusqu'à nos jours.* (Paris: Lerebours & Secretan, 1854. 58 pp.).

325 Anon. 'The Photographic Patents'. *Humphrey's Journal*, vol. 6, no. 10 (1 Sept. 1854), p. 155–59.

326 Anon. 'Mr. Fox Talbot's Patents'.

Humphrey's Journal, vol. 6, no. 11 (15 Sept. 1854), p. 162–65, 168.

327 Anon. 'Photographic Society: Extraordinary Meeting – Thursday, July 6, 1854'. *Humphrey's Journal*, vol. 6, no. 11 (15 Sept. 1854), p. 172–73.

328 Anon. 'The Photographic Patents'. *Photographic and Fine Art Journal*, vol. 7, no. 9 (Sept. 1854), p. 277–78.

329 William J. Newton. 'Talbot's Patent'. *Humphrey's Journal*, vol. 6, no. 13 (15 Oct. 1854), p. 193–94.

330 *Affidavits made by Sir D. Brewster and Sir J. Herschel respecting the Calotype Photographic Process Invented by H.F. Talbot Esq.* ([London]: Privately printed by Cox (Bros.) & Wyman, [1854]. 8 pp.).

331 Anon. 'Photography'. *Journal of the Royal Scottish Society of Arts*, vol. 3, no. 110 (29 Dec. 1854), p. 100–01.

332 Auguste Belloc. *Les quatres branches de la photographie.* (Paris: Belloc, 1855. 475 pp.).

333 Anon. 'The Photographic Patent Right: Talbot v. Laroche'. *Art Journal* (1 Feb. 1855), p. 49–54.

334 Anon. 'The Talbot Patent'. *Photographic and Fine Art Journal*, vol. 8, no. 2 (Feb. 1855), p. 37–38.

335 Anon. 'Law Reports in Patents: Photography – Talbot v. Laroche – Infringement'. *Practical Mechanic's Journal*, vol. 7, no. 83 (Feb. 1855), p. 261–62.

336 J. Baker Edwards. 'Observations on

the Chemical Points at Issue in the Trial Talbot v. Laroche'. *Liverpool Photographic Journal*, vol. 2, no. 15 (10 March 1855), p. 40–42.

337 W.H. Thornthwaite. 'Correspondence: Talbot v. Laroche'. *Art Journal* (1 April 1855), p. 127.

338 Anon. 'The Photographic Patent Right: Talbot vs. Laroche'. *Photographic and Fine Art Journal*, vol. 8, no. 4 (April 1855), p. 101–10.

339 Anon. 'Fox Talbot v. Laroche'. *Photographic and Fine Art Journal*, vol. 8, no. 8 (Aug. 1855), p. 234.

340 Thomas Augustine Malone. [On the Fading of Prints]. *Liverpool Photographic Journal*, vol. 3, no. 28 (12 April 1856), p. 51–53.

Here Malone claims that he had seen prints of *The Pencil of Nature* in the library of the London Institution as fresh and brilliant as when they were first issued: 'He had some older specimens of Mr Fox Talbot's, which received a purple tint by allowing a small quantity of hyposulphite to remain after the last washing, and then, while the picture was slightly damp, passing a hot iron over its surface. In 1844 he first used this method of deepening the colour, and found that pictures prepared in this manner had retained their perfection and details for several years'.

341 Thomas Frederick Hardwich. 'On the action of Damp Air upon Positive Prints'. *Journal of the Photographic Society*, vol. 3, no. 42 (21 May 1856), p. 39–44.

On page 43 Nicolaas Henneman spoke in the discussion period about how he gave the

prints for *The Pencil of Nature* only three washings.

342 William J. Newton. 'Inventor of the Paper Process'. *Photographic and Fine Art Journal*, vol. 10, no. 3 (March 1857), p. 95.

343 Anon. 'Specifications of Mr. Fox Talbot's Calotype Patent'. *Photographic and Fine Art Journal*, vol. 10, no. 7 (July 1857), p. 208–10.

344 Anon. 'History of Photography. – Photographic Engraving'. *Photographic and Fine Art Journal*, vol. 10, no. 12 (Dec. 1857), p. 356–57.

345 Anon. 'Amateur's Column'. *Liverpool and Manchester Photographic Journal*, new ser. vol. 2, no. 2 (15 Jan. 1858), p. 23–24.

346 Anon. 'The "Pencil of Nature" Process of Mr. Fox Talbot'. *Photographic and Fine Art Journal*, vol. 11, no. 2–3 (Feb.–March 1858), p. 54–55, 94.

347 [William Crookes]. 'Mr. Fox Talbot's New Discovery: Photoglyptic Engraving'. *Photographic News*, vol. 1, no. 3 (24 Sept. 1858), p. 25–26.

348 Anon. 'Photoglyptic Engraving'. *Journal of the Royal Scottish Society of Arts*, vol. 6, no. 310 (29 Oct. 1858), p. 697–98.

349 [William Crookes]. 'The Prospective Advantages of the New Art – Photoglyphy'. *Photographic News*, vol. 1, no. 9 (5 Nov. 1858), p. 97–98.

350 [William Crookes]. 'Our Photoglyphic Illustrations'. *Photographic News*, vol. 1, no. 10 (12 Nov. 1858), p. 109, with a photoglyphic engraving between p. 114–15.

351 Anon. 'Photoglyphic Engraving'. *Photographic News*, vol. 1, no. 11 (19 Nov. 1858), p. 122.

352 Anon. 'Photoglyphy'. *Photographic News*, vol. 1, no. 15 (17 Dec. 1858), p. 173.

353 Anon. 'Photographic Engraving'. *Ballou's Pictorial Drawing-Room Companion*, vol. 16, no. 395 (15 Jan. 1859), p. 47.

354 Robert Hunt. 'Photoglyphic Engraving'. *Art Journal* (1 Feb. 1859), p. 46.

355 M.M.D. 'Photoglyphic Engraving'. *Photographic News*, vol. 1, no. 22 (4 Feb. 1859), p. 260.
This a complaint from someone living in Carlow, Ireland, having difficulties reproducing Talbot's process.

356 George Mathiot. 'Mr. Talbot's recent Patent for improvement in Photoglyptic Engraving, not Original'. *Humphrey's Journal*, vol. 11, no. 15 (1 Dec. 1859), p. 225–26.

357 Anon. ' "The Tuileries": Photoglyph by Mr. Fox Talbot's patent process'. *Photographic News*, vol. 3, no. 54 (16 Sept. 1859), frontispiece, p. 13–14.

358 Anon. 'Photographic Engraving: Letter from A Member of the Photographic Society'. *Photographic News*, vol. 3, no. 70 (6 Jan. 1860), p. 210–11.

359 Mr. Rothwell. 'On the apparently incorrect Perspective of Photographic Pictures'. *Photographic Journal*, vol. 7, no. 103 (15 Nov. 1860), p. 23–34.

On page 33 Thomas Malone recounts the tale about Henry Collen the artist, rejecting Talbot's set-up of *The Ladder* as inartistic on account of perspectival distortion.

360 Anon. 'Photography as Employed for the Illustration of Books'. *Art Journal* (Feb. 1861), p. 48.

361 Thomas Augustine Malone. 'London Photographic Society Proceedings'. *Photographic News*, vol. 5, no. 131 (8 March 1861), p. 113–16.
On page 115 Malone revealed that only six gallons of water was used to wash twenty-five nine by seven inch prints in the making of *The Pencil of Nature*, and surmised that the hyposulphite left in them was probably the main cause of their fading.

362 Anon. 'Waifs and Strays'. *British Journal of Photography*, vol. 10, no. 188 (15 April 1863), p. 173.

363 Anon. 'A Reward for Photographic Discovery'. *American Journal of Photography and the Allied Arts & Sciences*, new ser. vol. 5, no. 23 (1 June 1863), p. 534–35.

364 Anon. 'Chemical Engravings'. *Journal of the Society of Arts*, vol. 12, no. 574 (27 Nov. 1863), p. 31.

365 J. Traill Taylor. 'Wiliam Henry Fox Talbot'. *British Journal of Photography*, vol. 11, no. 217 (1 July 1864), p. 220–21; no. 219 (15 July 1864), p. 242–43; no. 222 (5 Aug. 1864), p. 278–79; no. 224 (19 Aug. 1864), p. 303; no. 227 (9 Sept. 1864), p. 340–41; no. 233 (21 Oct. 1864), p. 412–13.

366 W.H. Fitch. Illustration of *Talbotia elegans* named in honour of Talbot by Prof. Balfour, Royal Botanic Garden, Edinburgh. *Curtis's Botanical Magazine*, ser. 3, vol. 25, (1869), plate 5803.

367 *Catalogue of the Scientific Papers*. Compiled and published by the Royal Society of London (1800–63), vol. 5 (1871), p. 909–10; (1864–73), vol. 8 (1879), p. 1056, vol. 11 (1896), p. 546.

368 Sir Henry Rawlinson. 'Inscription of Tiglath Pileser I, King of Assyria', [p. 5–26] in *Records of the Past, being English Translations of the Assyrian and Egyptian Monuments*, vol. 5 (1875), Edited by Samuel Birch (London: Samuel Bagster and Sons under the sanction of the Society of Biblical Archaeology, 12 volumes, 1874–81).

369 Vernon Heath. 'Correspondence: Mr. Fox Talbot and the Bichromate process'. *Photographic News*, vol. 21, no. 968 (23 March 1877), p. 142.

370 Anon. 'Photography In and Out of the Studio: Honour from Abroad to Fox Talbot'. *Photographic News*, vol. 21, no. 975 (11 May 1877), p. 217.

371 Anon. 'William Henry Fox Talbot. F.R.S.'. *Photographic News*, vol. 21, no. 995 (28 Sept. 1877), p. 462–63.

372 J. Traill Taylor. 'The Late W.H. Fox Talbot'. *British Journal of Photography*, vol. 24, no. 908 (28 Sept. 1877), p. 460–61.

373 Anon. 'The Discoverer of Talbotype'. *Photographic News*, vol. 21, no. 995 (28 Sept. 1877), p. 459.

374 Anon. 'Mr. Fox Talbot'. *Athenaeum*, no. 2605 (29 Sept. 1877), p. 406.

375 Anon. 'The Late W.H. Fox Talbot'.

Photographic News, vol. 21, no. 996 (5 Oct. 1877), p. 471–72.

376 Ernest Lacan. 'French Correspondence: Fox Talbot'. *Photographic News*, vol. 21, no. 997 (12 Oct. 1877), p. 487.

377 Anon. 'Fox Talbot'. *Nature*, vol. 16, no. 416 (18 Oct. 1877), 523–25.

378 Anon. 'The Late H. Fox Talbot'. *Photographic News*, vol. 21, no. 999 (26 Oct. 1877), p. 507–09.

379 Anon. 'Obituary: William Henry Fox Talbot'. *Philadelphia Photographer*, vol. 14, no. 166 (Oct. 1877), p. 311.

380 Anon. 'Obituary: William Henry Fox Talbot'. *Anthony's Photographic Bulletin*, vol. 8, no. 10 (Oct. 1877), p. 308.

381 Anon. 'The Late W.H. Fox Talbot'. *Philadelphia Photographer*, vol. 14, no. 167 (Nov. 1877), p. 321–25.

382 Anon. 'William Henry Fox Talbot, F.R.S.'. *Photographic Times*, vol. 7, no. 83 (Nov. 1877), p. 246–48.

383 Anon. 'The Discoverer of the Talbotype'. *Photographic Times*, vol. 7, no. 83 (Nov. 1877), p. 248–50.

384 Anon. 'Obituary: William H. Fox Talbot, F.R.S.'. *Art Journal* (Dec. 1877), p. 367.

385 F.A. Wenderoth. 'Honor to Whom Honor is Due'. *Philadelphia Photographer*, vol. 14, no. 168 (Dec. 1877), p. 356–57.

386 C.H. Talbot. 'The Photoglyphic Engraving Process' [Appendix A, Part III, p. 366–78] in Gaston Tissandier, *A History and Handbook of Photography*, Edited by John Thomson, second and revised edition (London: Sampson, Marston, Low & Searle, 1878. 400 pp. 20 illus.). Reprinted (New York: Arno Press, 1973).

387 Anon. 'Secretary's Report for the Year 1877, presented at the Anniversary Meeting, January 8, 1878'. *Transactions of the Society of Biblical Archaeology*, vol. 6, part 1 (Jan. 1878), p. i.

388 Richard Cull. 'A Biographical Notice of the Late William Henry Fox Talbot, F.R.S.'. *Transactions of the Society of Biblical Archaeology*, vol. 6 (1878), p. 543–59.

389 Anon. 'Condensed Report of the Proceedings, 1876–77'. *Transactions of the Society of Biblical Archaeology*, vol. 6, part 2 (Jan. 1879), p. 589.

390 J. Traill Taylor. 'Home and Foreign News Epitomized'. *Photographic Times*, vol. 11, no. 124 (April 1881), p. 129–30.

391 H. E. Roscoe and C. Schorlemmer. *A Treatise on Chemistry*. 2 volumes (London: Macmillan, 1880), vol. 1, p. 465–69.
This historical sketch on spectrum analysis shows Talbot made a significant contribution to the field.

392 Samuel Carter Hall. *Retrospect of a Long Life*. 2 volumes (London: Richard Bentley, 1883), vol. 1, p. 4–5.

393 W. Jerome Harrison. 'The First Book Illustrated by Photographs'. *Amateur Photographer*, vol. 2, no. 43 (31 July 1885), p. 262–63.

394 J. Traill Taylor. 'Editorial Mirror'. *Photographic Times*, vol 15, no. 216 (6 Nov. 1885), p. 623.

395 W. Jerome Harrison. 'The Chemistry of Fixing'. *Photographic Times*, vol. 20, no. 471 (26 Sept. 1890), p. 481–82.

396 W. Jerome Harrison. 'The Toning of Photographs Considered Chemically, Historically, and Generally. Chapter 2. Talbot and Hunt on the Toning of Paper Prints'. *Photographic Times*, vol. 21, no. 499 (10 April 1891), p. 171–73.

397 William Lang, Jr. 'The Photographic Work of Herschel and Fox Talbot'. *British Journal of Photography*, vol. 38, no. 1628 (17 July, 1891), p. 452–55.

398 W.H. Sherman. 'Photographers, Don't Forget the Founder of Your Art'. *Photographic Mosaics: 1891*, vol. 27 (1891), p. 250–52.

399 Anon. 'Early Photographs by Fox Talbot' [p. 191–92] in *The Year-Book of Photography and Photographic Times News Almanac*, 31st year (London: Piper & Carter, [1891]).

400 William Lang Jr. 'Early Talbotypes and Where to Find Them'. *American Annual of Photography and Photographic Times Almanac for 1892*, (1892), p. 73–74.

401 B. Cowderoy. 'The Talbotype or Sun Pictures'. *Photography*, vol. 7 (6 June 1895), p. 361–63.

402 Anon. 'An Old Instantaneous Albumen Process'. *Wilson's Photographic Magazine*, vol. 35, no. 499 (July 1898), p. 317–18.

403 René Colson, Editor. *Mémoires originaux des créateurs de la photographie. Nicéphore Niépce, Daguerre, Bayard, Talbot, Niépce de Saint-Victor, Poitevin.* (Paris: G. Carré et C. Naud, 1898. 186 pp.). Reprinted (New York: Arno Press, 1979).

404 [George Brown]. 'An Enquiry into the Early History of Photography: A Sketch of the Life of W.H. Fox Talbot'. *The Photogram*, vol. 7, no. 79 (July 1900), p. 223–25; no. 80 (Aug. 1900), p. 245–47; no. 81 (Sept. 1900), p. 275–81.

405 George Brown. 'Enquiry into the Early History of Photography – A Sketch of the Life of W.H. Fox Talbot'. *Photographic Times*, vol. 32, no. 7 (July 1900), p. 297–302; no. 8 (Aug. 1900), p. 355–60; no. 9 (Sept. 1900), p. 400–03.

406 G.C. Boase. 'William Henry Fox Talbot', [p. 339–41] in *Dictionary of National Biography*, Edited by Sidney Lee, vol. 19 (London: Smith, Elder & Co., 1909).

407 [Memorial bronze portrait tablet dedicated to Talbot at the house of the Royal Photographic Society, 35 Russell Square, September 13, 1924]. *Nature*, vol. 114, no. 2864 (20 Sept. 1924), p. 441.

408 Giuseppe Albertotti. *Disegni Fotogenici Communicati da Fox Talbot a G.B. Amici (1840–41) e Correspondenza Amiciana.* (Roma: Typografia delle Scienze, 1926. 11 pp.).

409 Edward Epstean. 'William Henry Fox Talbot'. *Photo-Engravers Bulletin*, vol. 23, no. 11 (June 1934), p. 14–37.

410 Anon. 'The Fox Talbot Centenary: Commemoration at Lacock Abbey'.

Photographic Journal, vol. 74, no. 8 (Aug. 1934), p. 427.

411 Prebendary W.G. Clark-Maxwell. 'The Personality of Fox Talbot'. *Photographic Journal*, vol. 74, no. 8 (Aug. 1934), p. 428–30.

412 Herbert Lambert. 'Fox Talbot's Photographic Inventions'. *Photographic Journal*, vol. 74, no. 8 (Aug. 1934), p. 430–32.

413 A.J. Bull. 'Fox Talbot's Photoglyphic Engraving'. *Photographic Journal*, vol. 74, no. 8 (Aug. 1934), p. 432–33, 435.

414 *Centenary of Photography. Exhibition of prints made by Henry Fox Talbot between 1834–1846 together with early cameras used by him.* London: Elliot & Fry's Gallery (November 1934. 4 pp.).

415 Beaumont Newhall. *Photography 1839–1937. A Short Critical History.* (New York: The Museum of Modern Art, 1937). Second edition, *Photography: A Short Critical History*, 1938. Third edition, *The History of Photography from 1839 to the Present Day*, 1949; fourth edition, 1964; fifth edition, 1982. Japanese edition, *Shashin no rekishi* (Tokyo: Hakuyosha, 1956). French edition, *L'histoire de la photographie, depuis 1839 et jusqu'à nos jours* (Paris: Bélier-Prisma, 1967). German edition, *Geschichte der Photographie* (Munich: Schirmer/Mosel, 1984). Italian edition, *Storia della fotografia* (Turin: Einaudi, 1984). Spanish edition, *Historia de la fotografia* (Barcelona: G. Gili, 1983).

416 A.J. Bull and H. Mills Cartwright. 'Fox Talbot's Pioneer Work in Photo-Engraving'. *Photographic Journal*, vol. 77, no. 5 (May 1937), p. 307–13.

417 Matilda Theresa Talbot. 'The Life and Personality of Fox Talbot'. *Journal of the Royal Society of Arts*, vol. 87, no. 4517 (23 June 1939), p. 826–30.

418 Matilda Theresa Talbot. 'The Life and Personality of Fox Talbot'. *Photographic Journal*, vol. 79, no. 9 (Sept. 1939), p. 546–49.

419 J. Dudley Johnston. 'Sidelight on Fox Talbot'. *Photographic Journal*, vol. 81, no. 1 (Jan. 1941), p. 24–26.

420 Josef Maria Eder. *History of Photography*. (New York: Columbia University Press, 1945.). Reprinted (New York: Dover Publications, 1978. 860 pp.).

421 J. Dudley Johnston. 'William Henry Fox Talbot, F.R.S.: Materials Towards a Biography'. *Photographic Journal*, vol. 87, no. 1 (Jan. 1947), p. 3–13.
For the second part of this article, published in 1968, see Bibl. **455**.

422 T.P. Kravets, Editor. *Dokumenti po istorii izobretenia fotografi*. (Moscow, 1949).

423 Harold White. 'William Henry Fox Talbot, The First Miniaturist'. *Photographic Journal*, vol. 89, no. 11 (Nov. 1949), p. 247–51.

424 Harold White. 'Fox Talbot – Founder of Modern Photography'. *Amateur Photographer*, vol. 100, no. 3196 (8 Feb. 1950), p. 92–94.

425 Harold White. 'The Story of Fox Talbot 1800–1877'. *Photography* (London)

new ser. vol. 5, no. 1 (Jan. 1950), p. 6–9, 32.

426 Anon. *The Father of Modern Photography. An Account of the Life of W.H. Fox Talbot.* ([London: Kodak, Ltd.?, 1951?]. 20 pp.).

427 Anon. *W.H. Fox Talbot Commemoration.* (Reading: Reading Camera Club, 1951. 8 pp.).

428 Anon. 'A Talbot Letter'. *Image*, vol. 1, no. 2 (Feb. 1952), p. 3.

429 André Jammes. 'A Scene in a Library'. *Photographie*, no. 1 (Spring 1953), p. 50.

430 Helmut and Alison Gernsheim. *The History of Photography.* (London, New York, Toronto: Geoffrey Cumberlege/ Oxford University Press, 1955. 395 pp. 359 illus.). Reprinted (London: Thames and Hudson; New York: McGraw-Hill Book Company, 1969. 599 pp. 390 illus.). Italian edition, *Storia della Fotografia* (Milan: Frassinelli, 1966). German edition, *Geschichte der Photographie* (Frankfurt, Berlin, Vienna: Propyläen Verlag, 1983).

431 Matilda Theresa Talbot. *My Life and Lacock Abbey.* (London: Allen & Unwin, Ltd., 1956. 261 pp. 11 illus.).

432 Beaumont Newhall. *On Photography: A Source-Book of Photographic History in Facsimile.* (Watkins Glen, N.Y.: Century House, 1956.).

433 Anon. 'Index to Resources: William Henry Fox Talbot'. *Image*, vol. 7, no. 1 (Jan. 1958), p. 20–21.

This description of holdings at George Eastman House, Rochester, New York, concerns replicas of Talbot's cameras.

434 Anon. 'Index to Resources: Publications – William H. Fox Talbot'. *Image*, vol. 7, no. 2 (Feb. 1958), p. 44–45.

435 Anon. 'Index to Resources: Photographs by Fox Talbot'. *Image*, vol. 7, no. 3 (March 1958), p. 68–69.

436 Anon. 'Index to Resources: Henry Fox Talbot'. *Image*, vol. 7, no. 4 (April 1958), p. 94–95.

437 Beaumont Newhall. 'Editorial: Prophetic Pioneer'. *Image*, vol. 8, no. 2 (June 1959), p. 58–59.

438 Beaumont Newhall. 'William Henry Fox Talbot, 1800–1877'. *Image*, vol. 8, no. 2 (June 1959), p. 60–75.

439 Beaumont Newhall. 'Notes on the Publication of "The Pencil of Nature" '. *Image*, vol. 8, no. 2 (June 1959), p. 75–76.

440 Helmut Gernsheim. 'Talbot's and Herschel's Photographic Experiments in 1839'. *Image*, vol 8, no. 3 (Sept. 1959), p. 132–37.

441 André Jammes. 'Photographic incunabula'. *Camera*, vol. 40 (Dec. 1961), p. 25.

442 Wolfgang Baier. *Quellendarstellungen zur Geschichte der Fotografie.* (Leipzig: Fotokinoverlag, 1964. 710 pp.).

443 Arthur Harold Booth. *William Henry Fox Talbot, Father of Photography.* (London: Arthur Barker, 1964. 119 pp. illus.).

444 David Bowen Thomas. *The First Negatives; An Account of the discovery and early use of the negative–positive photographic process*. (London: Her Majesty's Stationery Office, 1964. 42 pp. 34 illus. bibliog.).

445 R.S. Schultze. 'Rediscovery and Description of Original Material on the Photographic Researches of Sir John F.W. Herschel, 1839–1844'. *Journal of Photographic Science*, vol. 13 (Sept.–Oct. 1965), p. 57–68.

446 Eugene Ostroff. 'Early Fox Talbot Photographs and Restoration by Neutron Irradiation'. *Journal of Photographic Science*, vol. 13, no. 5 (Sept.–Oct. 1965), p. 213–27.

447 Arthur T. Gill. 'Another Look at Fox Talbot's "1839" Camera'. *Photographic Journal*, vol. 106, no. 10 (Oct. 1966), p. 344–45.

448 Eugene Ostroff. 'Restoration of Photographs by Neutron Activation'. *Science*, vol. 154, no. 3745 (7 Oct. 1966), p. 119–23. 3 illus.

449 Eugene Ostroff. 'Talbot's Earliest Extant Print, June 20, 1935, Rediscovered'. *Photographic Science and Engineering*, vol. 10, no. 6 (Nov.–Dec. 1966), p. 350–54. 6 illus.

450 Ricardo A. Caminos. 'The Talbotype Applied to Hieroglyphics'. *Journal of Egyptian Archaeology*, vol. 52 (Dec. 1966), p. 65–70. 3 illus.

451 Harold White. 'Fox Talbot's "1839" Camera'. *Photographic Journal*, vol. 106, no. 12 (Dec. 1966), p. 420.

452 Beaumont Newhall. *Latent Image: the Discovery of Photography*. (Garden City, N.Y.: Anchor Books/Doubleday, 1967. 155 pp. 29 illus. bibliog.). Reprinted (Albuquerque: University of New Mexico Press, 1983). Italian edition, *L'immagine latente* (Zanichelli, 1969). German edition, *Die Väter der Fotografie* (Heering-Verlag, 1978).

453 Naum Mikhailovich Raskin. *Zhozef Nisefor Neps, Lui Zhak Mande Dagerr, Vil'iam Genri Foks Talbot*. (Leningrad: Nauka, Leningradskop otd-nie, 1967. 188 pp.).

454 Beaumont Newhall. 'Introduction', [p. 1–7] in William Henry Fox Talbot, *The Pencil of Nature: A Facsimile of the 1844–45 edition*. (New York: Da Capo Press, 1968. 140 pp.).

455 J. Dudley Johnston and R.C. Smith. 'William Henry Fox Talbot, F.R.S. Material Towards a Biography, Part II'. *Photographic Journal*, vol. 108 (Dec. 1968), p. 361–71.
 For the first part of this article, see Bibl. **421**.

456 David Bowen Thomas. *The Science Museum Photography Collection*. (London: Her Majesty's Stationery Office, 1969).

457 Eugene Ostroff. 'Etching, Engraving and Photography: History of Photomechanical Reproduction'. *Journal of Photographic Science*, vol. 17, no. 3 (May–June 1969), p. 65–80.

458 Eugene Ostroff. 'Photography and Photogravure: History of Photomechanical Reproduction'. *Journal of*

Photographic Science, vol. 17, no. 4 (July–Aug. 1969), p. 101–15.*

459 Jean Dieuzaide. *Hommage à Fox Talbot*. (Paris: La Demeure, 1971. 72 pp.).

460 Rupert Derek Wood. 'J.B. Reade, F.R.S., and the early history of photography. Part I: A re-assessment on the discovery of contemporary evidence; Part II: Gallic acid and Talbot's calotype patent'. *Annals of Science*, vol. 27 (March 1971), p. 13–45, 47–83.

461 Rupert Derek Wood. 'The Involvement of Sir John Herschel in the Photographic Patent Case, Talbot v. Henderson, 1854'. *Annals of Science*, vol. 27, no. 3 (Sept. 1971), p. 239–64.

462 André Jammes. *William H. Fox Talbot: ein grosser Erfinder und Meister der Photographie*. (Luzern & Frankfurt/M: C.J. Bucher, 1972. 96 pp. 69 illus.). [Bibliothek der Photographie, herausgegeben von Romeo E. Martinez, Band 2].
 For English edition, see Bibl. **466**.

463 David Bowen Thomas, Editor. *From today painting is dead: the beginnings of photography*. Text by Tristram Powell, Asa Briggs, D.B. Thomas. London: The Victoria & Albert Museum, 16 March–14 May 1972. (Published by the Arts Council of Great Britain. 60 pp. 50 illus.).

464 Rupert Derek Wood. 'J.B. Reade's early photographic experiments – recent further evidence on the legend'. *British Journal of Photography*, vol. 119 (28 July 1972), p. 643–47.

465 Arthur T. Gill. 'Call Back Yesterday: William H. Fox Talbot'. *Photographic Journal*, vol. 112, no. 11 (Nov. 1972), p. 352–54.

466 André Jammes. *William H. Fox Talbot, inventor of the negative–positive process*, (New York: Collier Books, 1973. 96 pp. 69 illus.).

467 Arthur T. Gill. 'Call Back Yesterday: Photogenic Drawing'. *Photographic Journal*, vol. 113, no. 1 (Jan. 1973), p. 25, 47–48.

468 Anon. *Lacock Abbey – Wiltshire*. ([London]: The National Trust, 1974).

469 C.R. Baldwin. 'In Search of "Sun Pictures" '. *Artforum*, vol. 12, no. 5 (Jan. 1974), p. 54–56.

470 Arthur T. Gill. 'Call Back Yesterday: Calotype'. *Photographic Journal*, vol. 114, no. 6 (June 1974), p. 308–09.

471 Arthur T. Gill. 'Call Back Yesterday: Calotype, Part 2'. *Photographic Journal*, vol 114, no. 9 (Sept. 1974), p. 466–67.

472 Hollis Frampton. 'Incisions in history/segments of eternity'. *Artforum*, vol. 13 (Oct. 1974), p. 41.

473 Arthur T. Gill. 'The Reading Establishment'. *Photographic Journal*, vol. 114, no. 12 (Dec. 1974), p. 610–11.

474 Aaron Scharf. *Pioneers of Photography*. (London: British Broadcasting Corporation, 1975; New York: H.B. Abrams, 1976. 168 pp. 170 illus. bibliog.).

475 Rupert Derek Wood. *The Calotype Patent Lawsuit of Talbot v. Laroche 1854*. (Bromley, Kent: R.D. Wood, 1975. 34 pp. 2 illus.).

476 Carl Chiarenza. 'Notes on Aesthetic Relationships between Seventeenth-Century Dutch Painting and Nineteenth-Century Photography', [p. 20–34] in *One Hundred Years of Photographic History: Essays in Honor of Beaumont Newhall*, Edited by Van Deren Coke (Albuquerque: University of New Mexico Press, 1975. 180 pp. 110 illus.).

477 Anon. *The Art of Photogenic Drawing*. (Lacock: Fox Talbot Museum, n.d. [*c*.1975]. 8 pp.). [Fox Talbot Museum information leaflet, 1].

478 Christopher Lloyd. 'Picture Hunting in Italy: Some Unpublished Letters (1824–1829)'. *Italian Studies*, vol. 30 (1975), p. 42–68.*

479 Arthur T. Gill. 'Call Back Yesterday: A Fox Talbot Museum at Lacock'. *Photographic Journal*, vol. 115, no. 1 (Jan. 1975), p. 30–31.

480 Arthur T. Gill. 'Call Back Yesterday: "The Pencil of Nature" by H. Fox Talbot, F.R.S.'. *Photographic Journal*, vol. 115, no. 2 (Feb. 1975), p. 81, 83.

481 Baynham Honri. 'Fox Talbot Museum at Lacock'. *British Journal of Photography*, vol. 122, no. 5978 (14 Feb. 1975), p. 124–25.

482 Ian Jeffrey. 'British Photography from Fox Talbot to E.O. Hoppé', [p. 5–24] in *The Real Thing: an Anthology of British Photographs 1840–1950*. London: Hayward Gallery (19 March–4 May 1975). (Organized by the Arts Council of Great Britain. 124 pp. 99 illus. bibliog.).

483 Arthur T. Gill. 'Call Back Yesterday: The Sun Pictures Themselves'. *Photographic Journal*, vol. 115, no. 4 (April 1975), p. 180–81.

484 Arthur T. Gill. 'Call Back Yesterday: Calotype Correspondence'. *Photographic Journal*, vol. 115, no. 6 (June 1975), p. 284–85.

485 Robert Lassam. 'Fox Talbot: new horizons'. *Photographic Journal*, vol. 115, no. 7 (July 1975), p. 300–02.

486 Arthur T. Gill. 'Portraits of Fox Talbot'. *Photographic Journal*, vol. 115, no. 7 (July 1975), p. 303–05.

487 Ainslie Ellis. 'On view'. *British Journal of Photography*, vol. 122, no. 6005 (22 Aug. 1975), p. 742–43.

488 Hans Christian Adam. 'Fox Talbot pre-1840 Photos found in Göttingen, West Germany'. *Photographica*, vol. 7, no. 7 (Aug.–Sept. 1975), p. 1, 5.

489 Arthur T. Gill. 'Call Back Yesterday: Record of C.M.W.'. *Photographic Journal*, vol. 115, no. 10 (Oct. 1975), p. 490–91.

490 John Hannavy. *Fox Talbot: An Illustrated Life of William Henry Fox Talbot, 'Father of Modern Photography' 1800–1877*. (Princes Risborough, Aylesbury: Shire Publications, 1976. 48 pp. 25 illus.).

491 Robert Lassam. *An Illustrated Guide: Fox Talbot Museum, Lacock*. (London: National Trust, 1976. 16 pp. 20 illus.).

492 Anon. 'The Fox Talbot Museum, Lacock'. *Arts Review*, vol. 28, no. 4 (20 Feb. 1976), p. 80.

493 Laurel C. Ball. 'Fox Talbot Museum: a new museum of photography'. *Museums Journal*, vol. 75, no. 4 (March 1976), p. 163–64.

494 Arthur T. Gill. 'Call Back Yesterday: More Sun Pictures'. *Photographic Journal*, vol. 116, no. 3 (May–June 1976), p. 170–71.

495 Ian Jeffrey. 'Photography'. *Studio*, vol. 192 (Sept. 1976), p. 200.

496 Allan Porter, Editor. 'Sun Pictures: The Work of William Henry Fox Talbot 1800–1877'. *Camera* (Luzern), vol. 55, no. 9 (Sept. 1976), p. 1–42. 47 illus. biog. bibliog. [Special issue produced as the catalogue of the Kodak exhibit at Photokina in Cologne in 1976, organized jointly by the Science Museum, London; the Fox Talbot Museum, Lacock; and Kodak]. Reprinted as Allan Porter, Editor, *Sun Pictures: The Work of William Henry Fox Talbot, 1800–1877.* (London: Science Museum, Fox Talbot Museum and Kodak Ltd., 1976. 42 pp. plus list of items exhibited, 12 pp.).

497 Ian Jeffrey. 'First things first'. *Arts Review*, vol. 28, no. 21 (15 Oct. 1976), p. 550–51.

498 H.J.P. Arnold. *William Henry Fox Talbot: Pioneer of Photography and Man of Science.* (London: Hutchinson Benham, 1977. 382 pp. 108 illus. index).

499 John Charity. *Photographs from Welsh collections.* Cardiff, Wales: Oriel Gallery (n.d. [1977?]. 44 pp. 28 illus.). (Organized by the Welsh Arts Council, Cardiff).

500 Helmut Gernsheim. 'W.H. Fox Talbot and the History of Photography'. *Endeavour*, new ser. vol. 1, no. 1 (1977), p. 18–22.

501 Brian W. Coe. 'Sun Pictures: Talbot's Calotype Negatives'. *History of Photography*, vol. 1, no. 3 (July 1977), p. 175–82.

502 Robert Lassam and Michael Seaborne. *W.H.F. Talbot: scientist, photographer, classical scholar 1800–1877: a further assessment. [William Henry Fox Talbot Centenary Exhibition].* Lacock, Chippenham, England: Fox Talbot Museum (Aug.–Oct. 1977. 36 pp. 23 illus.).

503 Gordon Winter. 'Fox Talbot, the Overlooked Genius: Centenary Exhibitions at Lacock and in London'. *Country Life*, vol. 162, no. 4185 (15 Sept. 1977), p. 674–75.

504 Anon. 'Obituary: W.H. Fox Talbot'. *British Journal of Photography*, vol. 124, no. 6112 (16 Sept. 1977), p. 781–82.
 Reprint of the obituary published in *British Journal of Photography* (28 Sept. 1877) [Bibl. **372**] by J. Traill Taylor.

505 David Reed. 'Fox Talbot: the artist?'. *British Journal of Photography*, vol. 124, no. 6112 (16 Sept. 1977), p. 783.

506 Margaret F. Harker. 'William Henry Fox Talbot – pioneer of photography and man of science'. *British Journal of Photography*, vol. 124, no. 6112 (16 Sept. 1977), p. 787–94.
 This is a review of Arnold's biography of Talbot [Bibl. **498**].

507 James Clement. 'Douglas Arnold: Fox Talbot's Shadow'. *British Journal of Photography*, vol. 124, no. 6112 (16 Sept. 1977), p. 796–99.

508 John P. Ward. 'The Fox Talbot Collection at the Science Museum'. *History of Photography*, vol. 1, no. 4 (Oct. 1977), p. 275–87.

509 Robert Lassam. 'The Fox Talbot Museum'. *History of Photography*, vol. 1, no. 4 (Oct. 1977), p. 297–300.

510 H.J.P. Arnold. 'Lacock miscellany'. *British Journal of Photography*, vol. 124, no. 6119 (4 Nov. 1977), p. 946–47.

511 Marie-Thérèse Jammes and André Jammes. *Niépce to Atget: the first century of photography from the collection of André Jammes*. Chicago: Chicago Art Institute (16 Nov. 1977–15 Jan. 1978. 115 pp. 121 illus.).

512 Gail Buckland. *Fox Talbot and the Invention of Photography*. (New York: Camera/Graphic Press, 1978. 268 pp. 190 illus.). Reprinted (Boston: David R. Godine; London: Scolar Press, 1980. 216 pp. 264 illus. biog. bibliog.).

513 Robert Lassam. *W.H.F. Talbot: Scientist, Photographer, Classical Scholar*. (Lacock: Fox Talbot Museum, 1978. 28 pp.).

514 Roger Sandall. 'Objective graphics: ways of mapping the physical world'. *Art International*, vol. 22, no. 1 (Jan. 1978), p. 21–25.

515 Eugene Ostroff. 'The Calotype and the Photographer'. *Journal of Photographic Science*, vol. 26, no. 1 (Jan.–Feb. 1978), p. 83–88.
 This article concerns correspondence between Calvert Richard Jones and Talbot.

516 Arthur T. Gill. 'Fox Talbot's photoglyphic engraving process'. *History of Photography*, vol. 2, no. 2 (April 1978), p. 134.

517 Italo Zannier. *Henry Fox Talbot: la raccolta della Biblioteca Estense di Modena*. (Milan: Editfoto [1978], special supplement of *Fotografia Italiana*, no. 237 (May 1978). 23 pp. illus.).

518 Alan Thomas. 'The Merlin of the darkroom'. *Times Literary Supplement*, no. 3975 (9 June 1978), p. 641.

519 Harold White. 'W.H. Fox Talbot and photo-engraving'. *Photographic Journal*, vol. 118, no. 4 (July–Aug. 1978), p. 163.

520 Rosalind Krauss. 'Tracing Nadar'. *October*, no. 5 (Summer 1978), p. 29–47.

521 Mark Haworth-Booth. 'William Henry Fox Talbot, pioneer of photography'. *Museums Journal*, vol. 78 (Sept. 1978), p. 87–88.

522 Gail Buckland. 'Another Fox Talbot'. *Exposure*, vol. 16, no. 3 (Fall 1978), p. 30–37.

523 Gail Buckland. 'William Henry Fox Talbot: The True Inventor of Photography'. *American Photographer*, vol. 2, no. 1 (Jan. 1979), p. 42–49.

524 Larry Schaaf. 'Sir John Herschel's 1839 Royal Society paper on photography'. *History of Photography*, vol. 3, no. 1 (Jan. 1979), p. 47–60.

525 Eugene Ostroff. 'Herschel and Talbot: Photographic Research'. *Journal of Photographic Science*, vol. 27, no. 2 (March–April 1979), p. 73–80.

526 Gail Buckland. 'Fox Talbot: father

of photography'. *Portfolio*, vol. 1, no. 1 (April–May 1979), p. 40–47.

527 Robert Lassam, with a foreword by Cecil Beaton. *Fox Talbot photographer.* (Salisbury: Compton Press in association with the Dovecote Press; Kent, Ohio: Kent State University Press, 1979. 96 pp. 83 illus. biog. bibliog.).

528 G. Needham. 'Artists' and photographers' views of London and Paris in the mid-nineteenth century', [p. 5–9] in *The City and the Camera*, Edited by N. Wiseman (Downsview, Ontario: Urban Studies Programme, York University, 1979. 42 pp. 18 illus.).

529 Anon. 'Calotypes and photogenic drawings'. *British Journal of Photography*, vol. 126, no. 6219 (5 Oct. 1979), p. 961–63.

530 Gail Buckland. *Fox Talbot and the Invention of Photography.* (London: Scolar Press; Boston: David R. Godine, 1980. 216 pp. 264 illus. bibliog. appendices. index).

531 Michael Seaborne. *The Art of Photogenic Drawing.* (Chippenham: Fox Talbot Museum, n.d. [1980?]. 8 pp. 2 illus.). [Fox Talbot Museum information leaflet, 1].

532 Rupert Derek Wood. 'The Daguerreotype Patent, the British Government, and the Royal Society'. *History of Photography*, vol. 4 no. 1 (Jan. 1980), p. 53–59.

533 Rupert Derek Wood. 'Latent Developments from Gallic Acid, 1839'. *Journal of Photographic Science*, vol. 28, no. 1 (Jan.–Feb. 1980), p. 36–42.*

534 Richard Morris. *John Dillwyn Llewelyn 1810–1882: the first photographer in Wales.* Swansea, Wales: Glynn Vivian Art Gallery and Museum (23 Feb.–15 March 1980. 48 pp. 27 illus. bibliog.). (Organized and sponsored by the Welsh Arts Council).

535 Larry Schaaf. 'Herschel, Talbot and Photography: Spring 1831 and Spring 1839'. *History of Photography*, vol. 4, no. 3 (July 1980), p. 181–204.

536 Arthur T. Gill. 'Nicholas Henneman 1813–1893'. *History of Photography*, vol. 4, no. 4 (Nov. 1980), p. 313–22.

537 Isabelle Jammes. *Blanquart-Evrard et les origines de l'édition photographique française: catalogue raisonné des albums photographiques édités 1851–1855.* (Geneva, Switzerland: Librairie Droz, 1981. 326 pp. 606 illus.). [Histoire et civilisation du livre, 12].

538 Reese V. Jenkins. 'Talbot, William Henry Fox', [p. 237–39] in *Dictionary of Scientific Biography* vol. 13, Edited by Charles Coulston Gillipsie (New York: Charles Scribner's Sons, 1981).

539 A.J. Lambert. *Victorian and Edwardian Country-house Life from Old Photographs.* (London: B.T. Batsford, 1981. 120 pp. 122 illus.).

540 Arthur T. Gill. 'Nicholas Henneman'. *History of Photography*, vol. 5, no. 1 (Jan. 1981), p. 84–86.

541 Ian Jeffrey. 'Photography and Nature'. *Art Journal*, vol. 4, no. 1 (Spring 1981), p. 26–32.

542 H. Mark Grosser. 'Further Notes on Herschel and Talbot: the term "Photo-

graphy" '. *History of Photography*, vol. 5, no. 3 (July 1981), p. 269.

543 Larry Schaaf. 'Further Notes on Herschel and Talbot: the term "Photography": Correspondence'. *History of Photography*, vol. 5, no. 3 (July 1981), p. 269–70.

544 Robert Lassam. 'Britain loses a family connection'. *British Journal of Photography*, vol. 128, no. 6312 (17 July 1981), p. 720–21.

545 William Bishop. 'A Great British Artist'. *British Journal of Photography*, vol. 128, no. 6328 (6 Nov. 1981), p. 1136–37.

546 Helmut Gernsheim. *The Origins of Photography*. (London: Thames and Hudson, 1982. 280 pp. 191 illus.).
This is a revised edition of the first part of Helmut and Alison Gernsheim, *The History of Photography* (London: Thames and Hudson, 1969). In particular, see pages 53–62, 181–232.

547 Daniela Palazzoli, Editor. *Fox Talbot*. (Milan: Gruppo Editoriale Electa, 1982. 14 pp. 12 illus.).
This is a portfolio of reproductions.

548 Sean Thackrey, Editor. *Masterworks of photography from the Rubel Collection*. Sacramento, California: Crocker Art Museum (21 Jan.–Feb. 1982).

549 Julia Van Haften. *From Talbot to Stieglitz: Masterpieces of Early Photography from the New York Public Library*. (New York; London: Thames & Hudson, 1982. 126 pp. 93 illus.).

550 Nancy B. Keeler. 'Illustrating the "Reports by the Juries" of the Great Exhibition of 1851: Talbot, Henneman, and their failed commission'. *History of Photography*, vol. 6, no. 3 (July 1982), p. 257–72.

551 Larry Schaaf. 'Henry Collen and the Treaty of Nanking'. *History of Photography*, vol. 6, no. 4 (Oct. 1982), p. 353–66.

552 F. Rodari, J. Goodman, André Jammes. *De Niépce à Stieglitz: la photographie en tailledouce*. Lausanne, Switzerland: Musée de l'Elysée (19 Nov. 1982–20 Feb. 1983); Zurich, Switzerland: Kunsthaus (22 April–5 June 1983); Chalon-sur-Saône, France: Musée Nicéphore Niépce (1 July–4 Sept. 1983. 72 pp. 28 illus. bibliog.).

553 A.J. Stirling. 'The Society of Arts' photographic exhibition of 1852'. *Royal Society of Arts Journal*, vol. 131, no. 5317 (Dec. 1982), p. 54–57.

554 Floris M. Neusüss, Editor, with an introduction by Ditmar Albert. *Fotogramme: die lichtreichen Schatten*. (Kassel, Germany: Fotoforum, 1983. 80 pp. 78 illus. bibliog.).

555 Paul Jay. 'Un album de William H. Fox-Talbot'. *Revue du Louvre*, vol. 33, part 5–6 (1983), p. 423–33.

556 Richard R. Brettell, with Roy Flukinger, Nancy Keeler, Sydney M. Kilgore. *Paper and Light; the Calotype in France and Great Britain*. (Boston, Massachusetts: David R. Godine; London: Kudos & Godine, 1984. 216 pp. 156 illus. bibliog.).

557 Mark Haworth-Booth, Editor. *The Golden Age of British Photography*.

London: Victoria & Albert Museum (6 June–19 Aug. 1984); Philadelphia: Philadelphia Museum of Art (27 Oct. 1984–6 Jan. 1985); Houston: Museum of Fine Arts (18 May–4 Aug. 1985); Minneapolis: Minneapolis Institute of Arts (24 Aug.–20 Oct. 1985); New York: Pierpont Morgan Library (20 Nov. 1985–2 Feb. 1986); Boston: Museum of Fine Arts (5 March–18 May 1986). (Organized in conjunction with the Alfred Stieglitz Center, Philadelphia Museum of Art. Sponsored by the National Endowment for the Arts, Washington, D.C., and the Pew Memorial Trust. 191 pp. 186 illus. biog. index).

558 Hubertus von Amelunxen. 'William Henry Fox Talbot. *The Pencil of Nature* (I): Ein kleines Plädoyer für einer neue "Lektüre" '. *Fotogeschichte*, vol. 4, no. 14 (1984), p. 17–29.

559 Andrew Lanyon. 'The First Cornish Photographs?'. *History of Photography*, vol. 8, no. 4 (Oct.–Dec. 1984), p. 333–36.

560 Steven F. Joseph. 'Wheatstone's double vision'. *History of Photography*, vol. 8, no. 4 (Oct.–Dec. 1984), p. 329–32.

561 Margaret F. Harker. 'A Golden Age?'. *British Journal of Photography*, vol. 131 (9 Nov. 1984), p. 1197–1200.

562 Hans P. Kraus, Jr. *Sun Pictures: Early British Photographs on Paper* Catalogue One (New York: Hans P. Kraus, Jr., [1985]. [55 pp.]. 45 illus.).

563 Peter-Cornell Richter. *Mit Licht gezeichnet: aus dem Tagebuch der Photographie*. (Freiburg, Germany; Basle; Vienna: Herder, 1985. 95 pp. 24 illus.).

564 Peeter Tooming. 'Original Talbot photographs in Estonia'. *History of Photography*, vol. 9, no. 2 (April–June 1985), p. 162–67.

565 Margaret F. Harker. ' "Fox Talbot: The Family Connection and the Work of other Early Practitioners of the Calotype Process" '. *British Journal of Photography*, vol. 132, no. 6517 (28 June 1985), p. 718–20.
This is a review of an exhibition at Lacock Abbey.

566 Hubertus von Amelunxen. 'William Henry Fox Talbot (II): "New Art. Nature's Pencil No. 1". Anmerkungen zu einer rezeptions-ästhetischen Fototheorie'. *Fotogeschichte*, vol. 5, no. 16 (1985), p. 5–21.

567 Hans P. Kraus and Larry J. Schaaf. *Sun Pictures: Llewelyn, Maskelyne, Talbot: A Family Circle*; Catalogue Two. (New York: Hans P. Kraus, Jr. Fine Photographs, 1986. 79 pp. 70 illus.).

568 Hugh Murray. *Photographs and Photographers of York: the early years 1844–1879.* (York: Yorkshire Architectural and York Archaeological Society, 1986. 136 pp. 105 illus.).

569 Mike Weaver. 'A Photographic Artist: W.H. Fox Talbot', [p. 10–15] in M. Weaver, *The Photographic Art: Pictorial Traditions in Britain and America.* (London: Herbert Press; New York: Harper & Row, 1986. 144 pp. 122 illus.).

570 David Lee. 'The Photographic Art'. *Arts Review*, vol. 38, no. 2 (31 Jan. 1986), p. 36.

571 John Ward and Sara Stevenson. *Printed Light: the Scientific Art of William*

Henry Fox Talbot and David Octavius Hill with Robert Adamson. Edinburgh: Scottish National Portrait Gallery (1 Aug.–26 Oct. 1986). (Organized in cooperation with the Science Museum, London. 173 pp. 197 illus. bibliog.).

572 Michael Hallett. 'Early Magnesium Light Portraits'. *History of Photography*, vol. 10, no. 4 (Oct.–Dec. 1986), p. 299–301.

573 A. Vartanov. 'Éstetika fotografi 11: natyurmort'. *Sovetskoe Foto* (U.S.S.R.), part 4 (1986), p. 22–23.

574 David Lee. 'Printed Light'. *Arts Review*, vol. 38, no. 18 (12 Sept. 1986), p. 484–89.

575 Graham Smith. 'Printed Light at the Scottish National Portrait Gallery, Edinburgh'. *Burlington Magazine*, vol. 128, no. 1003 (Oct. 1986), p. 768–69.

576 Graham Smith. 'William Henry Fox Talbot's Calotype Views of Loch Katrine'. *Bulletin of the University of Michigan Museums of Art and Archaeology*, vol. 7 (1984–85) [published in 1987], p. 56–67.*

577 Robert Lassam. *Fox Talbot: an Illustrated Souvenir*. ([Lacock]: The National Trust, 1987).

578 Eugene Ostroff, Editor. *Pioneers of Photography: Their Achievements in Science and Technology*. (Springfield, Virginia: SPSE – The Society for Imaging Science and Technology, 1987. 285 pp. 264 illus. bibliog.).

579 Harold White. 'William Henry Fox Talbot', [p. 86–115] in Larry J. Schaaf, *Sun Pictures: the Harold White collection of works by William Henry Fox Talbot*;

Catalogue Three. (New York: Hans P. Kraus, 1987. 116 pp. 84 illus.).

580 Larry J. Schaaf. *Sun Pictures: the Harold White collection of historical photographs from the circle of Talbot*; Catalogue Four. (New York: Hans P. Kraus, 1987. 40 pp. 38 illus.).

581 Hubertus von Amelunxen. 'Une photographie – Un texte (*The Pencil of Nature* de William Henry Fox Talbot)' [p. 181–91] in *Texte et Médialité*, Edited by J.E. Müller, *MANA* (Mannheimer Analytika), vol. 7 (1987).

582 Timm Starl. 'Prospect and view: Daguerre's and Talbot's *Boulevards of Paris*'. *Camera Austria*, no. 24 (1987), p. 81–86.

583 Margaret F. Harker. 'Printed Light'. *British Journal of Photography*, vol. 134 (16 Jan. 1987), p. 64–65.

584 George S. Layne. 'The Langenheims of Philadelphia'. *History of Photography*, vol. 11, no. 1 (Jan.–March 1987), p. 39–52.

585 Graham Smith. 'Printed Light'. *History of Photography*, vol. 11, no. 2 (April–June 1987), p. 155–57.

586 H.J.P. Arnold. 'Talbot and the "Great Britain"'. *British Journal of Photography*, vol. 134, no. 35 (28 Aug. 1987), p. 984–88, 998.

587 Michael Hallett. 'John Benjamin Dancer 1812–1887: a perspective'. *British Journal of Photography*, vol. 134, no. 6643 (3 Dec. 1987), p. 1474–77.

588 Hubertus von Amelunxen, with an essay by Michael Gray. *Die aufgehobene*

Zeit: die Erfindung der Photographie durch William Fox Talbot. (Berlin: Nishen, 1988. 159 pp. 159 illus.).

589 Robert Lassam and Michael Gray. *The Romantic Era: La Calotypia in Italia 1845–1860*. (Firenze: Fratelli Alinari, 1988. 96 pp. 114 illus.).

590 Graham Smith. 'Magnesium Light Portraits'. *History of Photography*, vol. 12, no. 1 (Jan.–March 1988), p. 88–89.

591 Joanna Lindgren Harley. 'Talbot's plan for a photographic expedition to Kenilworth'. *History of Photography*, vol. 12, no. 3 (July–Sept. 1988), p. 223–25.

592 Larry J. Schaaf. 'The Pencil of Nature Redrawn'. *British Journal of Photography*, vol. 135, no. 6686 (29 Sept. 1988), p. 56–57.

593 Hans P. Kraus, Jr. 'The Beginnings of Photographic Book Illustration'. *Antiquarian Bookman's Weekly*, vol. 82, no. 18 (31 Oct. 1988), p. 1657–64.

594 Melissa DuBose. *Photogenic Drawing: The New Art*. (Tempe: Arizona State University, [1988]. 16 pp.). [History of Photography Monograph no. 23, Fall 1988].

595 Brett Rogers. *William Henry Fox Talbot e seu círculo familiar: Fotografias de John Dillwyn Llewelyn, Nevil Story Maskelyne e William Henry Fox Talbot 1839–1860*. (London: The British Council, 1989. 36 pp. 28 illus.).

596 Larry Schaaf. *Introductory Volume* ('Historical Sketch', 'Notes on the Plates'*, 'Census') [p. 4–93, 41 illus.] in *H. Fox Talbot's The Pencil of Nature: Anniversary Facsimile*. (New York: Hans P. Kraus, Jr., Inc., 1989. [n.p.]. 24 plates).

597 A.V. Simcock. *Photography 150: Images from the First Generation*. (Oxford: Museum of the History of Science, 1989. 36 pp. 13 illus.).

598 Sarah Greenough, Joel Snyder, David Travis, and Colin Westerbeck, Editors. *On the Art of Fixing a Shadow: One Hundred and Fifty Years of Photography*, (Washington, D.C.: National Gallery of Art, 1989. 510 pp. 441 illus.).

599 Graham Smith. *Sun Pictures in Scotland*. (Ann Arbor: University of Michigan Museum of Art, 1989. 78 pp. 32 illus.).

600 Mike Weaver. 'Henry Fox Talbot: Conversation Pieces', [p. 11–23] in *British Photography in the Nineteenth Century*, Edited by Mike Weaver (Cambridge and New York: Cambridge University Press, 1989. 304 pp. 101 illus. bibliog.).

601 Weston J. Naef. 'Photography: discovery and invention'. *Antiques* (U.S.A.), vol. 135, no. 1 (Jan. 1989), p. 288–97.

602 Andreas Haus. 'Henry Fox Talbot, philosophe de la photographie', [p. 22–28] in *Les Multiples Inventions de la Photographie*, Edited by Pierre Bonhomme (Paris: Association Française pour la diffusion du Patrimoine photographique, 1989. 189 pp. 70 illus.).

603 Mike Weaver, 'Talbot: imagination ou invention', [p. 58–62] in *Les Multiples Inventions de la Photographie*, Edited by Pierre Bonhomme (Paris: Association Française pour la diffusion du Patrimoine photographique, 1989. 189 pp. 70 illus.).

604 Larry J. Schaaf. 'L'amour de la lumière: Herschel, Talbot et la photographie', [p. 118–24] in *Les Multiples Inventions de la Photographie*, Edited by Pierre Bonhomme (Paris: Association Française pour la diffusion du Patrimoine Photographique, 1989. 189 pp. 70 illus.).

605 Larry Schaaf. 'Talbot & Nature's Pencil'. *Center Quarterly* [Woodstock, N.Y.] vol. 11, no. 1 (1989), p. 4–7.

606 Mike Weaver, 'The Picture as Photograph' [p. 7–11] in *The Art of Photography 1839–1989*, Edited by Mike Weaver. Houston: Museum of Fine Arts (11 Feb.–30 Apr. 1989); Canberra: Australian National Gallery (17 June–27 Aug. 1989); London: Royal Academy of Arts (23 Sept.–23 Dec. 1989). (Sponsored by the Billy Rose Foundation, published in association with Yale University Press, New Haven, Connecticut, and London, 472 pp. 476 illus. biog. bibliog.).

607 Beaumont Newhall, 'The Pencil of Nature' [p. 12–14] in *The Art of Photography 1839–1989*, Edited by Mike Weaver. Houston: Museum of Fine Arts (11 Feb.–30 Apr. 1989); Canberra: Australian National Gallery (17 June–27 Aug. 1989); London: Royal Academy of Arts (23 Sept.–23 Dec. 1989). (Sponsored by the Billy Rose Foundation, published in association with Yale University Press, New Haven, Connecticut, and London, 472 pp. 476 illus. biog. bibliog.).

608 Hans S. Dommasch and Brock Silversides. 'The Silver image: Fox Talbot and the calotype'. *Photographic Journal*, vol. 129, no. 4 (April 1989), p. 194–95.

609 Graham Smith. 'W. Holland Furlong, St. Andrews and the origins of photography in Scotland'. *History of Photography*, vol. 13, no. 2 (April–June 1989), p. 139–43.

610 H.J.P. Arnold. 'A problem resolved'. *British Journal of Photography*, vol. 136, no. 6718 (18 May 1989), p. 25–27; vol. 136, no. 6719 (25 May 1989), p. 20–21.

611 H.J.P. Arnold. 'Henry Talbot – founding father'. *British Journal of Photography*, vol. 136, no. 6724 (29 June 1989), p. 28–31.

612 H.J.P. Arnold. 'Henry Talbot – founding father [concluded]'. *British Journal of Photography*, vol. 136, no. 6725 (6 July 1989), p. 19–21.

613 Keith I.P. Adamson. '1839 – the year of Daguerre'. *History of Photography*, vol. 13, no. 3 (July–Sept. 1989), p. 191–202.

614 P. Maynard. 'Talbot's technologies: photographic depiction, detection and reproduction'. *Journal of Aesthetics and Art Criticism*, vol. 47, no. 3 (Summer 1989), p. 263–76.

615 Chris Roberts. 'Fox Talbot – his life, family and character'. *Photographic Journal*, vol. 129, no. 9 (Sept. 1989), p. 408–11.

616 Graham Smith. 'The Pencil of Nature. By H. Fox Talbot F.R.S. Anniversary facsimile with an introductory volume by Larry J. Schaaf'. *The Print Collector's Newsletter*, vol. 20, no. 4 (Sept.–Oct. 1989), p. 147–48.

617 Alasdair Hawkyard. *William Henry Fox Talbot: Scientist, Inventor, Classicist*. Harrow, England: Old Speed Room

Gallery, Harrow School (19 Oct. 1989–14 Jan. 1990. 35 pp. 22 illus. biog. bibliog. plus list of works exhibited.).

618 H.J.P. Arnold. 'What I would like for Christmas [Mr. William Henry Fox Talbot writes]'. *British Journal of Photography*, vol. 136 (14 Dec. 1989), p. 19.

619 Graham Smith. *Disciples of Light: Photographs in the Brewster Album.* (Malibu, California: The J. Paul Getty Museum, 1990. 200 pp. 185 illus.).

620 Larry Schaaf. ' "A Wonderful Illustration of Modern Necromancy": Significant Talbot Experimental Prints in the J. Paul Getty Museum', [p. 31–46] in *Photography, Discovery & Invention, 1839–1989* [Symposium Celebrating the Invention of Photography, J. Paul Getty Museum, 30 January 1989] (Malibu, California: The J. Paul Getty Museum, 1990. 116 pp. 90 illus.).

621 Nancy B. Keeler. 'Souvenirs of the Invention of Photography on Paper: Bayard, Talbot, and the Triumph of Negative–Positive Photography', [p. 47–62] in *Photography, Discovery & Invention, 1839–1989* [Symposium Celebrating the Invention of Photography, J. Paul Getty Museum, 30 January 1989] (Malibu, California: The J. Paul Getty Museum, 1990. 116 pp. 90 illus.).

622 André Jammes. ' "A Glaring Act of Scientific Piracy?" ', [p. 63–70] in *Photography, Discovery & Invention, 1839–1989* [Symposium Celebrating the Invention of Photography, J. Paul Getty Museum, 30 January 1989] (Malibu, California: The J. Paul Getty Museum, 1990. 116 pp. 90 illus.).
 This paper discusses Blanquart-Evrard's unethical use of Talbot's calotype process.

623 Graham Smith. 'James David Forbes and the Early History of Photography', [p. 9–13] in *Shadow and Substance: Essays on the History of Photography in Honor of Heinz K. Henisch*, Edited by Kathleen Collins (Bloomfield Hills: Amorphous Institute Press, 1990. 361 pp. 191 illus.).

624 Robert E. Lassam. 'Fox Talbot's Original Iron Copper Press', [p. 15–16] in *Shadow and Substance: Essays on the History of Photography in Honor of Heinz K. Henisch*, Edited by Kathleen Collins (Bloomfield Hills, Michigan: The Amorphous Institute Press, 1990. 361 pp. 191 illus.).

625 Geoffrey Batchen. 'Burning with desire: the birth and death of photography'. *Afterimage*, vol. 17, no. 6 (Jan. 1990), p. 8–11.
 This article reassesses the very idea of invention before Talbot.

626 Susan L. Taylor. 'Fox Talbot as an Artist: The "Patroclus" Series'. *Bulletin of the University of Michigan Museums of Art and Archaeology*, vol. 8 (1986–88) [published in 1990], p. 38–55.

627 John Moffat. *John Moffat: Pioneer Scottish Photographic Artist 1819–1894.* (Eastbourne: J.S.M. Publishing, 1991. 60 pp. 49 illus.).

628 Larry Schaaf. 'The Fox Talbot Collection' [National Museum of Photography, Film and Television, Bradford, Yorkshire]. *Science Museum Review* (1991), p. 26–29.

629 Graham Smith. 'Maida and Blanche: Talbot, Scott, and John Adamson'.

Scottish Photography Bulletin [of the Scottish Society for the History of Photography] no. 1 ([Spring] 1991), p. 2–6. illus.

630 Michael Gray. 'Talbot Today: Changing Views of a Complex Figure'. *Aperture* 129 (Fall 1991), p. 9.

631 Robert Harbison. 'Decoding the Cipher of Reality: Fox Talbot in His Time'. *Aperture* 129 (Fall 1991), p. 2–8.

632 Graham Smith. 'Talbot and Amici: Early Paper Photography in Florence'. *History of Photography*, vol. 15, no.3 (Autumn 1991), p. 188–93.

633 Mike Weaver. 'Talbot's Broom and Swift's Broomstick'. *History of Photography*, vol. 15, no. 3 (Autumn 1991), p. 242–43.

634 Weston Naef. 'Daguerre, Talbot and the Crucible of Drawing'. *Aperture* 129 (Fall 1991), p. 10–15.

635 Keith I.P. Adamson. 'Early British Patents in Photography'. *History of Photography*, vol. 15, no. 4 (Winter 1991), p. 313–23.

636 Giuseppina Benassati, Editor. *Fotografia & Fotografi a Bologna 1839–1900.* (Bologna: Grafis Edizioni, 1992.)
 This exhibition catalogue includes writings by Andrea Emiliani, Pier Luigi Cervellati, Marina Miraglia, Giuseppina Benassati, Angela Tromellini, Roberto Spocci, Franca Di Valerio, and Michael Gray.

637 Larry J. Schaaf. *Out of the Shadows: Herschel, Talbot & the Invention of Photography.* (London and New Haven: Yale University Press, 1992. 192 pp. 105 illus. index).

638 Graham Smith. 'Talbot and Botany: The Bertoloni Album'. *History of Photography*, vol. 17, no. 1 (Spring 1993), in press.
 Talbot sent Antonio Bertoloni, the Bolognese botanist, 36 photogenic drawings, suggesting the usefulness of photography to botany. This essay describes the volume preserved in the Department of Photographs, Metropolitan Museum of Art, New York.

Index

In this index, numbers printed in light type refer to page numbers and those in bold refer to bibliographical entry numbers as indicated in the Bibliography section.